ART SYSTEMS

BRAZIL AND THE 1970S

ART SYSTEMS

ELENA SHTROMBERG

UNIVERSITY OF TEXAS PRESS ⬩ AUSTIN

This book is a part of the Latin American and Caribbean Arts and Culture publication initiative, funded by a grant from the Andrew W. Mellon Foundation.

Requests for permission to reproduce material from this work should be sent to:

Permissions

University of Texas Press

P.O. Box 7819

Austin, TX 78713-7819

http://utpress.utexas.edu/index.php/rp-form

♾ The paper used in this book meets the minimum requirements of ANSI/NISO Z39.48-1992 (R1997) (Permanence of Paper).

LIBRARY OF CONGRESS CATALOGING-IN-PUBLICATION DATA

Shtromberg, Elena, author.

 Art systems : Brazil and the 1970s / Elena Shtromberg. — First edition, 2016.

 pages cm — (Latin American and Caribbean arts and culture publication initiative (Andrew W. Mellon Foundation))

 Includes bibliographical references and index.

 ISBN 978-1-4773-0744-1 (cloth : alk. paper)

 ISBN 978-1-4773-0858-5 (pbk. : alk. paper)

 ISBN 978-1-4773-0808-0 (library e-book)

 ISBN 978-1-4773-0809-7 (non-library e-book)

1. Art, Brazilian—20th century. 2. Art—Political aspects—Brazil—20th century.

3. Art—Social aspects—Brazil—20th century. 4. Art—Economic aspects—Brazil—20th century. I. Title.

N6655.S58 2016

709.81′0904—dc23 2015013010

doi:10,7560/307441

CONTENTS

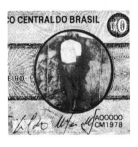

ACKNOWLEDGMENTS

The many years that it has taken to complete this project make it difficult to properly acknowledge all the mentorship, intellectual advice, and emotional support generously dispensed by mentors, colleagues, friends, and family. Throughout this time I have also been aided by helpful strangers at many cultural centers, museum archives, and libraries, where I found unexpected information that helped me piece together the content of this book. I am now left with the uncomfortable suspicion that I cannot adequately compensate their generosity other than to affirm that I would not have gotten here without them. I would first like to thank my dissertation advisor from UCLA, Professor Charlene Villaseñor Black, who since the first moment I contacted her has proven to be an unfaltering and tireless mentor. I have often felt and continue to believe that without her wholehearted support, guidance, availability, and wisdom in all aspects relating to this journey, I would not have gotten here. I also want to thank the members of my dissertation committee, Elizabeth Marchant, Miwon Kwon, and George Baker, for early feedback on this topic. A special thank you to the former editor-in-chief at the University of Texas Press, Theresa May, whose enthusiasm and eager reception of the first outline of this book encouraged me to plunge ahead. A significant dose of gratitude to Aleca Le Blanc for her careful reading (and often rereading) of every chapter. Her editing prowess and skill with narrative helped me to clarify weak spots, identify gaps in logic, and confront critical questions. Profound appreciation to Alessandra Santos, who not only read all of the chapters but was also my authority on language and translation questions. Her enthusiasm and jolts of optimism helped keep my pessimism in check. Additional appreciation for lucid feedback goes to the anonymous reviewer and to Christopher Dunn, whose expertise in the topic was not only welcomed but also helpful in correcting critical errors, making this a more accurate study.

I received significant financial and institutional support from the University of Utah and elsewhere that made this book possible. An early Charlotte W. Newcombe Doctoral Dissertation Fellowship from the Woodrow Wilson Foundation helped fund the research that later informed this book. An American Council of Learned Societies International and Area Studies Fellowship gave me the opportunity to take time off from teaching to write the majority of the manuscript. I also want to acknowledge the

Getty Research Institute for welcoming and hosting me as a guest scholar during 2011–2012 for the theme year on Artistic Practice. I am grateful not only for the priceless availability of all the research materials I needed but also for the uniquely stimulating intellectual environment that I was lucky enough to participate in, not to mention the stunning sunsets. A special thank you to the Brazilianists in the group, Amy Buono, Roberto Conduru, and Claudia Mattos.

I also want to thank Dean Raymond Tymas-Jones, from the College of Fine Arts at the University of Utah, and my chair, Brian Snapp, for their support of the book and for granting research leave at a critical time in the process. A generous College of Fine Arts grant from the University helped me pay for a research assistant to administer copyright permissions. A very special acknowledgment goes to my former graduate student Emily Lyver for performing this task. Her organizational skills and ability to very capably manage the daunting task of obtaining image permissions no doubt moved this project forward to completion much sooner than it otherwise would have. Further, a University Research Council grant from the University of Utah helped fund summer research for additional artist interviews. I am also grateful for a summer Faculty Research Grant from the DAAD German Academic Exchange Service, and to Professor Siegfried Zielinski and the folks at the Vilém Flusser Archive at the Universität der Künste in Berlin for facilitating a portion of the research on Brazilian video. I want to thank Sebastian Edwards, at the University of California, Los Angeles, for his counsel on the economics of inflation, and Randal Johnson for reading the manuscript. Appreciation goes to all my colleagues and particularly to Monty Paret and Lela Graybill for many years of listening to me complain about the minutiae of writing this manuscript. A special thank you to Amelia Walchli for her help and expertise in compiling the images.

The seed of this project was nurtured and grew to fruition in Brazil, and I want to acknowledge insightful and motivating conversations throughout the many different phases of this project, including the exploratory stage more than a decade ago. I am profoundly grateful to Aracy Amaral, Ronaldo Brito, Clóvis Brigagão, Augusto de Campos, Fernando Cocchiarale, Frederico Coelho, Sergio Cohn, Neville D'Almeida, Wlademir Dias-Pino, Paulo Sergio Duarte, Celso Favaretto, Gloria Ferreira, Ferreira Gullar, Paulo Herkenhoff, Heloísa Buarque de Hollanda, Arlindo Machado, Katia Maciel, Cacilda Teixeira Mello, Christine Mello, Décio Pignatari, and Walter Zanini, who generously shared files, documents, and abundant anecdotes, filling in important gaps that helped put the facts into clearer perspective. Thank you also to Andre Parente, who shared the video work of the late artist Leticia Parente, and to Katia Maciel for sharing her video on Hélio Oiticica's work. A very special posthumous thank you to Haquira Osakabe, a former professor and dear friend who passed away before seeing this project come to

fruition. A special thank you to Laura Vinci and Miguel Wisnik for housing me during long stints of research in São Paulo.

My heartfelt and deepest appreciation goes out to the artists who first inspired me to write about them and whose work will always continue to inspire me. Thank you to Sonia Andrade, Artur Barrio, Gabriel Borba, Ana-livia Cordeiro, Antonio Dias, Iole de Freitas, Anna Bella Geiger, Nelson Leirner, Ivens Machado, Antonio Manuel, Cildo Meireles, Ana Vitoria Mussi, José Resende, and Regina Silveira for taking the time to speak with me, often repeatedly, and for sharing details about your life and work and answering pesky, probing questions. It is our conversations that made this project feel real, worthwhile, and urgent. Anna Bella, thank you for first taking me under your wing, and for your unfailing generosity in sharing your personal experiences and historical documentation of this period. Our frequent encounters and conversations led to a special friendship that will long outlive this book. To Sonia, meeting you was one of the many fortu-itous results of this journey, and our special friendship has long ago sur-passed the scope of research.

Thank you to so many colleagues and dear friends who provided criti-cal emotional and intellectual support at different stages of what has at times been an agonizing process. Among them are Amy Buono, Ondine Chavoya, Magdalena Edwards, Marisa Flórido, Christine Foerster, Carrie and Eric Hinderaker, Rebecca Horn, Aleca Le Blanc, Kate Lyra, Harper Montgomery, Glenn Phillips, Kim Richter, Ken Rogers, and Irene Small. I apologize for not naming so many other friends who brightened my life and this task with the reward of their company. Tasty meals, conversations, and handholding were the incentive to get through. Words cannot convey just how much I appreciate you all. Gratitude is also due my family, Roman, Svetlana, and Mila Shtromberg; Alla and Michael Voskov; Jennifer and Dennis, for accompanying the journey; and gracias a mi familia en México: Arabella Rodríguez Pampín, Donovan and Mónica, Ana Paula Rosales, and Luis García. And finally to my dearest of companions and my partners in life, Aravier and Galileo: thank you for your calm confidence, generosity, eternal patience, and joyful smiles.

ART SYSTEMS

The work no longer exists. Art is a sign, a situation, a concept.
—Frederico Morais[1]

During a six-month period in 1971, renowned art critic Frederico Morais organized *Domingos da Criação* (*Sundays of Creation*), a series of six events held the last Sunday of every month on the grounds of the Museum of Modern Art in Rio de Janeiro. These events were hugely popular and drew thousands of participants across class, age, and gender divides. Each Sunday, the public was encouraged to let their imagination run wild as they interacted with a single material structuring the event, including paper, string, fabric, bodies, dirt, and sound.[2] The traces of these creative and temporary encounters were quickly erased the following Monday morning when the museum returned to business as usual. Following "O Tecido do Domingo" (The Fabric Sunday) on March 28, 1971, the widely read *Jornal do Brasil* newspaper described the event as "O livre exercício da criação" (The Free Exercise of Creation), claiming that the Sunday episode and the museum were cultivating freedom and creativity.[3] What is uniquely noteworthy about the creative freedom that these artistic events inspired was that they coincided with a dark political period in Brazilian history known for military repression, censorship, and the attendant curtailing of personal freedom. This political moment is often referred to as the "leaden years" (*anos de chumbo*), a reference to the iron-fisted rule of General Emílio Garrastazu Médici's presidency from 1969 to 1974, a five-year interval during the twenty-one-year military dictatorship (1964–1985). Remarkably, the morose tenor of this period, captured in images depicting clashes between the military and civilians, posters for missing persons, and a preponderance of army tanks on the streets, is absent from the documentation of these events. Instead, the Sundays are remembered for their jubilant and wildly inventive collaborations between artists and their public, highlighting the creative and cathartic possibilities of artistic encounters whose parameters were set only by the choice of an object from everyday life. Indeed, the ephemerality and suppleness of the materials used, such as string, dirt, paper, or sound, were diametrically opposed to the overbearingly oppressive and unyielding administration of President Médici, positioning artistic production as an antidote to hard-line military tactics.

Morais's proposals for the interactive engagement between the museum, art, and the public resonated with the utopian energy espoused by the Brazilian avant-garde during the 1960s, when participation in artworks became de rigueur among artists and thinkers who eschewed the passive consumption of art objects. Opting instead for the creation of situations requiring spectator participation, Brazilian avant-garde artists, like their counterparts elsewhere in the world, saw such partnerships between the artist and the viewer as catalysts for the building of a better world. By assimilating activities into the artistic experience, aesthetic "situations" would thus not only allow more people to relate to—or live—art but would also stimulate a collective consciousness from which collective progress was fathomable. While such aspirations were dimmed by the oppressive political state in Brazil during the 1970s, the legacy of the avant-garde was channeled into the commitment to art as a site of collective and creative freedom. According to Morais's criteria, "The museum has to bring the act of creation to the broader public, generating the conditions necessary for everyone to exercise their creativity freely."[4]

The Sundays of Creation provide a small glimpse into the artistic energy of the 1970s, when the shape of aesthetic freedom underwent a number of significant changes, including the expansion of materials defining artistic production (many of which were now drawn from everyday objects), and the reconfiguration of how and for whom art circulated. These Sunday events foregrounded a pressing concern for artists working during the 1970s, which was to mobilize artistic expression in the name of creative and political freedom by engaging a broader public outside of the confines of artistic institutions. This was achieved by integrating artistic production into social communication outside of the art world, using strategies drawn from systems outside of traditional conceptions of art, in particular those associated with media and communication.

This book details the story of art as it infiltrated four central systems of communication, exchange, and representation, each explored in its own chapter: "Currency," "Newspapers," "Television," and "Maps." The choice of these systems allowed me to focus this investigation on the core economic, media, technological, and geographic conditions that circumscribed artistic production, without limiting my analysis to the strictly political perspective that has dominated the interpretation of the artworks from this period. By extending the notion of "systems" as a framework for investigating Brazilian art from the 1970s, my objective was not to expand on the existent scholarship on systems theory or its application to the art world, but rather to examine the specific historical details of the different social systems with which artistic production was irrevocably integrated.[5] This book, then, proposes a unique and widely applicable framework for theorizing artistic practice that is bound to be useful to historians working with

cultural production and its intersection with social and political life in the latter half of the twentieth century.

My adaptation of systems as a theoretical framework owes a partial debt to the theory proposed by the Austrian-born biologist Ludwig von Bertalanffy in his groundbreaking article from 1950, "An Outline of General System Theory."[6] In the expanded 1968 book version of his work on general systems theory (or GST), von Bertalanffy defined "open systems" as a means to approach life's phenomena as a web of intersecting relationships, rather than as discrete wholes.[7] His claim that an organism should be approached as a complex system in interaction with its environment (including its researcher) rather than as an isolated entity caused a paradigmatic shift that was felt not only in the sciences but also widely within the humanities. During the 1960s, a systems outlook was experienced in the art world, both by practitioners and critics, and in 1968, the New York City–based art critic Jack Burnham published "Systems Esthetics," one of the seminal essays on how a systems perspective reconfigured the art object.[8] Burnham's claims were that art "does not reside in material entities, but in relations between people and between people and the components of their environment" and that the artist "strives to reduce the technical and psychical distance between his artistic output and the productive means of society."[9] Burnham suggested that an understanding of art should not be limited to art objects inside an artistic institution but rather should view art as a network of relationships.[10] A systems perspective thus affected not only the configuration of the art object but the whole critical apparatus surrounding artistic practice more broadly, shifting the terms of how art should be approached, displayed, viewed, and written about.

While I have not found direct evidence that Burnham's work was read or circulated in Brazil (although it *is* possible, given the international popularity of *Artforum* as a publication that featured concept-based work for artists), it is clear that the ideas he expressed in his essay were applicable to a number of international artistic contexts. In neighboring Argentina, for example, the exhibit *Arte de Sistemas* (*Systems Art*), organized by the art critic Jorge Glusberg, united a group of international artists at the Center for Art and Communication (CAyC) in 1971.[11] Glusberg did not cite Burnham in his writing about *Arte de Sistemas*, but he was well aware of international trends in the art world and would likely have encountered systems esthetics during his many travels.[12] In his writing, he emphasized that artists were no longer interested in art objects but rather in artistic projects bridging technology with social and community interests, a position that echoed a systems perspective.[13]

The idea of art as an open system, a site that is the matrix of social exchange, is one that I have adapted for this book, a study that excavates the constellation of economic, legislative, and aesthetic activities surround-

ing artistic production during one of Brazil's most socially and politically fraught decades. At its core, this book offers an in-depth social history not only of a select group of artworks but also of what they reveal about the historical moment they emerge in and the social systems they navigate. The social systems organizing this study—currency, television, newspapers, and maps—are important for a number of reasons. Not only were they the site of widespread economic, communication, technological, and geographic reforms, they also definitively altered the cultural landscape of Brazilian art. A study of these systems provides a window onto important historical factors, such as Brazil's economic boom, monetary inflation and the art market; the heavy-handed presence of censorship in the press; the role of Brazil's largest television network, TV Globo; and the military regime's expansion into the Amazon—all of which shaped the place of art in society. Further, all four systems played a role in people's everyday life and thus presented the artist with the opportunity to reach a more widespread public and, even more significantly, to engage with audiences outside the confines of artistic institutions. While Brazilian artists were not the only ones to look to these systems—in fact, during the 1970s, all four were highly visible in artistic practices within many different international contexts—a close examination of how they surfaced in Brazilian art allows the reader to fully grasp the ethos and the stakes behind artistic practice at this time.

As an art historian, my own history with this topic is closely related to the systems I have chosen to examine for this book. During my initial research trip to Brazil, I first needed to obtain national currency, read newspapers to be aware of current events, watch television to learn popular visual codes, and finally use maps to navigate the cities where I conducted research. Little did I know that this first trip would change the course of my academic life and pave the way for this book. During the course of my travels to Brazil, my original objective to study Brazilian modernism was derailed by meeting artists who lured me away from working in archives to listening instead to living memories of their works. Invited into artists' homes, I conducted as many interviews as I could, amassing countless anecdotes along with photocopies from personal archives of photos, newspapers, reviews, critiques, pieces of paper, and other textual misfits. I relied heavily on testimony from many of the artists and poets who figured prominently in Brazilian art in the 1970s, among them Sonia Andrade, Artur Barrio, Gabriel Borba, Augusto de Campos, Antonio Dias, Wlademir Dias-Pino, Iole de Freitas, Anna Bella Geiger, Ferreira Gullar, Nelson Leirner, Ivens Machado, Anna Maria Maiolino, Antonio Manuel, Cildo Meireles, Ana Vitória Mussi, Décio Pignatari, José Resende, and Regina Silveira.[14] Oral and anecdotal traces of their stories inevitably shaped and enriched my understanding of this historical period. Many of the artists opened their files to me, allowing me the opportunity to amass invaluable documentation not available else-

where. However, what I most sought out during these conversations was an understanding of the texture of the social life in which their art was conceived. This book is my attempt to narrate the details of this texture and the social relationships that artworks cultivated, by piecing together the existing written histories with the anecdotal fragments of memory and text culled from diverse sources.

Although the title of the book refers to artistic production of the 1970s, the point of departure for this study is 1968, a year that is often considered to have prematurely ushered in the 1970s. Echoing unforgettably within the national and international psyche, the year 1968 invokes painful memories of human rights abuses in cities across the world—Mexico City, Prague, and Paris, among others—as well as mass student manifestations, political agitation, and increased demands for social justice. In Brazil, it was a year full of political strife following the passage of the institutional amendment AI-5, which significantly curbed political and social freedoms. Around this time, artists took their practice to new and often indefinable aesthetic heights by adapting the anti-authoritarian energy of political rebellion. Within this social sphere, art as a platform for defiance to existent aesthetic, political, and social agendas was prioritized.

Examining how visual artists adapt to and navigate repressive conditions, including censorship, is an important facet of understanding civilian resistance to authoritarian regimes, as much a pressing concern of society during the 1960s and 1970s as in the present moment. Brazilian artists working in the 1970s are a unique if underanalyzed case study in such an inquiry, especially because their work was part of a broader civilian response pressuring the military regime toward *"abertura"* (opening), a transitional phase that preceded democratic elections. Uncovering the different layers that influenced Brazilian artistic production at this time will give scholars of Latin American art and contemporary art a distinctive frame of reference from which to understand one of the most important epistemological shifts in art, the transition of the artwork from its object status to a set of experiences shaped by everyday social systems.

When I began this journey over a decade ago, only a handful of publications broached the topic of artistic production in Brazil during the 1970s, a decade that has been notoriously difficult to classify using recognizable art historical parameters, such as style, medium, theme, or materials, as organizing categories. That is not to say that the artists included in this book were unknown; in fact, it was quite the opposite, and many of the artists I write about—Sonia Andrade, Artur Barrio, Paulo Bruscky, Anna Bella Geiger, Antonio Manuel, and Cildo Meireles, among others—are not only renowned in Brazil but are internationally recognizable figures. Artur Barrio and Cildo Meireles, for example, were featured in *Information*, the Museum of Modern Art's seminal exhibition of international conceptual

art tendencies that were closely aligned with systems theories in 1970. The art historian Aracy Amaral discussed many of these artists in a 1985 essay on non-object-based art for an exhibition catalogue titled *Arte novos meios/ multimeios: Brasil 70/80* (Art of new media/multimedia: Brazil 70/80).[15] Years later, the art historian Gloria Ferreira featured these as well as many other artists in two of the most comprehensive exhibitions on this period: the first in 2000, *Situações: Arte brasileira: Anos 70* (*Situations: Brazilian Art, the 1970s*), and the second in 2007, an expanded version, *Arte como questão: Anos 70* (*Art as a Question: The 1970s*). Both exhibitions and their catalogues stand as important visual documents of the decade's artistic production. In this vein, the art historian Cristina Freire's works *Poéticas do processo: Arte conceitual no museu* (1999) and *Arte conceitual e concei- tualismos: Anos 70 no acervo do MAC, USP* (2000) described the institu- tional practices of the Museum of Contemporary Art at the University of São Paulo in cultivating works that challenged accepted artistic parame- ters. However, the corpus of publications in this field is still largely domi- nated by exhibition catalogue essays and monographic studies, all of which provide important biographical information but little in-depth analysis of the materiality of the artwork or details of the specific historical moment in which it emerged.

In the past fifteen years, as publications detailing the grim history of the dictatorship have proliferated, the political dimension of artistic pro- duction during the 1970s, that is, art as a response to the dictatorship, has received much-needed attention.[16] This has been particularly true with re- gard to the study of concept-based artworks in Brazil and, more broadly, in Latin America.[17] Most recently, the publication by the art historian Claudia Calirman titled *Brazilian Art under Dictatorship: Antonio Manuel, Artur Barrio, and Cildo Meireles* (Duke University Press, 2012) contributes to scholarship on this topic, using the lens of the political dictatorship to situ- ate the artistic production of three of the best-known artists from this de- cade. While there is no question that the political dimension of art is of exceeding importance, my examination has revealed the complexity of this political period and the instability surrounding the conditions of the dictatorship. In my research on Brazil, I have found that the dictatorship rarely stood for a singular and stable notion of authoritarian abuse. Avoid- ing strictly causal interpretations between art and politics enabled me to uncover the multiplicity of relationships surrounding art production during this time. This was confirmed by my conversations with artists, who rarely relegated their work solely to a political cause, although all claimed to be politicized in their approach to making art. It is the task of future publica- tions to build on the scholarship available today with more nuanced atten- tion to the aesthetic and historical details surrounding specific artworks and what facet of the military dictatorship they engage. In Brazil, the com-

plexity of political rule and the number of competing factions within the dictatorship demand that military rule be considered in its different phases, addressing the presidents in power and the legislation passed during their administration. For example, the first president elected after the coup in 1964, Marshal Humberto de Alencar Castelo Branco, was aligned with the Grupo Sorbonne faction, a more intellectual group of military men, who described themselves as conservative democrats. The Grupo Sorbonne envisioned an imminent return to a democratic system and saw their objective as temporarily defending the country from the threat of a communist takeover. The other dominant faction in the military was the *linha dura*, or hard-liners, who believed in iron-fisted rule and proposed a long period of dictatorship in which violence and repression could be freely wielded. Marshal Artur da Costa e Silva, who came to power in 1967, was affiliated with the hard-liners, and it was under him that the Ato Institucional Número Cinco (Institutional Act Number 5), known as AI-5, was issued in 1968. General Emílio Garrastazu Médici replaced Costa e Silva in 1969, initiating one of the most repressive periods of the dictatorship, but ironically, the day after he was elected, the newspaper *Jornal do Brasil* featured the headline "Médici assume a Presidência prometendo ao povo a volta ao regime democrático" (Médici assumes the presidency promising the people a return to a democratic regime).[18] By 1974, General Ernesto Geisel, affiliated with the Grupo Sorbonne, came to power. Geisel's rule was characterized by what historians call *distensão*, or a relaxation of authoritarian control, and a move toward democratic rule. This period initiated the move toward *abertura*, or political opening, a gradual and slow process that would lead to a softening of repressive government measures, including censorship, and democratic elections in 1985. The dictatorship, while unquestionably authoritarian, was neither united nor consistent, and each president's rule was riddled with myriad contradictions, as I demonstrate.

Such contradictions were especially notable with regard to the administration of censorship, one of the dominant forces of control imposed by the regime. This was particularly true of who and what was targeted by censorship laws, many of which were so arcane and ambiguous as to be arbitrary. In 1971, the journalist Zuenir Ventura detailed instances of censorship within the arts, stating that the prohibitions targeted plays, films, songs, and actors working in television and radio. At the same time, countless books were removed and placed into police vaults. Ventura and his coauthors described one instance in which Sophocles and even Michelangelo were censored because a poster of the latter's *David* was considered immoral.[19] When determining prohibitions, censorship decrees often invoked language such as "immorality" and "bad taste," terms that were not only difficult to define but essentially made everything suspect. Contradictions abounded even within the terms the censors defined. For example, while

Michelangelo's *David* was censored on the grounds of nudity, a new film genre called *pornochanchadas*, sex comedies featuring explicit sexuality, not only proliferated during the years of the regime but were supported by the state film organ, Embrafilme.[20] The irregular treatment of the visual arts by censors, unlike that of music, literature, cinema, and theater, often provided artists a pocket of creative freedom in which they could evade certain restrictions by adapting and transgressing the obscure and bureaucratic language of the regime.

In *Art Systems*, I have included information on specific political situations and legislation, particularly with regard to censorship, that affected the system in question and, as a result, the artist engaging that system. To do so, I leaned heavily on scholarship from outside the discipline of art history, probing the social sciences and the fields of history, economics, sociology, political science, geography, and communication. Thus, the research and organization of the book is also modeled on a systems perspective, positioning the object of study as a complex organism to be addressed as a network of relationships. No one dominant theoretical voice structures the narrative, as each chapter presents a series of different historical considerations and methodological problems based on the artworks in question. This book is thus a radical departure from the more conventional biographical, artist-based model of narrating art history, and is instead focused on the relationship between the select system and the artworks engaging it. It became clear that employing a traditional art historical approach with works whose ontological existence depended on opposition to existent artistic paradigms would betray the range of the artworks' interpretive possibilities. Additionally, the works featured in this book do not conform to an easily identifiable style, form, material use, or medium, nor do they coalesce under prevailing artistic tendencies. While I do not want to suggest that artists were not in dialogue with more internationally prominent artistic movements such as conceptual art, arte povera, performance art, and others, affinities that I address throughout the book, I have found that these tendencies are limited in addressing the full scope and impact of the artworks in question. Appropriating Morais's claim from 1970, I have instead positioned the artwork as "a sign, a situation, a concept," allowing for a broader range of analysis.[21]

While this book attempts to expand on the narratives and meanings surrounding both renowned and lesser-known artworks during the 1970s, it by no means attempts to be encyclopedic or comprehensive in scope, a task that goes beyond my objective and is futile at best. The artworks selected for this study illustrate different facets of the social systems structuring this book, and this has meant that countless other artworks and artists, many of whom are critical to artistic production during this decade, have been left out. I, like others who attend to a decade's worth of artistic production, struggled with these decisions, particularly in those cases where I

truly admired the artist and recognized that their works deserve to be written about.

The narrative in each of the chapters unfolds by establishing the circumstances surrounding the designated systems—currency, newspapers, television, and maps—chosen because of their importance as agents in shaping and communicating information. Many artists working at this time adapted, mimicked, and attempted to transgress the mechanisms of these systems through their art practice. While each chapter presents a separate system, there is significant overlap between the systems and the ideas they broached, and therefore they are never situated as fully circumscribed or closed entities. Instead, all four chapters were guided by a series of questions, such as: What would it mean to understand the inner workings of these systems, both at this time and historically? How did artists adopt the internal operational logic of these systems and what did that do to expand accepted ideas about an artwork? What can an artwork and its integration into a broader social system tell us about that system? What does it mean to interpret a work of art as a network of relationships?

The first chapter, "Currency," investigates Brazil's monetary policy, economic miracle, and rampant inflation by turning to a series of artworks using currency, both real and proctored, by artist Cildo Meireles. Throughout the 1970s, Meireles produced a number of projects in which he employed banknotes to circulate alternative and subversive information as well as poignant commentaries on commercial and artistic value. Meireles's use of money as a material support for an artwork encourages an exploration of Brazil's volatile numismatic history. Marked by rampant hyperinflation and multiple currency changes spanning the decade under consideration, banknotes pointed to both the instability of economic institutions and the complexity of determining economic and social value. Positing banknotes as an alternative circuit for information exchange, Meireles's work provides a compelling case study to address the paradoxes defining this period and to further illuminate the shift from the work of art as a static art object of display to one relying on existent exchange mechanisms.

Chapter 2 examines newspapers, a social system that presents and represents all manner of commentary on the political, economic, and cultural life of the day and its intersection with artistic practice. In this chapter, I present detailed information on specific censorship measures enacted after the passage of AI-5 in 1968 as a means to understand the political stakes of communicating in print media at this time. The newspaper featured prominently in artistic production during the 1970s. Embedded in the newspaper's graphic space is a unique texture, pattern, layout, and iconography, as well as an inexpensive and inexhaustible source of content on everyday life. Given its daily circulation, easy reproducibility, and portability, the newspaper provided an attractive material and graphic space to those art-

ists who sought to elude any association with artworks as precious objects. This chapter focuses on those artists who not only adopted the graphic aesthetic of newspapers but also went further by inserting their work within the pages of the newspaper, using it as a mechanism for circulating their work. This was the case in the work of artists such as Antonio Manuel, Cildo Meireles, and Paulo Bruscky, who uniquely negotiated graphic experimentation within the conditions surrounding newspaper censorship. The easy accessibility of the newspaper and its detachment from both art institutions and the art market fulfilled the reigning desire on the part of artists to reach and communicate with a broader public outside of a capitalist system that emphasized culture as commodity. Given that newspapers were manipulated to shape the ideological needs of the military government during the 1970s, artists' appropriation of the newspaper's mechanism became a subversive undertaking. Thus, at the crossroads of information and censorship, the newspaper embodied a productive tension between the limits of freedom of expression and its sublimation into alternate forms.

Chapter 3, "Television," explores advances in communications and satellite technologies that accounted for the ubiquity of television in even the most remote of Brazilian households. By the 1970s, television became the most effective system of communication, a focal point of interest for both artists and the military regime. This chapter reveals the points of divergence and convergence in the relationship of political and artistic spheres with regard to television, foregrounding how an emphasis on communication provided the context for the widespread expansion of television and later video art in Brazil. Despite their decidedly different agendas, both the regime and artists sought to exploit television's capacity as a mass media mechanism. For the regime, rigid control over television programming served as a means to disseminate its propaganda and conservative principles, thus expanding the reach of the military complex. This was made possible by a complicity between the military and TV Globo, which rose to staggering prominence during the 1970s. Not only will the history of TV Globo be addressed but also how its programming strove to create a model Brazilian citizen through the introduction of "The Globo Standard of Quality." The appropriation of the televisual apparatus in the visual arts at this time, particularly through the medium of video art, presented artists with the possibility of creating an alternative to mainstream television programming, a "countertelevision," as one critic called it, where dissident voices could be heard.[22] This chapter details the history of the emergence of video art and includes in-depth analyses of several key artist videos by Leticia Parente, Sonia Andrade, Paulo Herkenhoff, and Geraldo Anhaia Mello. As part of this history, I also address why women artists played such a prominent role in early video art and visual art more broadly. In contrast to TV Globo's and the military's initiatives for television, Brazilian video artists offered viewers

an alternative to prescribed identities. Rather than continue to support the broadcast of content promoting depoliticized subjects, Parente, Andrade, Herkenhoff, and Mello stage uncomfortable and often tortuous confrontations with their bodies to communicate and denounce the violence of the regime and activate the viewer to reflect on their surroundings. While early artist videos did not constitute an artistic movement per se, when analyzed within the context of television as a system dominating social life in Brazil during the 1970s, they reveal the ways in which artists absorbed communications technologies into their work.

Chapter 4, "Maps," elucidates how cartography was deployed in the service of the regime's expansionist ethos at the same time that a pronounced mapping impulse influenced artistic production. As a point of departure, the chapter positions three crucial events as transforming the spatial orientation of the Brazilian citizen. First among these events was the speedy construction of the new capital city, Brasília, between 1957 and 1960 on the formerly barren scrubland of the interior central plateau, directing political as well as economic and cultural attention inland away from the more densely populated coastal regions. Second, the eagerly anticipated moon landing by the United States' Apollo spacecraft in 1969, broadcast globally to millions of television viewers, expanded the possibilities for navigating and dominating space. Finally, the forced resettlement of the Amazonian rainforest in the 1970s, carried out by the military government through the construction of the Trans-Amazon Highway in 1972, among other initiatives, extended the physical and conceptual boundaries of the Brazilian nation with grave consequences for the region's inhabitants.

Foregrounding a diversity of mapping strategies, this chapter hones in on the technological, cartographic, and aesthetic apparatuses surrounding the definition and representation of territories. Maps have a long history in Brazil, having paved the way for fifteenth-century European colonization. The vestiges of historical mapping projects resonate in the regime's integrationist politics of exploiting the vast and isolated Amazonian territories during the 1970s. In contrast to the maps generated for government purposes, artworks incorporating maps and mapping operations, such as those by Cildo Meireles, Anna Bella Geiger, and Sonia Andrade, signal the ways in which artists advanced alternative forms of understanding territorial identity. Merging a variety of media, including drawing, sculpture, video, and installation, the artworks featured in this chapter propose unique models for the organization and depiction of space within urban, regional, and national boundaries. Central to their mapping practices is an attempt to adapt and subvert official modes of mapping space by introducing different strategies for representing topographic data.

The term "economic miracle" will unfailingly be encountered in reference to Brazilian history from the 1970s and, more specifically, to the rule of General Emílio Garrastazu Médici, Brazil's president from 1969 to 1974. The word "miracle" describes a period when Brazil's economy was expanding beyond expectation and experiencing one of the fastest growth rates in the world. During the early 1970s, the international press was stirring with enthusiasm about Brazil's path to becoming a global superpower. The optimistic, almost upbeat tone connoted by "miracle" is, however, immediately trumped by another phrase, "*anos de chumbo*," or the leaden years, used to describe the iron-fisted rule of Médici, the most repressive and violent five-year period of the military government in power from 1964 to 1985. Reconciling these two histories—on the one hand, a thriving economy, the sign of a vibrant nation, and on the other, an oppressive state, characterized by the poisonous and dangerous qualities of lead—is one way to grasp the complex and contradictory nature of Brazilian history of this time. The coexistence of multiple realities becomes even more apparent by looking closely at the details surrounding Brazil's economic boom and the ways in which it affected and afflicted the everyday lives of Brazilian citizens. What did it mean to live in a society where the optimism accompanying economic growth was coupled with the dread of being apprehended by the police, and where government propaganda and censorship replaced access to unmediated information? This question spotlights the contradictory realities of Brazil during the 1970s: unbridled growth versus constrained liberties; the uneven flows of money and information. How did one participate in the growth and the censorship at the same time in a meaningful way?

By way of a response, I propose in this chapter an investigation of Brazil's monetary policy through an analysis of currency as a social system. In what is likely a departure from traditional entryways into studies of currency, I suggest that this analysis originate in a series of artworks using currency, both real and proctored, by artist Cildo Meireles (b. 1948). Though I have yet to find mention of Meireles's work in the scholarship of historians or economists, it can productively be used to study the paradoxical paths and inconsistencies of this period. Artistic practice, intimately linked to the art market as well as to different modes of communication and information transfer, was

uniquely and ideally suited to tackle both the economics and the censorship of this time. An in-depth analysis, then, of Meireles's work with currency provides a distinctive and indispensable lens through which to explore the aesthetic, economic, political, and even legislative contexts specific to Brazilian cultural life during the 1970s.

Most discussions of money and currency in artistic production are dominated by the role of the art market, or the monetary value of a particular artwork as it circulates in galleries or auction houses. Without ignoring this facet of money, which, as we will see, was important to artists working at this time, my objective is instead to broaden the focus of strictly economic or historical inquiries by applying a systems theoretical approach. To do so, I concentrate on the indivisible intersections between seemingly distinct facets of life at this time. In my study of currency and its convergence with Meireles's money-based artworks, I am informed by the ideas of the German philosopher Georg Simmel, who, in his seminal work *Philosophy of Money* (1900), posited that as a ubiquitous presence in people's daily lives, money could teach us about a wide range of social phenomena.[1] Simmel argued that as the "objectified articulation of exchange relations," money linked the individual to modern society, exposing their interrelationship.[2] It is this nexus between money, the individual, and society that I would like to interrogate further.

Though anachronistic to the 1970s, Simmel's emphasis on a sociological rather than a strictly economic perspective to the study of money not only influenced my approach to currency as a system but is also conversant with Meireles's position with regard to his currency projects. Widely exhibited as an example of Brazil's politically inflected conceptual art, Meireles's currency series boasts an extensive exhibition history. However, despite the international exposure of his work, the writing on it has too often focused on a limited range of political motives rather than on the complex and multilayered social spheres circumscribing its emergence. An in-depth analysis of currency is a unique opportunity to investigate some of the lesser-explored stakes of Meireles's artworks using banknotes. In my analysis, Meireles's works act as a locus for elucidating international manifestations of conceptual art, information, and communication theories as much as the policies generated by the military government. A systems theoretical framework, I argue, is the most appropriate one to access the relationships and institutional factors that are embedded in Meireles's work and in the system of currency itself. As Simmel pointed out, the study of money as a social lens cannot rely on a single disciplinary perspective or point of reference.

THE BRAZILIAN MIRACLE

Much has been written about the economic changes Brazil underwent during the twenty-one-year rule of the military dictatorship. The economic data depict irrefutable evidence that the country experienced exceptional growth after the military takeover in 1964. Commonly referred to as the "Brazilian miracle," the early years of military rule, especially from 1968 to 1973, witnessed tremendous financial gains, with unusual surges in the gross domestic product (from 1.5% in 1963 to 11.3% in 1971).[3] The remarkable growth in the Brazilian economy came at a cost, resulting from oppressive measures with regard to labor rights and the suppression of union and labor organizations in order to keep national labor costs artificially low to draw foreign investment.[4] Nevertheless, Brazil's growth positioned the country as an economic world leader, despite brewing social turbulence, growing international concern over human rights abuses, and persistent problems with inflation leading to monetary devaluation.[5] During the 1960s and well into the 1990s, the Brazilian economy was marked by rampant inflation and underwent several currency changes. In 1967, the cruzeiro, Brazil's official currency since 1942, was phased out and the cruzeiro novo (new cruzeiro) was introduced, a transition that lasted only three years when in 1970 it reverted back to the cruzeiro.[6] The currency modification of 1970 lasted throughout the rest of the dictatorship and was replaced by the cruzado in 1986.[7] Alongside the transitions in currency, the face value of money was constantly fluctuating as Brazilians lived with the continuous threat of monetary devaluation resulting from inflation. The economist Ronald Krieger has written that Brazil has a centuries-long history of inflationary pressures, due to what he identifies as "a chronic tendency toward federal budget deficits and overexpansion of the money supply."[8] The Brazilian economy reached an alarmingly high inflationary rate in the early sixties, just before the military coup, following the drastic increases in spending during the rapid and expensive industrialization projects undertaken throughout Juscelino Kubitschek's presidency (1956–1961), in particular the construction of Brazil's new interior capital, Brasília. The inflationary peaks, from 55 percent in 1962 to 150 percent in 1964, caused a recession that historians have long claimed was responsible for the removal of the elected president, João Goulart (1961–1964), and the military takeover in 1964.[9]

Throughout the first decade of military rule, the growing Brazilian economy continued to be plagued by inflation. The monetary policy of the military government sought strategies to reduce the rate of inflation and improve cash flow and savings; however, it did so through a series of draconian measures, including lowering the minimum wage, keeping labor cheap by outlawing unions to avoid labor strikes, and overtaxing the minimum-wage workers. In 1968, as a means to curb inflation and the attendant devalua-

tion of the currency, the military government adopted a measure to devalue the cruzeiro every four weeks instead of the more infrequent and irregular devaluations experienced until then. The "crawling peg" strategy, as this measure is often called, meant that from 1968 to 1971, there were twenty-four currency devaluations, occurring every forty-four days.[10] Given the insurmountable task of eliminating inflation altogether, people adopted the saying "We don't fight inflation, we live with it."[11]

Through the ups and downs of such monetary processes, Brazilian citizens confronted and tackled inflation on a daily basis well into the 1990s. For most people, this meant that there was no sense of price stability, and the cost of basic everyday products such as milk, bread, and eggs would fluctuate daily. The price of beans, a staple of the Brazilian diet, for example, increased 400 percent during 1973, and the price of potatoes, another staple, grew by 300 percent that same year.[12] One woman explains that at the beginning of the month, when people got paid, there was an instant rush to the supermarket, where people braved colossal lines, compelled by the urgency to stock up on as much as possible before prices went up the next day.[13] These vacillations in prices caused supermarkets to hire several people whose sole responsibility was to keep up with relabeling the merchandise according to daily price changes. One writer describes racing to get to an item and grab it before it was relabeled with a higher price.[14] Though the government attempted to curb such variability in prices on staple foodstuffs by imposing price limits on certain items, the strategy backfired, resulting instead in hoarding and shortages.[15] This was especially difficult for the minimum-wage working class, who had no room in their budget to negotiate even the most minor price modifications.[16] Such variability in the prices of common goods made it difficult, if not impossible, to rely on money as a barometer of value. In fact, at this time, people who could afford to either converted their earnings in cruzeiros into US dollars or bought goods that had more concrete value. As the economic analyst Raymond Devoe wrote, any extra cash was "channeled into 'collectibles' before its value deteriorate[ed] further."[17]

Art objects became one of the goods people channeled their money into. The art market in Brazil gained a great deal of momentum during the years of the economic boom, particularly between 1970 and 1975. In his thorough study of the Brazilian art market, the social scientist José Carlos Durand explained that investment experts encouraged clients to look to art objects as a lucrative alternative to stocks and buildings.[18] The art market at this time comprised galleries, auctions, and art fairs, but it was by far the art auctions that were responsible for the largest influx of money, accounting for the sudden boom.[19] In particular, sales of works by well-known modernist painters soared, selling at prices that competed with the cost of European master paintings, all of which created an inflated market demand for

painting.[20] Newspaper and magazine articles fed the frenzy by constantly featuring the escalating prices of artworks and the growing value of art investments. The clients for these artworks belonged to an emerging and newly wealthy sector of society for whom buying art was a way to gain cultural credibility. For many of these new millionaires, the auctions were also an important social event, described in gossip columns as the "place to be seen." Durand also remarked on the whole industry that surfaced as a result of this mad rush of art commerce, including banks and investment companies devoted to financing the sales of paintings.

MONEY TREE

The contradictory reality of value as experienced in the instability of the prices of everyday goods and in the capricious conditions of the art market circumscribes Cildo Meireles's works of art with currency. The first of these works, *Árvore do dinheiro* (*Money Tree*, 1969), a humorous reference to the old saying "Money doesn't grow on trees," was instead a minimalist sculptural display of one hundred one-cruzeiro bills (figure 1).[21] Folded into a neat square and tied together with an orange elastic band, the object mimicked how the bills would have been stockpiled in a bank. *Money Tree* was exhibited as a square bundle on a wooden pedestal with the following statement printed on the base: *Título: Cem notas de 1 cruzeiro. Preço: Dois mil cruzeiros* (Title: One hundred one-cruzeiro notes. Price: Two thousand cruzeiros).[22] The ordered and tightly folded banknotes, pressed together and bearing the government's insignia, seem incongruous as an object of display, given their commonplace association as compensation for a work of art.[23] Certainly the work hints at the paradox of determining the value of an object through the ironic gesture of randomly reassessing the price of the currency on display. Value here, detached from deeply held ideas of artistic labor and skill, defies the market predilection for painting by proposing a conceptual exercise in favor of a material one. By intentionally exaggerating the cost of the artist's labor—after all, anyone could simply re-create the work at home by putting bills together in a rubber band—Meireles undermined any fixed ideas about artistic skill. He claimed that he did not believe in the "artist creator," but rather in a creator who is a member of society, like any other, pushing for "harmony, justice and happiness."[24] The de-skilling of the artist and the idea that anyone could do it were concepts that he actively encouraged in future works as well.

Describing the *Money Tree*, Meireles cited the "paradox of value: symbolic value and the real value of things, exchange value and use value."[25] Referencing the different attributes of value, Meireles is drawing on Marxist economic principles with regard to the circulation of goods or commodities in the market. The paradox he draws on highlights not only the arbitrary

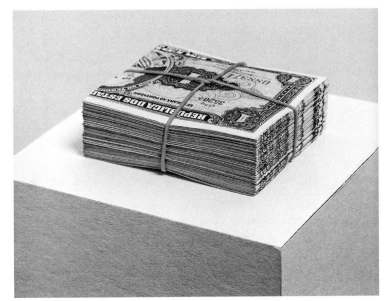

FIGURE 1.
Cildo Meireles, *Árvore do dinheiro* (*Money Tree*), 1969. One hundred folded one-cruzeiro banknotes tied with a rubber band and placed on a pedestal. Courtesy of the artist. Photograph by Pat Kilgore.

appraisal of the commercial worth of artworks, particularly with regard to the fledgling Brazilian art market, but also the mercurial value of Brazilian currency and household goods at the time. The work dramatizes not only the monetary transactions common within the art market but also the fickleness of monetary transactions taking place in the daily reality of citizens living in Brazil at this time.

ZERO CRUZEIRO

The contradictions inherent in determining value are revisited more explicitly in Meireles's later projects with currency, *Zero Centavo* and *Zero Cruzeiro* (1974–1978).[26] In these works, he continued his investigation into the contradictory realities circumscribing the Brazilian currency. For *Zero Cruzeiro*, Meireles fabricated cruzeiro notes with a zero denomination (figure 2). He printed the zero bills in offset by making photolithographs, one of the most common and least expensive techniques for producing large quantities of printed material. This was also the method used by the Casa da Moeda, the agency that printed paper money in Brazil after 1965, following the redesign of the cruzeiro.[27] By imitating the official printing method, Meireles created zero bills that, upon examination, resembled government-issued ones, both in size and design.[28] The artist explained that for the bills he would first cut the zeros off actual cruzeiro notes, then glue them onto his notes and erase the existing number by replacing it with a similarly patterned (moiré) design, after which he created the photolithograph used to print his bills.[29] To further the graphic veracity of his bills, Meireles included serial numbers on the left- and right-hand corners (he used simply

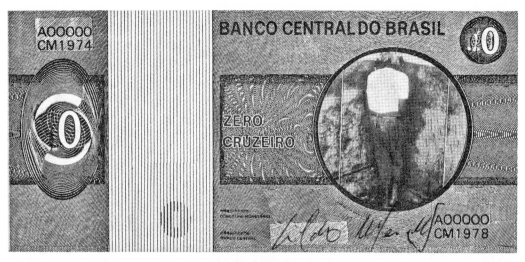

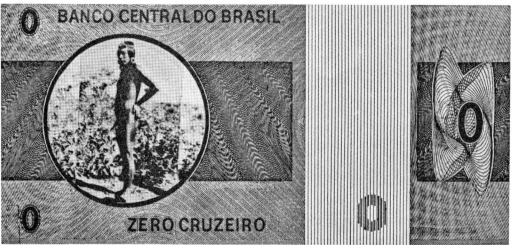

FIGURE 2.
Cildo Meireles,
Zero Cruzeiro,
1974–1978.
Offset print
lithograph,
7 x 15.6 cm.
Courtesy of
the artist.
Photograph by
Pat Kilgore.

Aooooo) of the obverse (front) side, imitating the layout of the bank-issued bills, which all bore different serial numbers. Underneath the serial numbers, he included his initials, CM, and the year of the work; the bills I have seen featured CM1974 at the top left and CM1978 on the bottom right. The artist made one other alteration on his *Zero Cruzeiro*: In place of the signature of the president of the Banco Central do Brasil, the artist signed his full name, replacing government authority with artistic agency.

The *Zero* currency projects, Meireles claims, "were born from the action of thinking about that pile of banknotes [*Money Tree*]." In one, value is artificially inflated through an arbitrary assignment of worth, and in the other, value is deflated, so that it is of zero worth. Despite what appears to be a direct influence, Meireles denies that *Money Tree* and *Zero Cruzeiro* are a commentary on Brazil's problem with inflation, largely for fear of limiting the works' interpretive potential by regionalizing them.[30] Nevertheless, it is hard to cast aside the possibility that these works are closely related to the

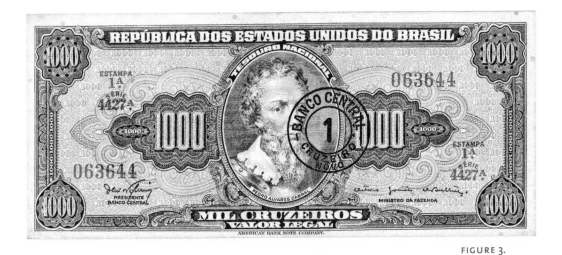

FIGURE 3.
1,000–cruzeiro
novo banknote
stamped with
a 1. Photograph
by author.

reality of someone who had experienced monetary devaluation and multiple currency changes, as well as their accompanying adjustments to value.

Though it takes a measure of mental gymnastics to keep up with currency changes in Brazil—one US journalist working in Brazil described this history as a "numismatic saga of incredible complexity"—it is important to outline some of the changes that took place during the years leading up to and throughout the 1970s.[31] The first currency change that Meireles would likely have known about, though he was born a few years after it took place in 1942, transpired under the dictatorship of Getúlio Vargas when the real (also Brazil's current monetary unit) was replaced by the cruzeiro; one cruzeiro was worth 1,000 réis. The currency change of 1967, from cruzeiro to cruzeiro novo, would likely have had more of an impact on Meireles's life, especially because it was the year he came into his artistic career, with his first solo exhibition at the Museu de Arte Moderna da Bahia, in Salvador. As in 1942, the cruzeiro novo brought with it the depletion of three extra zeros, so that 1,000 cruzeiros were now worth one cruzeiro novo (NCr$). The cruzeiro novo was created by simply stamping the new values on the old banknotes, so that a 1,000-cruzeiro banknote would have a round black stamp in the center labeling its new value as 1 NCr$, and the issuer as Banco Central do Brasil (figure 3).[32] This was seen as a temporary measure, and it lasted until 1970, when the currency reverted back to the cruzeiro and the Casa da Moeda printed a new series of banknotes. These new cruzeiro bills were issued in denominations from one to one hundred, although in 1972, a 500-cruzeiro note was added, and in 1978, a 1,000-cruzeiro note as well. Each denomination was a different color in muted tones (unlike the uniform green used in US dollar bills), and the new cruzeiro notes, redesigned by Aloísio Magalhães, unlike their predecessors, were sparsely decorated, with less ornament, and cleaner, more angular designs, including moiré patterns—all in line with a more modern aesthetic. The cruzeiro banknotes

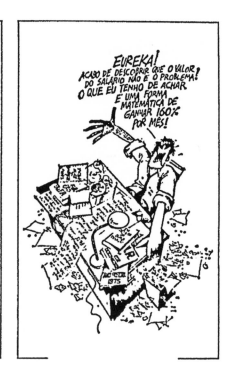

continued to feature major historical figures, such as the emperors Dom Pedro I and II, and important military figures like Deodoro da Fonseca and Floriano Peixoto.[33]

The multiple currency changes were part of the national treasury's more extensive strategy to curb inflation through an economic policy known as monetary correction, or indexing. To briefly summarize, indexing referred to the price adjustments made to salary wages, rents, interest rates, tax rates, and a series of other payments to offset the negative effects of price increases accompanying inflation.[34] One of the problems with indexing was that it often lagged a week or up to a month behind, leaving people in a constant state of catching up with daily price hikes. A comic strip from the newspaper *Jornal do Brasil* illustrated the reigning sentiment, "Eureka! I've just discovered that it isn't the value of my salary that is the problem! I just have to find a mathematical formula to earn 160% more per month!" (figure 4).

Whether deliberate or not, it would be difficult to extricate Meireles's *Zero* project from Brazil's monetary policy during the late 1960s and 1970s. It is both a unique commentary on the military government's economic policies and a political critique. The issuing agency for Brazilian currency during this time, the Banco Central do Brasil (Central Bank of Brazil), was an entity established by a military government decree on December 31, 1964, a few months after the military takeover.[35] The currency changes introduced during the brief span of the military government's rule, which

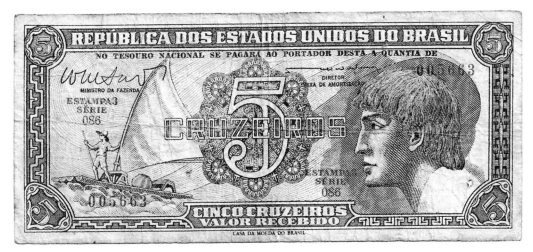

REPÚBLICA DOS ESTADOS UNIDOS DO BRASIL

NO TESOURO NACIONAL SE PAGARÁ AO PORTADOR DESTA A QUANTIA DE

5 CRUZEIROS

CINCO CRUZEIROS
VALOR RECEBIDO

CASA DA MOEDA DO BRASIL

FIGURE 5.
Five-cruzeiro
banknote.
Photograph
by author.

were part of its strategy of monetary correction, meant that with every re-placement of a currency, the older banknotes would become worthless, a version of a *Zero Cruzeiro*. The replaced banknotes thus became material testaments to the failure of the old currency, so much so that Meireles once quipped that at the time of the currency project, "money was the cheapest material" around.[36] So not only did *Zero Cruzeiro* insinuate the ineffectiveness of the government's monetary policies, it also highlighted the instability of the national economy, disturbing the credibility, integrity, and thereby the authority of the state.

Further straining the boundaries of acceptable political critique are the images Meireles selected for his banknote: a Krahô Indian on one side, and an inmate from a mental asylum on the other.[37] Traditionally, currency is an efficient way to circulate national symbols and historical figures, turning them into readily recognizable national icons. In Meireles's *Zero Cruzeiro*, it is clear that he deliberately chose two marginal and controversial figures as national symbols. The male figure on the zero bill stands nude and in profile, not unlike commonly available ethnographic images of indigenous people frequently sold on postcards at newsstands. The elevation of the Krahô man to the national currency highlighted the government's policy regarding indigenous groups living in the Amazon region during the 1960s and 1970s. From 1961 to 1967, a government-issued five-cruzeiro banknote was in circulation that depicted the head of a man in profile generically identified as *indio* (Indian), looking forward at an unidentifiable sailor steering a raft (figure 5).[38] On the obverse side was the image of the Vitória-régia, a beautiful water lily plant native to the Amazon River basin. The unusual and exotic plant is positioned as the reward for the lone intrepid sailor, featured in the act of braving the ocean while the Indian looks on neutrally, neither posing threat nor evoking displeasure. The scene has decidedly colonial undertones, referencing a long history of travel narra-

tives and images related to Portuguese and Dutch colonial expansion. Indigenous groups in colonial narratives were often depicted nude or holding weapons, suggesting they were savage and threatening, an obstacle to European expansion. The *indio* represented on the five-cruzeiro banknote, however, appears tame if not friendly, with no menacing or identifiable visual attributes.

The expanded exposure to and depiction of Brazilian indigenous groups was part of an optimistic government initiative, called Plano de Integração Nacional (National Integration Plan), or PIN, to develop and integrate Brazil's Amazon region into the economy.[39] PIN, instituted in July of 1970, stated three main goals: the mapping of 2 million hectares of the Amazon basin by air photography; the construction of the Trans-Amazonian and Cuiabá-Santarém Highways; and land settlement along the newly opened federal highways.[40] The government declared that it would take charge of not only the territory of the highway itself but also 100-kilometer stretches of land on each side of it, to be used for relocating settlers from the Northeast region.[41] In an effort to alleviate regional economic imbalances, President Médici affirmed, "The Trans-Amazon Highway will be an open route to enable the inhabitants of the Northeast to colonize the vast demographic wasteland and start to utilize its hitherto inaccessible potential."[42] However, markedly increased contact with and media exposure of the Amazon region did little to ensure the rights of indigenous people, who have experienced a long history of mistreatment and abuse as a result of colonial exploits and government integration measures.

The Krahô people in particular had suffered a series of setbacks during the twentieth century, but it was during the 1970s, pressured by government policies encouraging them to modernize their farming practices and abandon their traditional approaches to agriculture, that they were most at risk.[43] Meireles was both intimately acquainted with and sympathetic to the tribulations of indigenous people in Brazil. As a child, he traveled around the country with his father (Cildo Furtado Meirelles) who worked for the Serviço de Proteção ao Índio (SPI; Indian Protection Service), founded in 1910.[44] The artist claimed that he chose the image of a Krahô Indian after having read his father's file about a massacre involving the Krahô people during the 1930s, a case his father was sent to investigate. According to Meireles, his father had discovered that a prominent landowner had orchestrated the massacre by ordering a Beechcraft airplane to fly over the region where the Krahô lived and drop clothes infected with the flu virus and tuberculosis bacteria. Fifteen days after the incident, Meireles recounts, "The four thousand Indians were now only 400, 200 of whom had gone mad because they had lost everything: family, relationships, and their identities."[45] Though I was not able to locate any reference to this specific incident with the Krahô, there is substantial evidence that these kinds of massacres were

not rare, and that fraudulent employees of the SPI often acted as accomplices. One report cited evidence that landowners commonly used biological weapons to eradicate whole tribes by spreading smallpox, tuberculosis, and influenza between 1957 and 1963.[46]

The Indian Protection Service was disbanded shortly after the reports about its illegal activities were publicized in the international press. Fundação Nacional do Índio (National Indian Foundation), most often referred to as FUNAI, was created in its place by a government decree in January of 1967. The Brazilian sociologist Octavio Ianni was an outspoken critic of FUNAI and spoke openly of its collusion with the military regime in their exploitation of the Amazon region at the expense of indigenous tribes the agency was meant to protect.[47] Given the tragic social outcomes following both colonial and twentieth-century encounters with the indigenous people, one would certainly question the government's renewed interest and intervention in the region during the 1970s. If anything, the construction of the highway would facilitate and ensure a more intrusive military presence in the Amazon region. Confirming this suspicion is a statement made by President Médici's minister of the interior, José Costa Cavalcanti: "Tomaremos todos os cuidados com os índios, mas não permitiremos que entravem o avanço do progresso" (We will take all precautions with the Indians, but we will not allow them to hamper the advance of progress).[48] The suggestion that the indigenous people stand in the way of progress makes Meireles's use of the image of the Krahô man as a national symbol all the more subversive. The threat of subversion was amplified even further after the passage of a law in 1973 (Lei No. 6.001) prohibiting the use of images of "the Indian or the indigenous community as an object of tourist propaganda" or "for any lucrative ends," just a year before Meireles's first zero-cruzeiro note.[49] As an artwork, it would not have been unreasonable to assume the banknote would be considered a for-profit object.

The reverse image of Meireles's bill is one of a patient in a mental asylum located in Goiás, where Brasília, the new Brazilian capital inaugurated in 1961 and the seat of the military government, was located.[50] Meireles traveled to the hospital to conduct a series of interviews and to photograph the inmates, though it is unclear when he did so. Meireles recounts that he was particularly taken by one of the inmates, a man who was always on his own, far off in the distance, with his head lowered.[51] The interest in mental asylums, particularly within artistic spheres, was encouraged during the 1950s by such well-known art critics as Mario Pedrosa, who was interested in the idea of outsider art, or art brut. One particularly well-known initiative showcasing the intersection between psychology and art was the founding of the Museu de Imagens do Inconsciente (Museum of Images of the Unconscious, 1952) in Rio de Janeiro by Nise da Silveira (1905–1999), one of Brazil's most well-known psychiatrists. Silveira introduced Jungian

psychology to Brazil and spoke out openly against electric shock treatments and lobotomy. In 1956, she founded the Casa das Palmeiras in Rio de Janeiro, a clinic where patients formerly treated by psychiatric institutions could come for artistic rehabilitation by engaging in creative activity.[52] Meireles's interest in the Krahô and the psychiatric inmates demonstrates a concerted effort to document the victims of institutionalized forces whose identities had been defeated.[53] This is exemplified in the images he selected for the *Zero Cruzeiro*, on the one side a young Krahô man, representing the disregard for the lives of the indigenous people, and on the other, a man we can only identify through his affliction with mental illness.

Meireles had originally intended to have thousands of the *Zero Cruzeiro* bills sold by Rio's street vendors, a robust informal economy prominent throughout major urban centers in Latin America. Though such alternative economies are technically illegal, they are largely left to their own recourses and are often supported by the police, who frequently get a share of the profits. Meireles sought out the person in charge in Rio's city center, and found that it was a policeman who went by the name Oxossi. During a test run, Oxossi called on one of the vendors to sell about fifty bills, which surprisingly sold quite quickly.[54] Enthusiastic about the prospects of selling more the next day, the two made arrangements to meet again. As a precaution, Meireles consulted with his friend, a lawyer, who saw no legal grounds to halt the project and advised him to go ahead as planned. When Meireles encountered Oxossi the next day, he regretfully revealed that he was not able to continue selling the notes, explaining that there was a problem with the catchy verse the vendor had come up with to sell the notes, a common tactic for peddling goods on the street. The jingle, "Veja a que ponto nós chegamos: zero cruzeiro" (Just look how far we've come: zero cruzeiro), sounded like a critique of inflation, and they were afraid that this would cause problems for them, since it could be read as a critique of the government.[55] Disappointed, Meireles later imagined that he might distribute the bills by dropping them from a plane flying over the beach, where they would dramatically fall from the sky, a veiled reenactment of the infested clothing that had been dropped on the Krahô. But eventually he gave the bills to an art gallery, where they were displayed, but where their subversive intent was not likely to be detected.

Read as a political critique, Meireles's project could certainly have been grounds for provocation of the military regime and subject to censorship. However, as a work of art, rather than a published text, it was able to evade the censors. Additionally, the lack of an actual value for the notes assured that they could not be used in a counterfeit manner to purchase goods, so that their value and circulation remained strictly in the symbolic sphere. The circulation of the bills, albeit momentarily, in Rio's informal economy defied the traditional art circuit, and particularly the art auction.

ZERO DOLLAR

Closely related to the *Zero Cruzeiro* project, *Zero Dollar* (1978–1984) was an attempt to use a more universally recognizable currency, the US dollar. Meireles stated that "by using the dollar in my work, I specifically hoped to escape from the stereotypical association of Brazilian money with inflation."[56] Though the *Zero Cruzeiro* and *Zero Dollar* projects are proclaimed to be different, there is no question that they are both closely aligned with the social and economic context they originate in and both shared many visual properties, including the zero denomination. Though the *Zero Dollars* were also printed, they did not incorporate actual dollar bills (as the *Zero Cruzeiro* did). Instead, Meireles collaborated with his friend João Bosco Renaud, an engraver who had worked for the Casa da Moeda, to design the bills. Renaud maintained the basic design of the dollar so that at quick glance it is a convincing match. However, upon closer observation, the serial number is C 000000000 M, under which was printed RIO DE JANEIRO, R.J., instead of Washington, DC. He also signed the bills with his full name. Unlike actual dollar bills, which depict former presidents of the United States, Renaud's bills depicted Uncle Sam on the front of the bill and an image of Forte Knox [*sic*] on the back (figure 6). The reference to the US army post Fort Knox, located in Kentucky, addresses an important facet of US currency, since it is also the location of the United States Bullion Depository. Constructed in 1936, during the throes of the Great Depression, the depository was seen as a measure to protect the US gold reserves. The gold bullions stored in the depository backed every dollar bill to something stable, in this case the gold standard.

The inclusion of US military (and, to a certain degree, currency) history through the depiction of Fort Knox and the image of Uncle Sam, an iconic representation of army recruitment, highlighted the US military complex as symbolic of the US nation. In this way, the bill was a pointed critique of US military policies and, perhaps most pertinent for the Brazilian context, of the role of the United States in supporting Brazil's military coup on March 31, 1964. In 1975, the journalist Marcos Sá Corrêa, writing for the *Jornal do Brasil*, was sent to research released files of declassified documents regarding the US backing of Brazil's military takeover.[57] Called "Operation Brother Sam," the US involvement was undeniable and included not only financial assistance but also a shipment of arms. Documents today are easily accessible through the National Security Archives (NSA), and they describe just how unequivocal the US intervention was in facilitating Brazil's military coup. Audiotapes and documents of the correspondence between then US ambassador to Brazil, Lincoln Gordon, and President Lyndon Johnson in Washington detail the event from days before the coup. On March 27, 1964, Gordon wrote: "If our influence is to be brought to bear to help avert a major disaster here—which might make Brazil the China of the 1960s—

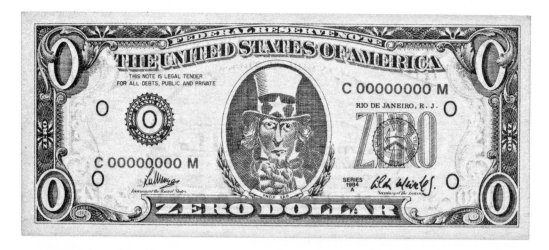

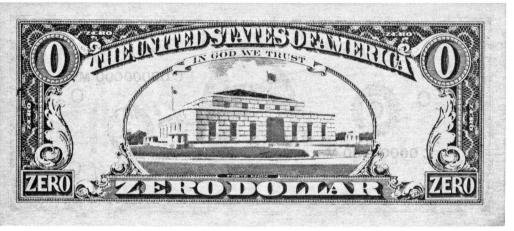

this is where both I and all my senior advisors believe our support should be placed."[58] Even more blatantly, Gordon beseeched the US president to secretly deliver arms of non-US origin and make them available for supporters of the military general Humberto de Alencar Castelo Branco. Further, he suggested concealing the extent of US involvement by having the arms arrive in an "unmarked submarine to be off-loaded at night in isolated shore spots in [the] state of São Paulo south of Santos."[59] By 1978, the year of the first *Zero Dollar*, it was clear that the United States had played an important role in installing a number of other repressive Latin American military regimes, including those of Chile, Argentina, and Uruguay, among others.

Zero Dollar is also closely tied to the *Zero Cruzeiro* project in its relationship to Brazil's economic policy. One of the military government's objectives in curbing inflation through monetary correction was to contain the speculative conversion of savings into dollars.[60] While scanning through *O Estado de São Paulo* and *Jornal do Brasil*, two of Brazil's major newspapers from

1968 to 1974, I encountered numerous advertisements encouraging investment in Brazilian-currency bonds that disparaged the US dollar. One in particular advertised: "Quanto está valendo hoje sua coleção de dólares?" (How much is your collection of dollars worth today?), below which was an album with different denominations of dollars, as if they were photographs or mementos meant to be stored away.[61] The ad suggested that while the US dollars are gathering dust and losing value, investing in Brazilian bonds makes one's money more readily available, all the while earning a higher interest rate. The message one could take away from the series of advertisements circulating in Brazilian print media promoting investment in Brazilian currency was that the dollar was without value, a zero dollar.

INSERTIONS INTO IDEOLOGICAL CIRCUITS

Both *Zero Cruzeiro* and *Zero Dollar* were unique in their relationship to the Brazilian political and economic context, but they were not the first time Meireles had worked with currency. In fact, his most widely known works from the 1970s are part of his series *Inserções em circuitos ideológicos* (*Insertions into Ideological Circuits*). Meireles conceived of *Insertions into Ideological Circuits* for an exhibition of international conceptual art organized in 1970 by the curator Kynaston McShine at the Museum of Modern Art. Often referred to as one of the most important international exhibitions of conceptual art, *Information* focused on the informational aesthetic that became a hallmark of conceptual art. McShine claimed that his intention was not simply to gather material related to information but to exhibit art practices that had become the locus for the production, transmission, and circulation of information. Elaborating on his curatorial selection, McShine explains: "The activity of these artists is to think of concepts that are broader and more cerebral than the expected 'product' of the studio . . . they are interested in ways of rapidly exchanging ideas, rather than embalming the idea in an 'object.'"[62] He distinctly linked the shift from more traditional object-oriented practices to informational ones with the repressive political contexts in many countries. McShine explained in the opening pages of the exhibition catalogue:

> If you are an artist in Brazil, you know of at least one friend who is being tortured; if you are one in Argentina, you probably have had a neighbor who has been in jail for having long hair, or for not being "dressed" properly; and if you are living in the United States, you may fear that you will be shot at, either in the universities, in your bed, or more formally in Indochina. It may seem too inappropriate, if not absurd, to get up in the morning, walk into a room, and apply dabs of paint from a little tube to a square of canvas. What can you as a young artist do that seems relevant and meaningful?[63]

The exhibit was notable for including a large international cast of artists (150 artists from fifteen countries), as well as artworks by four Brazilian artists—Artur Barrio, Cildo Meireles, Hélio Oiticica, and Guilherme Magalhães Vaz. Meireles's contribution for the *Information* exhibit comprised two works, *Projeto Coca-Cola* (*Coca-Cola Project*, 1969) and *Projeto cédula* (*Banknote Project*, 1970) from the *Insertions into Ideological Circuits* series.[64] In numerous interviews, Meireles has indicated that one of the driving forces behind the *Insertions* series was to increase the efficacy of the artwork by expanding its public by using materials and situations people could relate to.[65] Unquestionably, Coca-Cola and money were part of many people's daily lives. The Coca-Cola project, the work most often cited in literature about international manifestations of conceptual art, was composed of empty Coke bottles that were screen-printed with the message "Yankees Go Home!" in English, below it "MARCA REG. DE FANTASIA" (Fantasy trademark), and just below that, the name of his project, "*Inserções em circuitos ideológicos*: *Projeto Coca-Cola*, Gravar nas garrafas opiniões críticas e devolve-las à circulação" (Record critical opinions on the bottles and return them to circulation). He signed the work with his initials and the date: CM 5.70 (figure 7). The reinsertion of the bottles into the typical distribution channels of the beverage gave life to the popular idea of a message in a bottle. The *Banknote Project* engaged in a similar process through the circulation of US one-dollar and Brazilian cruzeiro bills that had been stamped (using a red or black rubber stamp) with critical slogans such as "Yankees Go Home" and "Eleições Diretas" (Direct Votes, a plea for democratic elections), after which they were reintroduced into circulation. Meireles used various denominations of currency to circulate the messages in the *Banknote Project*.[66] For the most part, however, the bills were of lower denominations, such as one- and five-cruzeiro notes, the ones most likely to be used in a variety of daily transactions.[67]

While the anti-American sentiment was openly visible on the currency, the text on the Coca-Cola bottles only surfaced when they were refilled, providing a dark background for the white letters to become legible. Meireles described the Coca-Cola project as a metaphor of his work with banknotes, which he considered "broader and more comprehensive."[68] With the *Insertions* project, Meireles set out to address two problems he identified in Brazilian art: (1) its incapacity to overcome an outdated model of the art object, as opposed to nonbourgeois objects that rely on autonomous circulation; and (2) the insistence that the system of art focus on fraudulent and decadent commercial transactions.[69] In response, Meireles proposed redefining the art circuit "by taking advantage of a pre-existing system of circulation," where "texts on the Coca-Cola bottles and on the banknotes functioned as a kind of mobile graffiti."[70] The choice of graffiti was meant to imply something that surfaces outside of an institutional or formal art setting (geared

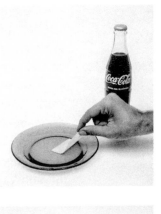
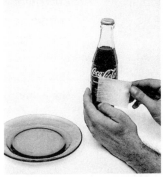

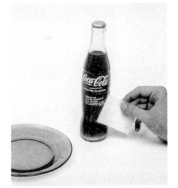

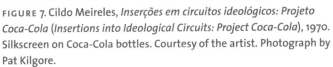

FIGURE 7. Cildo Meireles, *Inserções em circuitos ideológicos: Projeto Coca-Cola* (*Insertions into Ideological Circuits: Project Coca-Cola*), 1970. Silkscreen on Coca-Cola bottles. Courtesy of the artist. Photograph by Pat Kilgore.

toward autonomous circulation) so that "art," Cildo insisted, "would have a social function . . . A higher density of consciousness with regard to the society from which it emerges."[71]

The use of Coca-Cola bottles and US dollar bills as a critique of US expansion and mass consumerism was a relatively common practice in Latin American manifestations of pop art.[72] The Brazilian art critic Paulo Herkenhoff has written, "Coca-Cola represented, like no other company, the negative, imperialist expansion of capitalism through the spread of multinational companies in Latin American countries."[73] In Brazil, the expansion of multinational companies was remarkable. A 1972 article in *The Economist* cited Brazil as "the most attractive country for foreign investors."[74] Another report cited that "two-thirds of the fifty largest firms . . . were foreign subsidiaries."[75] In 1969, "90 percent of the automobile industry in Brazil, 87 percent of pharmaceuticals, 73 percent of heavy machinery, 65 percent of chemicals and plastics, and 33 percent of the steel industry were in foreign hands."[76] The embrace of such foreign investment was closely aligned with the economic miracle and points to the complicity between multinational corporations and the military government.

By incorporating actual Coca-Cola bottles—ready-made objects à la Marcel Duchamp—Meireles was building on the symbolic charge of the Coca-Cola brand, the multinational company par excellence. But the artist also clarifies that the bottle was not a ready-made product in the Duchampian sense, but instead its opposite. That is, rather than the industrial object acting as a work of art, he wanted the art object to circulate in the industrial world.[77] According to Meireles, industry promotes alienation, so he proposed that his circulating messages would promote social exchange and in this way art would become the opposite of industry. The work, then, should not be an object possessed or purchased by one person alone. In fact, the anonymity of the work was meant to challenge proprietorship, so that the message constantly sought out an expanded and broader public.

Meireles's insistence on the importance of exchange and social transactions with regard to his works of art is closely aligned to the ideas put forth by the philosopher and sociologist Georg Simmel, introduced at the beginning of this chapter. At the turn of the twentieth century, Simmel had posited the primacy of social formations over individual acts, claiming that society "is not just the sum total of individual acts, but refers to individuals connected through social interaction," and it is through individuals engaging with one another that the social is constituted.[78] Meireles's discussion of his *Insertions* series, and in particular his banknotes, bears an uncanny resemblance to Simmel's writings about money. Simmel located money at the center of the majority of social phenomena, arguing for "inextricable links between money, the individual and, ultimately, modern society in its totality."[79]

In addition to Meireles's affinity to Simmelian thought, it is clear that a heavy dose of Marxism, the reigning political ideology in Brazil during the 1960s and 1970s, permeated his work. His emphasis on the circulation and exchange of art objects as the antidote to alienation and, importantly, the invocation of ideology in the title of his *Insertions* series signal that the artist was conscious of intervening not only in dominant market strategies organizing artistic labor but also in the dominant political circumstances surrounding cultural expression in Brazil.

During the 1970s, Brazil had an active Marxist presence both culturally and politically, though the allegiance to Marxism among artists had shifted when the utopian fervor proclaimed during the early 1960s had dissipated with the installation of the military regime. Artists during the 1970s were much less likely to align themselves exclusively with any one political agenda and often adapted ideas and theories from multiple sources. Nevertheless, an increasing number of university students and faculty members had embraced Marxism, and many militant networks during the dictatorship identified themselves as Marxist armed revolutionaries. Groups such as MR8 (Movimento Revolucionário 8 de Outubro; Revolutionary Movement 8th October), largely composed of students, cultivated a national network of organized resistance to the military regime.[80] The best-known Brazilian ideologue of these movements was Carlos Marighella, a radicalized revolutionary (and friend of Che Guevara) who founded the communist guerrilla group Ação Libertadora Nacional (ALN; National Liberation Alliance), known for its support of armed struggle. Marighella authored two seminal texts, *Minimanual of the Urban Guerrilla* (1969) and *For the Liberation of Brazil*, published posthumously in France in 1970.[81] The journalist Elio Gaspari described Marighella's booklet as the most-cited Brazilian political text in international circuits, one that earned him a reputation as the theorist, ideologue, and patron of urban guerrilla warfare.[82] Important for our discussion is Marighella's emphasis on the relationship of an ideological agenda and its circulation in informational circuits. In the introduction to his *Minimanual*, he stressed the idea that activism be linked to such circulation: "Another important problem is not merely to read this minimanual here and now, but to circulate its contents. This circulation will be possible if those who agree with its ideas make mimeographed copies or print it in a pamphlet."[83] Such a call to action is directly in line with Meireles's "DIY" (do-it-yourself) message inscribed on the banknotes and bottles, beseeching the public to "Record critical opinions . . . and return them to circulation." Though decidedly less aggressive than Marighella's call to arms, Meireles's message was very much related to the ideas circulating in the revolutionary activist agenda of resistance to the authoritarian regime.

The establishment of a parallel system, or circuit, and the insertion of critical voices therein was what Meireles described as the possibility of

counterinformation.[84] The increased attention in artistic spheres to circuits and the flow of information was crystallized in 1975 when Meireles, along with a group of other artists, poets, and critics, began their own art journal titled *Malasartes*, dedicating the first issue to an in-depth and interdisciplinary analysis of art circuits.[85] In fact, the opening article by the art critic Ronaldo Brito was titled "Análise do circuito."[86] In it, Brito suggests that artists should stop being artists in order to go beyond the limits of the art circuit, by thinking of themselves instead as "committed to the systems and processes of signification taking place in society."[87] Meireles's *Insertions* series performed just such a commitment. Leaving behind traditional artistic materials, media, and modes of production, the artist advanced an intervention on a social scale that expanded the possibilities of the production, distribution, and consumption of information.

Seeking a space of expression outside of the mainstream channels most vulnerable to government censorship, Meireles claimed that *Insertions* was "born of the necessity to create a system of circulation, of exchange of information that did not depend on any type of centralized control . . . as in the case of television, radio, the press, and media that reach a mass public, but where a determined control is always exercised."[88] Meireles explained that he had already encountered notes and banknotes circulating surreptitious messages, as well as mass-mail chain letters used to transmit bits of information about people who had been imprisoned or who went missing.[89] By appropriating this underground convention, Meireles's project was coded with an existent mode of transmitting illicit information through an alternative network. Thus, the *Insertions* series was inscribed by a potent political agenda and a visible critique of the military government. Such tactics unquestionably exposed Meireles to the possibility of retaliatory measures, which included political exile, imprisonment, and torture.

Meireles's insistence that *Insertions* exist and circulate outside the confines of the art institution through its integration with activities from daily life was also a form of institutional critique, ironically one that was readily appropriated by the museum, as demonstrated by its immediate inclusion in McShine's *Information* exhibit. Challenging the project's critical potential, the art critic, curator, and occasional art practitioner Frederico Morais exhibited an installation of fifteen thousand Coca-Cola bottles (ironically donated and transported by the Coca-Cola Company in Brazil), which covered the whole floor of the Agnus Dei Gallery and included only one of Meireles's doctored bottles. In the sea of bottles, it was impossible to detect the one that was different, highlighting the difficulty of productively disturbing mainstream and widely used circuits of information.[90] Morais's installation effectively highlights the difficulty of measuring the extent to which Meireles's intervention disturbed the overwhelmingly powerful status quo of mainstream media. Nor is there data on exactly how many of the bottles

and banknotes were actually circulated outside of the museum (quantities that as far as I can determine are largely anecdotal, ranging from hundreds to thousands).[91] But, rather than thinking of quantifiable political efficacy, I would like to suggest that by opening up a symbolic space of dissent, and by straddling both the unconventional modes of artistic production associated with conceptual art and the more underground tactics of urban guerrillas, the bills represent an important step in constituting resistance.

INSERTIONS INTO IDEOLOGICAL CIRCUITS: PROJECT BANKNOTE, WHO KILLED HERZOG?

The creation of such an alternative network of information gained increasing urgency as the atrocities of the military dictatorship became more widespread and control over information regarding censorship measures became even more unyielding. In 1969, the government passed a decree stating that it would punish all professors, students, and school administrators who "participated in actions deemed to be against public order," resulting in the expulsion of over one thousand students.[92] Censorship measures in 1969 required that written texts as well as radio and television programs pass censorship clearance administered by the federal police in Brasília, ironically overseen by the Ministry of Justice. The newspaper *O Estado de São Paulo* published a decree detailing everything that needed to be examined by censors, which included "announcements and advertisements for radio and television, in written or recorded form."[93] By 1971, it was illegal to "disseminate via any media, press, radio, or television, the news . . . about torture in Brazil."[94] In 1973, the government published a decree prohibiting any published reference to "arbitrary imprisonments and kidnappings of persons."[95] Other measures included the banning of all live radio news broadcasts to prevent critical speech, as well as a ban on any reference to torture, opposition, and censorship. Given the susceptibility of established modes of communication to censorship, Meireles's *Insertions* deliberately provided a space for a dissenting voice, if not a subversive ideological agenda, via an alternative medium, or circuit, in this case currency.

The military regime's disregard for human rights was the political context for the latter materialization of the *Insertions* project entitled *Inserções em circuitos ideológicos: Projeto cédula: Quem matou Herzog? (Insertions into Ideological Circuits: Project Banknote: Who Killed Herzog?)* in 1975. As in previous iterations of this work, Meireles used a rubber stamp to mark cruzeiro bills with the statement Quem matou Herzog? and then reinserted them into circulation (figure 8). The work, while closely related to Meireles's banknote project, was much more pointed in its political critique, since it responded to a specific historical incident, the death of Vladimir Herzog. A popular São Paulo journalist, Herzog, also known as "Vlado," was the news chief for TV Cultura and taught television journalism at two of São

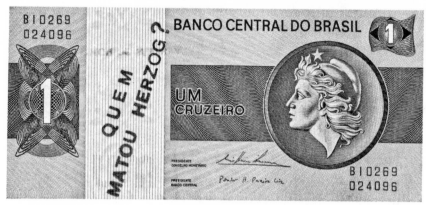

FIGURE 8. Cildo Meireles, *Inserções em circuitos ideológicos: Projeto cédula: Quem matou Herzog?* (*Insertions into Ideological Circuits: Project Banknote: Who Killed Herzog?*), 1976. Stamp on banknote. Courtesy of the artist. Photograph by Pat Kilgore.

Paulo's most important art schools, Fundação Armando Álvares Penteado, also known as FAAP, and Escola de Comunicações e Artes at the University of São Paulo.[96] It is perhaps not surprising that he was brought in for police questioning and arrested on suspicion of communist ties, given his commitment to teaching socially oriented journalism. According to official media sources, Herzog had committed suicide by hanging himself in his cell, an incident that only decades later was refuted by the publication of photos pointing to the torture Herzog underwent and the staged orchestration of his suicide.[97] Herzog's death ignited rage among fellow journalists, students, and opponents of the military regime, who publicly reacted against the lack of human rights in Brazil. Thousands came together to attend a public memorial mass while fifteen thousand students and professors at the University of São Paulo joined together to strike in protest of the regime's violence. One editorial boldly responded to allegations of

the suicide: "If we accept the absurd hypothesis that the newsman committed suicide, we must also know why he did it. The suicide is not the end of the Herzog case."[98] The public outrage surrounding Herzog's death was the backdrop for Meireles's artwork, which openly refuted the allegation of Herzog's suicide and instead pointed a finger at the perpetrators of the murder by asking a rhetorical and yet politically charged question. In the case of this work, the use of currency allowed for, or rather ensured, the continual transmission of Meireles's subversive message, since by its nature currency is constantly circulated. Additionally, within this political climate, the artist's anonymity not only facilitated the circulation of the bills but also challenged prized notions of authorship and authenticity.

THE TEXTUAL TURN

In addition to the sociopolitical and economic agendas embedded in Meireles's work with currency, his employment of text as the material content of the artwork related his *Insertions* series to international manifestations of conceptual art, a mode privileged in McShine's *Information* show. Characterized by the "tendency to reduce ideas to linguistic propositions," the textual turn is a phrase often used to refer to the prominence of text in conceptual art.[99] The art historian Liz Kotz describes the textual turn as "a withdrawal from visuality or objecthood in favor of a work of art constituted by series of linguistic propositions."[100] Many text-based artworks, by employing a textual over a visual aesthetic, took on the role of displaying, transmitting, and circulating information. The shift to an information interface as the sole content of an art object coincided with a more far-reaching paradigmatic shift from an economy based on industrial production to one based on the management of information. Palpable in many facets of society, particularly during the 1960s, the shift in emphasis from industrial products to electronic digits is a hallmark of the Information Age.

In the visual arts, the move away from objects and toward concepts can be identified as part of a move toward text-based works, often associated with the informational aesthetic. The emphasis on the textual aesthetic was undoubtedly influenced by information theory, a branch of applied mathematics elaborated by Claude E. Shannon during the 1950s.[101] Shannon, a mathematician, traced how data were communicated by systematically analyzing both the transmission and the reception of encoded messages.[102] Coinciding with the rise of advanced media technologies in print, television, radio, and video, information theory urged us to look at the properties of the medium in determining its efficacy at transmitting messages. Shannon concluded that the efficiency with which messages circulate is dependent on the features of the specific channels used to do so.

Accompanying the increased attention to communication of messages was a more dedicated scrutiny of media structures, exemplified by the

work of the media theorist Marshall McLuhan. In his 1964 groundbreaking study, *Understanding Media: The Extensions of Man*, McLuhan popularized the tenets of Shannon's mathematical model with the well-known phrase "the medium is the message." McLuhan was primarily concerned with the cultural impact of media and technology on society, and in particular the structural repercussions of this impact. McLuhan's idea of media literacy centered on becoming attuned to and "aware of the psychic and social consequences of technology."[103] McLuhan sought to clarify how different media communicate, suggesting we reorient the focal point of analysis of a message away from solely its content and instead to the particularities of the medium through which the message is communicated. Coincidentally, not only did he include a chapter on money as a medium in *Understanding Media*, but he also discussed the structural effect the introduction of money had on the Japanese economy.[104]

McLuhan's *Understanding Media* was widely read in Latin America. In 1966, a group of Argentine artists—Roberto Jacoby, Eduardo Costa, and Raúl Escari—responded directly to McLuhan's texts with a manifesto entitled "Un arte de los medios de comunicación" (An Art of Communications Media).[105] They accompanied the manifesto with a work, *Non-Happening* or *Happening que no existió* (*Happening That Did Not Exist*; also known as *Happening para un jabalí difunto; Happening for a Dead Boar*), that relied solely on mass media as the medium for its display and transmission in July of 1966. This event, which never physically transpired, took place only through its dissemination of staged photographs and simulated invitations, which had been sent to different media outlets. The artists explained their objective in employing the media as both the site of their work and the vehicle for its distribution in their manifesto: "People are not in direct contact with cultural events; rather they are informed about them via the media . . . a mass audience does not see an exhibition . . . but it does see footage of the event on the news."[106] Prodded by McLuhan's writing on media, the artists sought to bring the audience's attention to the role of media structures in informing (and misinforming) their public by demonstrating how an event can be conceived of and transmitted differently by distinct media sources, including the newspaper, television, and radio.

In Brazil, McLuhan's theories on media literacy also had an immediate impact, and in 1968 he was deemed the "novo gênio da comunicação" (the new genius of communication) by the popular Rio de Janeiro newspaper *Jornal do Brasil*.[107] The principles of Shannon's and McLuhan's information and media theories intersected with the visual arts as early as 1964, when Décio Pignatari, a well-known concrete poet, taught the first course on information theory at Rio de Janeiro's first graphic design school, Escola Superior de Desenho Industrial (ESDI, founded in 1963).[108] Not only did Pignatari translate McLuhan's work into Portuguese but he also wrote about

the confluence of ideas between McLuhan, Shannon, and semiotics, as well as their cultural significance in his seminal work *Informação, linguagem, comunicação* (Information, language, communication, 1968). While I do not mean to imply that Meireles was directly influenced by McLuhan or Pignatari (though he knew the work of both), there is no doubt that the two thinkers' influence in urging a systematic and structural analysis of communication and media systems was active in restructuring how Meireles and other Brazilian artists perceived of a work of art. Certainly Meireles was keenly aware of the impact of media circuits in society and their dominant role in circulating information, particularly within the confines of a repressive regime.

Throughout this chapter, my analysis has focused on Meireles's work with/on currency, primarily because his oeuvre with banknotes was the most extensive. I would nevertheless like to conclude this chapter by situating his work within a broader context of aesthetic sensibilities defining the 1970s in Brazilian art. More specifically, I identify Meireles's work using banknotes with the kind of graphic experimentation prominent in visual poetry, and with the graphic projects found in many of the alternative publications featuring collaborative efforts between artists and poets. One case in point is a visual poem by Paulo Miranda (b. 1950), *Poema de valor* (*Poem of Value*) from 1978 (figure 9).[109] Miranda, like Meireles, used the one-cruzeiro banknote as the material support for his poem. The title can be understood either as an ironic quip, that is, the poem is of value only because it is printed on a banknote, or that there is an inherent poetry to the banknote, which Miranda is drawing attention to. In both scenarios, the bill triangulates the relationship between poem and value, making it possible for the poem to become a part of everyday systems of exchange. Miranda used a rubber stamp on the currency, placing a round mark over the image of the female, the well-known symbol of the Brazilian Republic, with the Italian phrase "Che Move il Sole e L'altre Stelle" or "That Which Moves the Sun and the Other Stars."[110] Miranda, like Meireles before him, was questioning how value was determined in art, or in this case, poetry, with a bout of humor, since the value in question here is quite low.[111] Though I have no reason to assume Miranda knew Meireles personally, they appear to have worked together in one of the popular alternative newspapers, *Viva Há Poesia* (1979). The publication featured the same Italian verse Miranda had stamped on his *Poem of Value*, though he replaced all the S's with $ signs (he also changed the E's with the number three).[112] Just below Miranda's text, which appeared in bold as if it were a large headline in a newspaper, is an image of Meireles's 1976 work *A menor distância entre dois pontos é uma curva* (*The Shortest Distance between Two Points Is a Curve*). The work consists of three black-and-white photos in which the artist's headless torso holds two sheets of black sandpaper. In the first image, the two sheets are

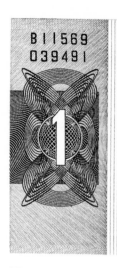
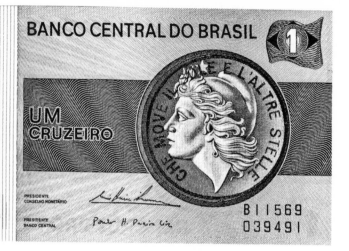

POEMA DE VALOR

folded open as if he were holding a book, and on one of the sheets is the handwritten text "O caminho entre dois pontos é uma curva" (The path between two points is a curve). The second photograph is of the two sheets pressed together with a small padlock on one end and a key on the other. The last photo shows the artist performing the written text by curving the sheets of paper together while fitting the key into the lock, creating a curve. The text and idea behind this work are drawn from Albert Einstein's general theory of relativity. The combination of Miranda's text, appropriated from Dante and reformatted for a notably different graphic space, along with Meireles's photographic performance of Einstein's complex theory on time and space, suggests the two artists were interested in relating their work to broader and more widespread cultural phenomena.

Their work is linked not only through the use of the cruzeiro as a material support but also through the use of the rubber stamp, a common practice in graphic experimentation in both visual arts and visual poetry during

the 1970s. For example, during the 1970 exhibition *Objeto e participação (Object and Participation)*, organized by Frederico Morais in Belo Horizonte (in which Cildo Meireles was a participant), the artist Thereza Simões had marked the passages of the entire exhibit hall at the Palace of the Arts with prints of rubber stamps containing messages such as "DIRTY," "VERBOTTEN," "FRAGILE," and "ACT SILENTLY" (figure 10).[113] The rubber stamp was also seen in works associated with mail art, a movement that modeled itself on the Fluxus movement, relying on the postal system to distribute and circulate visual poems internationally.[114] The Hungarian art critic and artist Géza Perneczky has described the use of rubber stamps in Latin America as a "confrontation with power."[115] Though typically associated with administrative procedures and bureaucratic approval or disapproval, the rubber stamp in the hands of artists and poets, particularly in the alternative press, was typically inscribed with a critical tone of dissent with regard to the military dictatorship. The German artist Leonhard Frank Duch, who lived in São Paulo, featured graffiti against the dictatorship that the artist found on São Paulo streets and converted into rubber stamp images in his work *Protestbook* (1979).[116] Given the prevalence of rubber stamps in different cultural expressions, the Brazilian artist and poet Unhandeijara Lisboa (b. 1944) edited a series of three mail art compendiums entitled *Karimbada: Arte em carimbo (Art of the Rubber Stamp)* in 1978, which featured graphic experimentation with rubber stamps (figure 11).[117] Though it is outside of the scope of this chapter to address the mail art movement in the detail it deserves, its existence in Brazil, and its relationship to artistic and poetic dissidence during the 1970s, makes it an important example of the possibilities for collaboration between artistic images and poetic texts.

The relationship between textuality and visuality had already been solidified during the collaborative proximity of artists and poets associated with the Brazilian concrete art and poetry movement from the 1950s. However, it was during the 1970s that the political urgency to evade censors gave rise to the widespread emergence of alternative "magazines" that encouraged artists and poets to interact more closely. The resulting publications, *Flor do Mal*, *Navilouca*, *Polem*, *Viva Há Poesia*, *Qorpo Estranho*, *Poesia Viva*, *Código*, and *Artéria*, to name only a few, are often referred to as the *imprensa nanica*, or the alternative press.[118] The Brazilian poet and scholar Philadelpho Menezes has described the collaborative efforts of the visual poetics characteristic of these journals as intersemiotic creation. I would like to suggest that one of the salient characteristics of the alternative press and its prevalence in Brazilian artistic circles during the 1970s was that it highlighted textual and graphic operations as a mode of artistic inquiry and a means for presenting dissenting voices. Though I have pointed to a more expansive textual turn as one of the distinguishing traits of conceptual art,

FIGURE 10. Thereza Simões, stamps marking the exhibition hall at the Palace of the Arts in Belo Horizonte for the 1970 exhibition *Object and Participation*. Courtesy of the artist.

FIGURE 11. Unhandeijara Lisboa, *Karimbada*, 1978. An envelope magazine, paper with rubber stamps, stamps, and woodcuts, 6.3 x 9.5 in. Courtesy of Paulo Bruscky.

and a driving force in Meireles's text-based currency works, I would also like to position his works within the more immediate context of graphic experimentation, particularly with the rubber stamp, prominent in Brazil. The details of these graphic operations are investigated further in chapter 2, where I present not only a close examination of the newspaper as an art system but also a more detailed analysis of the alternative press.

On December 14, 1968, readers of one of Brazil's oldest newspapers, *Jornal do Brasil,* encountered the following forecast: "Weather black. Temperature suffocating. The air is unbreathable. The country is being swept by strong winds"[1] (figure 12). The severity of the language would have caught readers off guard, particularly because the tone differed significantly from the report on December 13, just a day earlier, which stated simply: "Weather good. Temperature rising. Weak northern winds. Visibility good."[2] For those who paid attention to the fine print inside the small box (at the top left-hand corner of the cover page), where they would normally turn for the forecast, something was clearly askew. The day before, December 13, 1968, was a critical juncture in the history of the Brazilian military regime because of the passage of a government decree known as the Fifth Institutional Act, commonly referred to as AI-5. The new legislation, forwarded by army general Artur da Costa e Silva, president of Brazil since March of 1967, granted the president full congressional power, indefinitely suspending congress as well as civilian, constitutional, and political rights. AI-5 also prohibited activities of a political nature, such as demonstrations.[3] To the right of the forecast the headline read, "Yesterday was the Day of the Blind,"[4] and directed readers to page 12, where a rather peculiar article about dozens of blind people seeking the protection of Saint Lucia was wedged next to another article on the absolute power the new legislation granted and the media censorship that would follow. A cover-page article in the same issue of *Jornal do Brasil* emphasized the readiness of the military police to curb any civilian reactions that threatened to disrupt national security—crimes that would henceforth justify a dramatic increase in human rights abuses.

Though conceived during the presidency of Artur da Costa e Silva, AI-5 was largely exercised by General Emílio Garrastazu Médici, who became president in October of 1969 after a debilitating stroke left Costa e Silva incapacitated. Médici instituted a series of repressive measures to quell the opposition, and military raids on groups suspected of subversive activity became commonplace. AI-5 became a weapon Médici wielded without reservation. In one interview, he declared simply, "I can. I have AI-5 in my hands and, with it, I can do anything."[5] The sociologist Luciano Martins baptized the altered social reality inaugurated by the new legislation as the "AI-5 Generation" (Geração

JORNAL DO BRASIL

Rio de Janeiro — Sábado, 14 de dezembro de 1968

Ano LXXVIII — N.º 213

Ontem foi
o Dia
dos Cegos

(Página 12)

Govêrno baixa Ato Institucional e coloca Congresso em recesso por tempo ilimitado

O Ato Institucional n.º 5

Assinado pelo Presidente da República e por todos os Ministros de Estado, é o seguinte o Ato Institucional n.º 5, baixado ontem:

Art. 1.º — São mantidas a Constituição de 24 de janeiro de 1967 e as Constituições estaduais com as modificações constantes dêste Ato Institucional.

Art. 2.º — O Presidente da República poderá decretar o recesso do Congresso Nacional, das Assembléias Legislativas e das Câmaras de Vereadores por Ato Complementar, em estado de sítio ou fora dêle, só voltando os mesmos a funcionar quando convocados pelo Presidente da República.

§ 1.º — Decretado o recesso parlamentar, o Poder Executivo correspondente fica autorizado a legislar em tôdas as matérias previstas nas Constituições ou na Lei Orgânica dos Municípios.

§ 2.º — Durante o período de recesso, os senadores, os deputados federais, estaduais e os vereadores só perceberão a parte fixa de seus subsídios.

§ 3.º — Em caso de recesso da Câmara Municipal, a fiscalização financeira e orçamentária dos municípios que não possuam Tribunal de Contas, será exercida pelo do respectivo Estado, estendendo sua ação às funções de auditoria, julgamento das contas dos administradores e demais responsáveis por bens e valôres públicos.

Art. 3.º — O Presidente da República intervirá nos Estados e municípios sem as limitações previstas na Constituição.

§ único — Os interventores dos Estados e municípios serão nomeados pelo Presidente da República e exercerão tôdas as funções e atribuições que caibam respectivamente aos Governadores ou prefeitos, e gozarão das prerrogativas, vencimentos e vantagens fixados em lei.

Art. 4.º — No interêsse de preservar a Revolução, o Presidente da República, ouvido o Conselho de Segurança Nacional e sem as limitações previstas na Constituição, poderá suspender os direitos políticos de quaisquer cidadãos pelo prazo de 10 anos e cassar mandatos eletivos federais, estaduais e municipais.

§ único — Aos membros dos Legislativos federal, estaduais e municipais que tiverem seus mandatos cassados, não serão dados substitutos, determinando-se o quorum parlamentar em função dos lugares efetivamente preenchidos.

Art. 5.º — A suspensão dos direitos políticos com base neste Ato importa simultâneamente em:

1.º cessação de privilégio de fôro por prerrogativa de função;

2.º suspensão do direito de votar e de ser votado nas eleições sindicais;

3.º proibição de atividades e manifestações sôbre assuntos de natureza política;

4.º aplicação, quando necessária, das seguintes medidas de segurança:

a) liberdade vigiada;

b) proibição de frequentar determinados lugares;

c) domicílio determinado.

§ 1.º — O ato que decretar a suspensão dos direitos políticos poderá fixar restrições ou proibições relativamente ao exercício de quaisquer outros direitos públicos ou privados.

§ 2.º — As medidas de segurança de que trata o item 4.º dêste Artigo, serão aplicadas pelo Ministro de Estado da Justiça, defesa à apreciação de seu ato pelo poder judiciário.

Art. 6.º — Ficam suspensas as garantias constitucionais ou legais de vitaliciedade, inamovibilidade, estabilidade, assim como a do exercício de funções por prazo certo.

§ 1.º — O Presidente da República poderá, mediante decreto, demitir, remover, aposentar ou pôr em disponibilidade quaisquer titulares das garantias referidas neste Artigo, assim como empregados de autarquias, empresas públicas ou sociedades de economia mista, e demitir, transferir para a reserva ou reformar militares ou membros das Polícias Militares, assegurando, quando fôr o caso, rendimentos ou vantagens proporcionais ao tempo de serviço.

§ 2.º — O disposto neste Artigo e seu parágrafo 1.º, aplica-se também nos Estados, Municípios, Distrito Federal e Territórios.

Art. 7.º — O Presidente da República, em qualquer dos casos previstos na Constituição, poderá decretar o estado de sítio e prorrogá-lo, fixando o respectivo prazo.

Parágrafo único — Em caso de recesso do Congresso Nacional, fica dispensada a exigência contida no § 1.º do Artigo 152 da Constituição.

Artigo 8.º — O Presidente da República, poderá, após investigação, decretar o confisco de bens de todos quantos tenham enriquecido ilicitamente no exercício de cargos ou função pública, inclusive de autarquias, empresas públicas e sociedades de economia mista, sem prejuízo das sanções penais cabíveis.

§ único — Provada a legitimidade da aquisição dos bens, far-se-á a sua restituição.

Art. 9.º — O Presidente da República poderá baixar Atos Complementares para execução dêste Ato Institucional, bem como adotar, se necessária à defesa da revolução, as medidas previstas nas alíneas "b" e "e" do parágrafo 2.º do Art. 152 da Constituição.

Art. 10 — Fica suspensa a garantia de habeas-corpus nos casos de crimes políticos contra a segurança nacional, a ordem econômica e social e a economia popular.

Art. 11 — Excluem-se de qualquer apreciação judicial todos os atos praticados de acôrdo com êste Ato Institucional e seus Atos Complementares, bem como os respectivos efeitos.

Art. 12 — O presente Ato Institucional entra em vigor nesta data, revogadas as disposições em contrário.

Brasília, 13 de dezembro de 1968.

O Ato Complementar n.º 38

É o seguinte o Ato Complementar n.º 38, baixado ontem juntamente com o Ato Institucional n.º 5:

O Presidente da República, no uso das atribuições que lhe confere o Artigo 9.º do Ato Institucional n.º 5, de 13 de dezembro de 1968, resolve baixar o seguinte Ato Complementar:

Art. 1.º — Nos têrmos do Art. 2.º e seus parágrafos do Ato Institucional n.º 5, de 13 de dezembro de 1968, fica decretado o recesso do Congresso Nacional a partir desta data.

Art. 2.º — O presente Ato Complementar entrará em vigor nesta data, revogadas as disposições em contrário.

Brasília, 13 de dezembro de 1968.

TRADIÇÃO QUE SE RENOVA

O Presidente dirige a entrega de espadas aos novos guardas-marinha

IDENTIDADE PROFUNDA

Os Ministros militares confraternizam durante a homenagem à Marinha

HORA DRAMÁTICA

Garrincha foi expulso quando o Brasil vencia o Chile na Copa de 62

O Govêrno, depois de uma expectativa de várias horas, baixou, ontem à noite, o Ato Institucional n.º 5, e, com base nêle, o Ato Complementar n.º 38, que decreta o recesso do Congresso Nacional, sem prazo determinado. Durante o dia e a noite de ontem o povo manteve-se calmo e não houve corrida aos bancos, apesar das apreensões de alguns cidadãos que, decidiram permanecer em seus escritórios ou nas ruas, à espera da palavra oficial do Govêrno através de A Voz do Brasil — e deixaram de chegar ontem às suas casas.

Houve grande movimentação, ontem, nos quartéis do Rio, onde continua rigoroso o regime de prontidão. Na Vila Militar, os caminhões estão em posição de deslocamento. A Polícia Federal tem 400 homens, na Guanabara, "prontos para agir", e também estão totalmente mobilizadas a Polícia Militar, a Polícia Civil e a Guarda Civil.

Várias reuniões sucederam-se na área militar. O Ministério do Exército apresentou movimento incomum, devido à presença dos comandantes das principais unidades aquarteladas no Rio. Ora êles entravam no gabinete do Ministro do Exército, ora no do comandante do I Exército. Mas foi a reunião do Presidente da República com o Conselho de Segurança Nacional que determinou a promulgação do Ato Institucional n.º 5.

Bonifácio declara que Ato resulta de várias crises

Após tomar conhecimento, pelo rádio, do Ato Institucional n.º 5, o presidente da Câmara, Deputado José Bonifácio, disse que êle "resulta de crises e dificuldades do Govêrno e do mal-estar do povo. Não é o momento para examinar, mas sim para manifestar ainda uma vez mais a esperança de que esse crises como esta sejam resolvidas de maneira a possibilitar o desenvolvimento brasileiro."

Acrescentou o Sr. José Bonifácio "duas coisas, que jamais devemos esquecer, e neste país têm sido tradição: perenes têm sido as eleições, e nós, os eleitores, formulamos apêlo mais uma vez para que o Brasil permaneça e se transforme numa grande nação, como faz jus pelo trabalho de seu povo. Com essas palavras e, obedecendo ao nôvo regime, declaro nossa missão encerrada."

O presidente da Arena, Sr. Daniel Krieger, após ouvir, pelo rádio, a leitura do nôvo Ato, no Rio, dirigiu-se, com alguns parlamentares, para uma residência na zona sul, a fim de examinarem o quadro político. Admite-se a possibilidade de um pronunciamento dos dirigentes da Arena.

AI-5), referring to the alienation and individualism of the youth who grew up after the Fifth Institutional Act.[6]

With AI-5, a complex system of censorship sanctions was put into place, and after 1968 it is difficult to encounter any discussion of journalism that does not address the topic of press restrictions. *Jornal do Brasil* was an early target. A day after the brooding forecast was released, the government responded without humor by prohibiting international news agencies from transmitting weather reports, period. The chief editor, Alberto Dines, who was responsible for the ingenuous report, was arrested, as was the director of the newspaper, José Sette Câmara, along with a well-known journalist, Carlos Castello Branco, who had been brazenly outspoken against military violence in his popular daily column "Coluna do Castello."[7] The newspaper was suspended for two days and only returned to print on December 17, 1968. Other newspapers did not fare much better, and censors regularly targeted Rio de Janeiro's *Última Hora* and *Correio da Manhã*, among others. Following AI-5, censorship measures were outlined in a series of official decrees issued between 1969 and 1978 (there were five hundred in total), all of which detailed the expanded restrictions the media had to abide by.[8] Under President Médici alone there were 360 decrees issued.[9] It is perhaps no wonder that so many newspapers were shut down during the 1970s.[10] The first decree, issued in October of 1969, Decreto-Lei No. 972/69, laid out the terms of what was defined as journalistic activity, which included any public report disseminated by newspaper, radio, or television.[11] A few months later, in January 1970, the terms of censorship were described in Decreto-Lei No. 1.077, a shorter document detailing the kind of language that would not be tolerated by the government.[12] The first item of this decree made it illegal to publish anything that "offended morality and proper behavior."[13] This applied not solely to mass media but to any form of public entertainment. The decree clarified that foreign newspapers were also subject to the same measures and would have to be vetted by government censors as well. *Playboy, Penthouse, Lui*, and the German *Der Spiegel* were among sixty other casualties of this decree.[14] In 1973, another decree was issued that forbade any direct or indirect reference to censorship or its legitimacy, whether spoken, written, or televised.[15] Among the complex web of these decrees were very specific restrictions, such as the one from 1971 prohibiting any news relating to Lenin's birthday or the Soviet Union's Iron Curtain.[16] Other decrees would clarify when a previous ban on specific information was revoked, such as a 1974 decree stating that "news about Lúcio Flávio's imprisonment is now liberated."[17] The grouping of highly specific prohibitions with intentionally ambivalent ones, such as those surrounding morality, sensationalist news, and good behavior, made it difficult for even those with the best of intentions to determine what exactly was or was not off-limits, making the apparatus of censorship both highly bureaucratic and

at the same time arbitrary. Several newspapers, *Jornal do Brasil* in particular, attempted to compile the restrictions in what was known as the *livro negro* (black book), but given that restrictions varied from paper to paper and from region to region, no definitive source documenting the content and quantity of them has been published to date.

Just as the media were carefully scrutinized to ensure the military's agenda was not transgressed and threats to "morality" were routed out, so was intellectual life closely monitored. In the first semester of 1969, one thousand students were expelled and hundreds of high-profile academics were involuntarily suspended. For some, it was because of their association with labor movements, left-leaning scholarship, or politics, while for others the reason remained ambiguous.[18] Reading material was also closely monitored, resulting in the seizure of countless books from bookshops and publishing houses, either because "the author was persona non grata to the regime," or the books dealt with communism (even when taking a position against it) or had been translated from Russian, or sometimes simply because they had red covers.[19] But even as the stakes for subversive activity intensified, the period following the passage of AI-5 also witnessed a vibrant counterculture, where the stance toward censorship became increasingly more confrontational. The alternative press, also referred to by the terms "underground," "tropicalist," "marginal," and "*nanica*," among others, flourished and had a profound impact on cultural production, providing one of the few public spaces available for actively voicing dissent.[20]

Uniquely situated at the fringes of society, the alternative (counter)cultural press comprised publications of wide-ranging editorial and aesthetic agendas. In general terms, one could divide the alternative press into two broad categories: those journals that were critical of the dictatorship and embraced a more pronounced radical and subversive political agenda, and those of a more experimental nature, foregrounding graphic and textual experimentation in art and poetry.[21] Many of these alternative publications had limited runs, often only one issue, after which funding sources would run out or the editors would move on to another project. The "texts were often produced in rudimentary fashion—mimeograph, ditto, photocopy, chapbooks, pamphlets, etc., and professional design was freely sacrificed for the sake of printing at any cost, no matter how small."[22] As a general rule, the alternative press had intermittent patterns of production and an unpredictable reader base. Such irregularity allowed the alternative press to evade the rote bureaucratic processes governing censorship.

If I have lingered on the conditions surrounding newspaper censorship and the alternative press at this time, it was not only to drive home the dire circumstances surrounding their production but also to understand the driving force behind the political stakes of communicating in print media at this time. In the narrative that follows, I suggest that artistic practices

involving newspapers also functioned to give voice to critical and dissenting voices, just as within the alternative press. Of course, this was not the first time that artists worked with newspapers. Most famously, Picasso (followed by other artists working with cubism) used newspapers as early as 1912, selectively choosing headlines and text and incorporating them directly into his collage works and thus appropriating the political content.[23] But during the 1970s, a number of artists not only adapted the graphic aesthetic of newspapers but also went further by inserting their work within the pages of the newspaper, making use of its graphic layout and employing it as a mechanism for circulating their work. This was the case in the work of artists such as Antonio Manuel, Cildo Meireles, and Paulo Bruscky, who uniquely negotiated graphic experimentation and the informational aesthetic (discussed in chapter 1) with the conditions surrounding newspaper and media censorship. The shift to graphic works and in particular toward text as artistic practice, or the textual turn (first commented on in chapter 1), a hallmark of international manifestations of conceptual art, overlapped in Brazil with the tightening of censorship restrictions imposed on text in official media circuits. It is as if by suppressing text in official circuits, censorship inadvertently diverted it into unlikely spaces where it sought the freedom to exist.

At the center of graphic experimentation as a mode of artistic inquiry was the newspaper, a social system that presents and represents all manner of commentary on the political, economic, and cultural life of the day. One way artists incorporated the newspaper in their practice was by using it as an inexpensive material support, or canvas, for their work with painting and drawing.[24] Others referenced the newspaper by imitating the specificity of its typography and graphic layout or by inserting their work directly into the mainstream press in unexpected ways. The easy accessibility of the newspaper and its detachment from both art institutions and the art market fulfilled the prevailing desire on the part of both artists and poets to reach and communicate with a broader public outside of a capitalist system that emphasized culture as commodity. Embedded in the newspaper's graphic space is not only a unique texture, pattern, layout, and iconography but also an inexpensive and inexhaustible source of content on everyday life. Given its daily circulation, easy reproducibility, and portability, the newspaper provided an appealing graphic space to those artists who sought to elude any association with artworks as precious, singular objects.

In this chapter, I am interested in elaborating on the work of those artists who not only adapted the newspaper's aesthetic properties but also used it as a vehicle for transmitting information in alternative ways. The prevalence of newspapers in people's daily relationship with information made it an optimal means of summoning an expanded and more diverse audience. On the other hand, the intensified censorship sanctions and heightened

scrutiny following AI-5 severely curtailed the kind of information that could fill the newspaper's graphic spaces. Thus, at the crossroads of information and censorship, the newspaper embodied a productive tension between the limits of freedom of expression and its sublimation into alternate forms. This is clearly demonstrated by the cover page of the *Jornal do Brasil* on December 14, 1968 (see figure 12). On the one hand, the official information outlining the newly passed AI-5 is communicated, and on the other, a daring critique of it in the guise of a weather forecast—subtle but still present. These were strategies that shaped artistic practices as well.

Other critiques within the newspaper were expressed through the inclusion of strategic articles. For example, the same day that the *Jornal do Brasil* published the altered forecast, an article entitled "Cinco séculos de Gutenberg" (Five Centuries of Gutenberg) was featured on the first page of Caderno B (Notebook B, the cultural section of the newspaper). The piece recounted the history of the printed press from Gutenberg, with the invention of the printing press in the fifteenth century, to Marshall McLuhan, the media scholar deemed the "novo gênio da comunicação" (new genius of communication) in 1968.[25] Citing the importance of the press in having reformulated our experience of reality, the article went on to describe McLuhan's assertion that the newspaper "was truly a collective work of art: the image of the world in a form that combined news and publicity advertisements in a way that was no longer linear but a mosaic."[26] The invocation of McLuhan—the media scholar whose publication *Understanding Media* (1964) had been translated in Brazil only a few years earlier—on the day after the passage of AI-5 and alongside news declaring the government's control of the flow of information in newspapers was certainly calculated. By summoning McLuhan and his well-known slogan "the medium is the message," the article channels the readers' attention to the configuration of media, in this case the newspaper, as a vehicle for structuring communication.[27]

By becoming attuned to the newspaper's composition, readers would ostensibly have been able to identify the variety of tactics newspapers employed to communicate that censorship had taken place. *O Estado de São Paulo*, for example, replaced censored texts with *The Lusiads*, a sixteenth-century epic poem by the renowned Portuguese poet Luís Vaz de Camões, which ran 655 times from 1973 to 1975 (figure 13).[28] The São Paulo newspaper *Jornal da Tarde*, *O Estado de São Paulo*'s afternoon edition, substituted suppressed texts with recipes for inedible food. The weekly news magazine *Veja* replaced prohibited texts with symbols of trees (the logotype for Editora Abril, a publishing company; figure 14), while *Tribuna da Imprensa*, a sensationalist Rio paper, left censored articles blank—on May 20, 1977, for example, the cover page was half blank, although there was later a decree against leaving pages blank.[29]

Mudança põe em risco Escola de Belas-Artes

Da Sucursal do Rio

Com suas instalações e várias peças artísticas danificadas, a Escola de Belas-Artes da Universidade Federal do Rio de Janeiro — antiga Escola Nacional de Belas Artes — está atravessando uma das fases mais difíceis de sua existência, agravada com a intenção da UFRJ de transferir seus cursos para a cidade universitária da Ilha do Fundão. A transferência, se concretizada, poderá acarretar problemas para os alunos e para a própria estrutura do estabelecimento.

A denúncia — feita por um grupo de alunos dos cursos de pintura, gravura, escultura e restauração — será levada ao ministro da Educação e Cultura, professor Ney Braga, em audiência que está sendo tentada. Os alunos alegam que, não o pretexto de enquartar a escola na reforma do ensino e de devolver o prédio da avenida Rio Branco ao Museu Nacional de Belas Artes — que era o verdadeiro dono e seu proprietário — a Escola será confinada em quatro salas no Centro de Arquitetura e Urbanismo, com prejuízo para os cursos artísticos.

TRADIÇÃO E DEPREDAÇÃO

A Escola de Belas Artes foi criada há mais de 150 anos e é fortíssima tradição como um dos centros culturais do País. Por ela passaram alguns dos principais artistas brasileiros, como Portinari, Pedro Américo, Manoel de Araujo Porto Alegre, Victor Meireles, Almeida Junior, Guignard, além de Burle Marx e Oscar Niemeyer. Atualmente, porém, a imagem da escola, segundo seus alunos, é a pior possível: suas valiosas modeladas em originais do Louvre estão depredadas.

Simpósio ressalta o valor do documentário

Da Sucursal do RECIFE

O documentário cinematográfico brasileiro surte de problemas que o impedem de cumprir a cultura brasileira em geral e o facto que o é na sua cinema, nas televisões, nas escolas e universidades de material estrangeiro não só de inteira-

(...)

Encontro de música brasileira no Morumbi

O Movimento Mario de Andrade promove um encontro de música popular brasileira amanhã às 11 horas no auditório verde do Morumbi, à avenida Amarílis, com a presença de Hermeto Paschoal, Edison Machado Nenetto, A Rapaziada, Banda de Neive Ayres e João Carlos Trio.

A audição abrirá a fase do encerramento da programação deste ano do movimento, dentro do qual serão realizados espetáculos musicais nos parques, igrejas e ruas dos bairros da cidade. A programação, que prevê ainda a encenação de peças e sambões de artes plásticas, será encerrada nos dias 19 e 29 de dezembro com a montagem de "O que mantém um homem vivo" no Teatro Municipal.

RECITAL

O pianista Rubens Monteiro da Arruda Filho dará um recital hoje às 18 horas.

foi o caso recente da extinção das aulas de Perspectiva de Observação e Anatomia Construtiva, e os cursos de cerâmica, azulejaria e gravura em medalha. Outra disciplina importante — Desenho de Modelo Vivo — teve sua carga horária reduzida de 1.418 para 96 horas, apesar de ser considerada fundamental para o ensino da arte. Seria o mesmo, segundo os alunos, que se diminuísse a carga horária de matemática no curso de engenharia.

LEI E PATRIMÔNIO

A sede da Escola de Belas Artes, ao lado da Biblioteca Nacional, é considerada por professores e alunos como o ideal, pela luz construída especialmente para ela. Pouco se falar de pintura, escultura e restauração de obras de arte, galerias com sistemas de iluminação tanto e de claraboias, além de estar localizada num centro cultural com galerias de arte, teatros, bibliotecas e os acesso fácil às lojas de materiais especializados, o que não existe na cidade universitária.

Os alunos afirmam que o prédio da avenida Rio Branco não pertence ao Museu Nacional de Belas Artes, de acordo com a lei 8292, de 17 de dezembro de 1943, assinada pelo presidente José Linhares. Esta revoga uma outra lei, de número 378, de 13 de janeiro de 1937, que criou o Museu Nacional de Belas Artes, dando-lhe o prédio e uma verba de 600 contos de réis, para a instalação. A situação foi entendida de arrendamento pelo Instituto do Patrimônio Histórico e Artístico Nacional, que tombou o prédio em nome do museu.

PRECONCEITO

Além disso, os alunos reclamam do tratamento que têm recebido junto da diretoria da Escola como da reitoria da UFRJ. Segundo eles, no ano passado foi encaminhado ao reitor um memorial propondo a Educação, reitor Jarbas Passarinho, um memorial assinado por quase todos os 300 alunos dos cursos artísticos e por dezenas de professores e ex-alunos famosos. Até hoje, porém, eles não sabem se o documento chegou ao mãos do ministro. Suspeitam de que foi interceptado.

O comércio nos velhos quiosques da praia, um aspecto totalmente superado pelo tempo

Os Lusíadas
Canto Segundo

Luiz de Camões

Continuação

107 Mas, despois de ser tudo já notado
Do generoso Mouro, que passava,
Ouvindo o instrumento sublimado,
Que tamanho terror em si mostrava,
Mandava estar quieto e ancorado
No água o batel ligeiro que o levava,
Por falar devar ao forte Gama
Nas cousas de que tem notícia e fama.

108 Em práticas o Mouro diferentes
Se deleitava, perguntando agora
Pelas guerras famosas e excelentes
Co povo havidas que a Mafoga adora;
Agora lhe pergunta pelas gentes
De toda a Hespéria ultima, onde mora;
Agora, pelos povos seus vizinhos,
Agora, pelos humidas caminhos.

109 "Mas antes, valeroso Capitão,
Nos conta (lhe dezia) diligente,
Da terra tua o clima e região
Do mundo onde morais, distintamente;
E assi de vossa antiga geração,
E o princípio do Reino tão potente,
Cos sucessos das guerras do começo,
Que, sem sabê-las, sei que são de preço.

110 E assi também nos conta das rodeios
Longos em que te truz o Mar irado,
Vendo os costumes bárbaros, alheios,

Continua

Bahia anuncia restauração de monumentos históricos

Da Sucursal de SALVADOR

A Quinta do Tanque, o Ribeiro dos Jesuítas e o Paço da Associação Comercial da Bahia serão restaurados brevemente segundo um projeto da direção da arquiteto Paulo Ormindo de Azevedo e elaborado depois de um cuidadoso estudo feito pelo jovens baiano com o objetivo de rediticar plenamente estes monumentos históricos de Salvador, hoje praticamente abandonados.

OCUPAÇÃO

O prédio desenvolve-se em torno de um pátio — cercado de galerias — como uma fonte lobulada no interior. Segundo o arquiteto Paulo Ormindo, do Jardim e dos dois terraços de palmeiras que existiam até recentemente, nada restou depois que a area foi ocupada por edifícios e barracões. A sua direção o fol destruída por um incêndio há alguns anos e o resto do prédio também foi condenado, porque foram instalados serrarias e oficinas mecânicas.

O projeto prevê agora a restauração e economia da Quinta — cuja última unidade foi servir de sede a um órgão — augurando também a instalação de um centro para cursos e convenções. Embora a recuperação deveria ainda não exija aeroporto, o arquiteto Paulo Ormindo disse que já existem recursos do governo federal consignados no Plano de Recuperação das Cidades Históricas do Nordeste.

Importante e curiosa construção da segunda metade do

e 1787 quando a Quinta foi transformada no Hospital Público de São Cristóvão dos Lázaros, logo depois da expulsão dos jesuítas. Com esse destino, a conjunto lingüisticamente foi convertido em saão de memória.

A direção e Artéria Nacional para iniciar as obras, já que pretende de inaugurá-las justamente com uma avenida que está sendo construída próxima ao Colégio São Joaquim, onde se localiza o monumento.

Na cidade baixa e nos fundos da antiga rua do Lambari conhecida também na rua mais lobulada no interior há prédio foi remodelado e data da Companhia de Jesus em 1724, atingindo desde então o território de Amarelinda de Jesus em Portugal. Com a expulsão dos jesuítas, a casa foi transformada em colégio de órfãos, função que manteve até hoje. O nascimento foi originariamente uma das festas mais antigas da Salvador, sendo são comemorado durante a transformação do entradas do colégio.

O Paço da Associação Comercial da Bahia é unanimemente considerado o melhor exemplo da arquitetura civil do século XIX em todo o Estado e tem uma significação histórica particular, pois inaugura a transição entre os estilos rococó e neoclássico. Suas obras foram iniciadas em 1811 por dom Marcos de Noronha e Brito, o Conde dos Arcos.

Importante e curiosa construção da segunda metade do

BBC demitirá Burton

LONDRES — O ator inglês Richard Burton será dispensado de suas "serviços artísticos" na emissora de televisão da BBC de Londres, segundo anúncio estão Shaum Sutton, um dos dirigentes da rede, alegando que as recentes declarações do artista sobre Winston Churchill foram consideradas "estúpidas e ofensivas". As críticas de Burton à personalidade de Churchill coincidiram com o festejo do centenário de nascimento ou revelações múltiplas do maligno britânico.

Em uma entrevista dada ao "New York Times", publicada dias atrás, mesmo passado, Richard Burton declarou que Winston Churchill era um "covarde, belicista corrompido e um crá-barófilo de idade débil", além de comparar o "fracidáde" do líder inglês durante a II Guerra Mundial à do próprio Adolf Hitler e à outros combatentes.

Festival no México

O filme "Toda Nudes Se-

rá Castigada", de Arnaldo Jabor, representara o Brasil na IV Mostra Internacional de Cinema que será realizada na Cidade do México. O certame foi falado com a exibição da 15 de novembro e compreenderá um número aproximado de 200 obras de vários países.

Coral da FGV vai ser extinto

Do Serviço Local e do correspondente

O Coral da Fundação Getúlio Vargas, fundado há mais de um ano, será extinto em virtude de um problema de melhor conjunto no Concurso Nacional de Corais da Guanabara, deverá ter suas atividades encerradas pela nova direção da FGV. Em sua última entrada na memória Mouzyr del Prechis, a direção da Fundação Getúlio Vargas comunicou que a manutenção de um coral não era hoje as suas prioridades da entidade.

Para protestar contra a extinção, vários grupos corais, uns de São Paulo e uma amanhã às 18 horas, na auditório da FGV, durante o último recital do coral. Segundo dirigentes desta coral, a atitude da nova direção da escola é "extremamente significativa", refletindo a diferença entre o ideal de ocupação de reduzir toda a atividade cultural que tem um fim artístico, sem ou desinteressante na sua função cultural. No concerto de despedida do Coral da FGV comparecerão, entre outros, os coros conjuntos da USP — e Comunicativas o o Coralur.

Garota vence o concurso em Goiás

Eliane Rodrigues, de 15 anos, concorrendo pelo Rio de Janeiro, foi a vencedora do I Concurso Nacional de Música do Estado de Goiás — que, promovido com a colaboração da Instituto de Artes da Universidade Federal. Um concurso na segunda faixa do certame, destinado a artistas de idade compreendida entre 18 anos, em segundo lugar ficou Araceli Sabrinha, de 18 anos. Benito Akol, de 17 anos, em terceiro lugar.

No momento, o concurso realiza-se na prova semifinal para determinar, depois de amanhã, o vencedor do festival na primeira faixa, que receberá o prêmio principal de 15 mil cruzeiros e mais um contrato para recital atual do conjunto deverá se situar no torno da Fundação Palácio das Artes de Belo Horizonte. Para o segundo colocado o prêmio será de oito mil cruzeiros e, para o terceiro colocado, de seis mil cruzeiros.

Comédia no MASP

O "Festim na noite de quinta-feira, porém antes de Coia", comédia madrigalesca de Adriano Banchieri, comporta em 1602, será apresentada hoje às 21 horas no Museu de Arte de São Paulo, avenida Paulista 1.578, pelo Grupo Coral do MASP, Madrigal Mysteriotica de São José dos Campos, Conjunto Paraphernalia (conjuntos antigos) e revista Helena Hollmagel. O regente será Walter Lourenço. O concerto compreenderá o prêmio será de oito

FIGURE 13. Censored page from *O Estado de São Paulo* with *The Lusiads* by Luís Vaz de Camões, November 30, 1974, page 16. Reproduction courtesy of *O Estado de São Paulo*.

vora. Mas só nas últimas décadas tais cautelas começaram a freqüentar os planos de algumas empresas brasileiras.

Com o tempo, é possível que esses cuidados sejam adotados pelas empresas com mais de 100 funcionários, claramente deslocadas para a mira do Ministério do Trabalho com a Portaria 3 460, de dezembro passado. Segundo seu texto, a Comissão Interna de Prevenção de Acidentes (CIPA) dessas empresas deverão contar com médicos e engenheiros de segurança, recrutados entre os 30 000 profissionais intensivamente formados nos últimos meses. Por sua vez, as CIPAs terão o reforço adicional dos 5 000 líderes sindicais treinados em segurança pelos cursos da Fundacentro.

Weber: corrigindo estatísticas

Critérios misteriosos — Por enquanto, as empresas com menos de 100 funcionários — responsáveis por mais da metade dos acidentes graves — têm sido poupadas pelas inovações legais. Afinal, indagam os técnicos, como estabelecer exigências para firmas que ignoram qualquer vestígio de organização jurídica? O pedreiro Duda Francisco Gomes, por exemplo, é o patrão de seis pessoas que trabalham a seu lado na demolição de prédios — e, portanto, o dono teórico de uma pequena empresa. Mas todos se expõem democraticamente ao risco de desabamentos, protegidos apenas pela própria agilidade. Seria viável estender a eles o uso obrigatório de equipamentos de segurança?

Com ou sem interrogações, parece urgente subtrair também esses pequenos grupos às estatísticas dos próximos anos. E, enquanto isso, aperfeiçoar a deficiente legislação de amparo aos acidentados, asperamente criticada pelos trabalhadores.

"O operário que sofre um acidente é geralmente dispensado pela empresa alguns meses depois", afirma Joaquim dos Santos Andrade, presidente do Sindicato dos Trabalhadores na Indústria Metalúrgica — e vítima, ele próprio, de uma fresa que há dezoito anos deixoulhe uma extensa cicatriz no braço. Para Andrade, o ideal seria a criação de uma norma que garantisse ao acidentado o direito à estabilidade na própria empresa.

Trata-se de um sonho distante. Até agora, a vítima recebe, além de eventuais indenizações, apenas um pecúlio por redução da capacidade de trabalho, fixado pelo INPS através de misteriosos critérios de porcentagem. Em 1971, o mecânico de manutenção Francisco Di Cicco, hoje com 65 anos, perdeu uma falange do dedo médio da mão direita ao estampar tampinhas de garrafa. A princípio, o INPS calculou seu acidente em 4% "de incapacidade" e fixou um pecúlio de 775 cruzeiros. Muitas audiências depois, no fim do ano passado, uma junta médica comprovou que o acidente causara em Di Cicco "hipersensibilidade dolorosa no coto, ausência de flexão e extensão do dedo médio, e redução em grau máximo da força muscular na mão esquerda". A porcentagem de incapacidade subiu para 50%. E agora Di Cicco espera receber um pecúlio que ao menos permita sua sobrevivência.

MEMÓRIA

Zuzu Angel
(1921-1976)

Uma árvorezinha para cada gósto.

Num dia de 1950 apareceu uma árvorezinha nas bancas de todo o país. Era a primeira revista da Abril.

Com o tempo, apareceram muitas e muitas outras, trazendo na capa o símbolo da Abril e de uma alta qualidade jornalística, editorial e gráfica.

Hoje a Abril edita revistas de atualidades, de interêsse geral, femininas, infantis, especializadas em automóveis e turismo, esportes, televisão, foto-novelas, educação, moda. Além disso, publica mensalmente uma revista para executivos e diversas revistas técnicas, de circulação dirigida.

As sementes que esta árvore já espalhou, há muito dão bons frutos a este país.

Estas sementes você encontra em qualquer banca de revista.

São os fascículos da Abril. Tudo o que colocamos dentro destes fascículos sempre foi muito importante para a vida do homem. Mas, poucas pessoas sabiam desta importância.

Porque nunca tinham tido a oportunidade de ter essas coisas nas mãos: um livro de Dostoiévski, um concerto de Bach, um quadro de Michelângelo, a vida de Tiradentes, a receita de um bordado, a explicação de uma doença.

Hoje, todas estas coisas estão nas bancas. E, em forma de coleções, 300.000.000 de fascículos já estão dentro dos lares brasileiros.

São duas as razões do sucesso dos fascículos da Abril: a primeira, é que o nosso país tem uma enorme vontade de aprender. A segunda, é que faltava alguém que tornasse a cultura acessível para todos. Foi o que a Abril fez.

FIGURE 14. Page from *Veja* with image of censored text replaced with symbols of trees. Reproduction courtesy of *Veja* magazine.

Despite the risks, the editorial staffs at these newspapers were part of the resistance and sought to inform their readers through an alternative, coded language, communicating through a symbolic use of the newspaper's graphic spaces. This strategy, I argue, was one adopted by artists as well. Those artists who sought out the newspaper as a means to communicate with its readers relied primarily on textual propositions that adapted to and infiltrated the existing structure of the newspaper, including its channels of production and distribution, without attracting the attention of the censors. This was the strategy used in the classified ad projects by the artists Cildo Meireles and Paulo Bruscky, as well as by Antonio Manuel, whose extensive oeuvre with newspapers from 1968 to 1975 included using the newspaper both as a material support and as an alternative exhibition space. In my analysis of these works, I examine not only their aesthetic properties but also the network of relationships that is embedded in them through their co-optation of the newspaper as a structuring mechanism.

In Cildo Meireles's currency projects, Meireles was able to incorporate his confrontational text into mass-produced, officially sponsored banknotes (see chapter 1). His *Inserções em jornais: Classificados (Insertions into Newspapers: Classified Ads)* from 1970 operates in a similar way, but this time by intervening in the *Jornal do Brasil* newspaper. The work consisted of two postings in the Diversos (Miscellaneous) section of the classified ads. The first ad, from January 13, 1970, was located on the fifth page of the classifieds, following the Ensino e Artes (Education and Arts) section and just before Empregos (Employment). The ad stated simply: "Area n.° 1" on one line, followed by "Gildo [*sic*] Meireles 70" (figure 15). Meireles laments that the work was not carried out as he had intended it. The original idea "was to have a clearing, an entirely white space, marking out territory in a page from the classified ad."[30] The text was meant to be barely detectable so that there would be an almost empty box or, as Meireles put it, "a clearing . . . of a territorial possession."[31] Such an undertaking would propose a symbolic gesture of agency on the part of the consumer, suggesting the control of a piece of real estate in the world of information to do with as one chose. But instead, the newspaper personnel, in an effort to help, printed the word "Area" much larger than Meireles had intended it to be, and the resulting ad looked a lot like the other classifieds, with the exception of the text, which was incomprehensible for most readers. If his original proposition had been carried out, he would in fact have been performing an act of censorship himself, clearing the text at will and leaving a blank space, invoking the strategy used by *Tribuna da Imprensa* in response to their censored articles. That the editors at the classifieds did not follow his specific instructions indicates how tightly programmed its space was, making it all the more important that he was able to infiltrate it at all.

Meireles attempted this work a second time months later, on June 3,

FIGURE 15. Cildo Meireles, *Inserções em jornais: Classificados (Insertions in Newspapers: Classified Ads)*, January 13, 1970. Courtesy of the artist.

FIGURE 16. Cildo Meireles, *Inserções em jornais: Classificados* (*Insertions in Newspapers: Classified Ads*), June 3, 1970. Courtesy of the artist. Photograph by Pat Kilgore.

1970, again through the insertion of a classified ad in *Jornal do Brasil*, in the miscellaneous classified section (figure 16). Equally cryptic, the ad stated: "Áreas—Extensas. Selvagens. Longínquas. Cartas para Cildo Meirelles [*sic*]. Rua Gal. Glicério 445 apt. 1003. Laranjeiras. GB" (Areas—extensive, savage, faraway. Letters to Cildo Meirelles [*sic*]. Rua Gal. Glicério 445 apt. 1003 [a friend's street address and apartment number in Rio's Laranjeiras

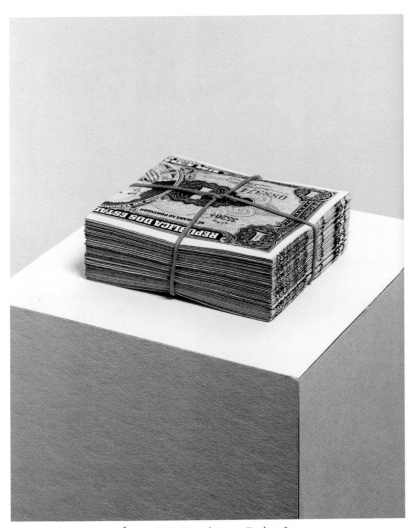

PLATE 1. Cildo Meireles, *Árvore do dinheiro* (*Money Tree*), 1969.
One hundred folded one-cruzeiro banknotes tied with a
rubber band and placed on a pedestal. Courtesy of the artist.
Photograph by Pat Kilgore.

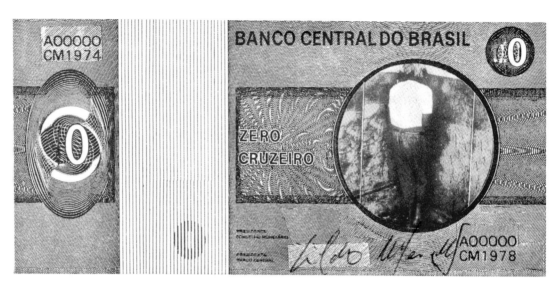

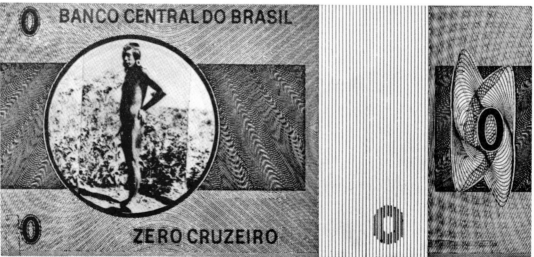

PLATE 2. Cildo Meireles, *Zero Cruzeiro*, 1974–1978. Offset print lithograph, 7 x 15.6 cm.
Courtesy of the artist. Photograph by Pat Kilgore.

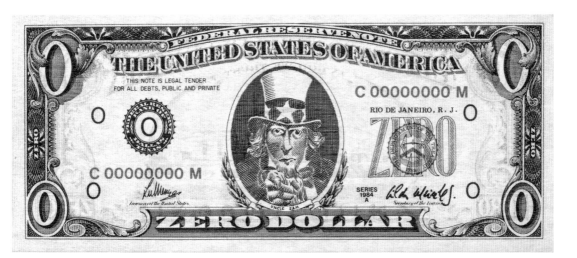

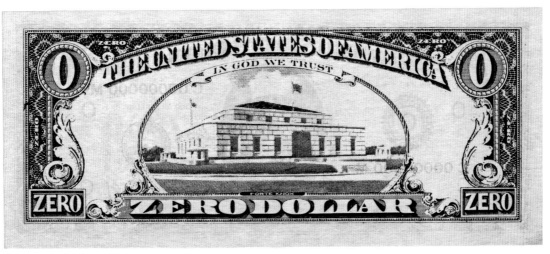

PLATE 3. Cildo Meireles, *Zero Dollar*, 1978–1984. Offset print lithograph, 7 x 16 cm. Courtesy of the artist. Photograph by Pat Kilgore.

PLATE 4. Cildo Meireles, *Inserções em circuitos ideológicos: Projeto cédula: Quem matou Herzog? (Insertions into Ideological Circuits: Project Banknote: Who Killed Herzog?)*, 1976. Stamp on banknote. Courtesy of the artist. Photograph by Pat Kilgore.

POEMA DE VALOR

PLATE 5. Paulo Miranda, *Poema de valor (Poem of Value)*, 1978. Poem stamped on a cruzeiro banknote. Courtesy of the artist.

PLATE 6.
Thereza Simões,
rubber stamps
marking the
exhibition hall
at the Palace of
the Arts in Belo
Horizonte for the
1970 exhibition
*Object and
Participation*.
Courtesy of
the artist.

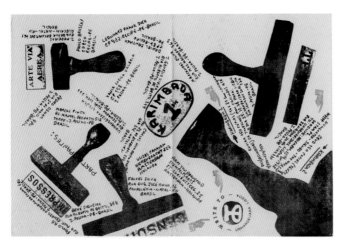

PLATE 7. Unhandeijara
Lisboa, *Karimbada*, 1978.
An envelope magazine,
paper with rubber stamps,
stamps, and woodcuts,
6.3 x 9.5 in. Paulo
Bruscky's Collection.

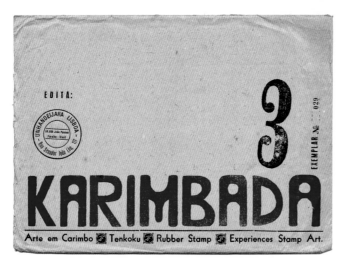

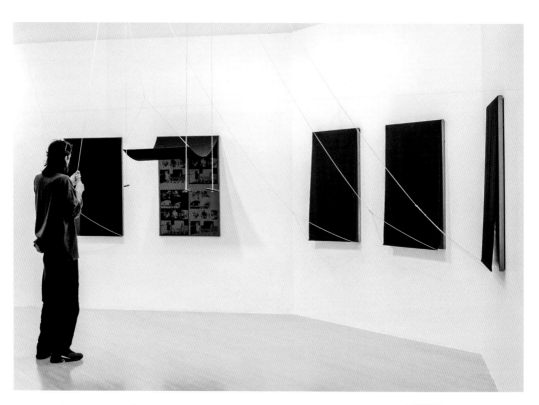

PLATE 8. Antonio Manuel, *Repressão outra vez—Eis o saldo* (*Repression Again—This Is the Consequence*), 1968. Wood, cloth, rope, and silkscreen (set of five canvases, each 48 x 31.5 in.). (*Below*) Two of the canvases. Courtesy of the artist.

PLATE 9. Antonio Manuel, *Jornal* (*Newspaper*), 1968. Crayon on printed newsprint. Courtesy of the artist.

PLATE 10. Antonio Manuel, *Alab atam emof* (anagram for "Bullets Kill Hunger") from the *Flans* series, 1975. Ink on papier-mâché stereotype mold, 22 x 15 in. Courtesy of the artist.

PLATE 11. Antonio Manuel, *Poema classificado* (*Classified Poem*) from the *Flans* series, 1975. Ink on papier-mâché stereotype mold, 22 x 15 in. Courtesy of the artist.

PLATE 12. Hélio Oiticica, *Tropicália*, 1967. Multimedia installation. Courtesy of Projeto Hélio Oiticica.

PLATE 13. Artur Barrio, *1. De dentro para fora. 2. Simples . . . (1. From Inside Out. 2. Simple . . .)*, 1970. Television covered with white sheet. Courtesy of the artist.

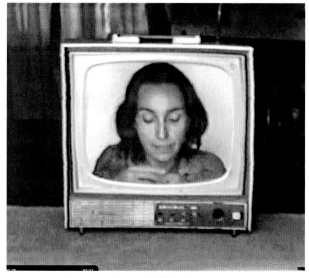

PLATE 14. Sonia Andrade, *Untitled (T.V.)*, 1974–1977. Video still. Courtesy of the artist.

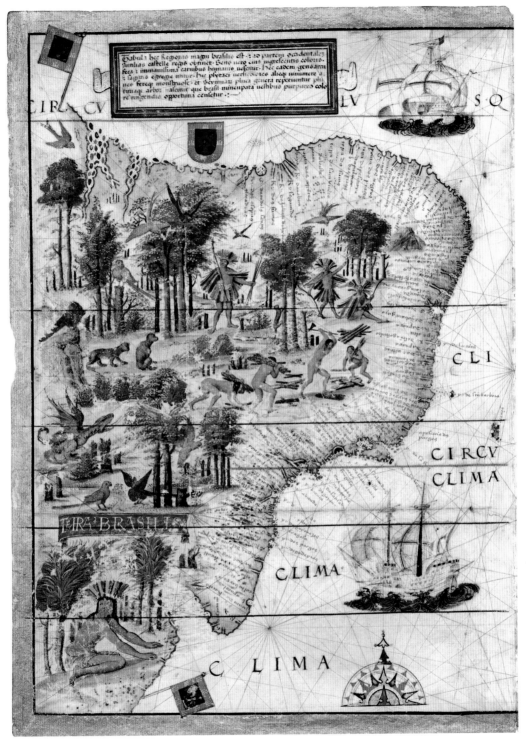

PLATE 15. *Carta do Brasil* from the *Miller Atlas* by Lopo Homem-Reinéis, from 1519. Courtesy of La Bibliothèque nationale de France.

PLATE 16.
Cildo Meireles,
*Arte física:
Marcos:
Tordesilhas
(Physical
Art: Marks:
Tordesilhas)*,
1969. Ink,
graphite, and
collage on
graph paper,
12.6 x 17.7 in.
Courtesy of the
artist.

PLATE 17. Cildo Meireles, *Arte física: Cordões/30 km de linha estendidos (Physical Art: Cords/30 km of Extended Line)*, 1969. Industrial line, map, and closed wooden box, 23.6 x 15.7 x 3.1 in. Courtesy of the artist. Photograph by Pat Kilgore.

PLATE 18. Cildo Meireles, *Mutações geográficas: Fronteira Rio-São Paulo* (*Geographical Mutations: Rio-São Paulo Border*). Leather case and dirt, 16.5 x 16.5 x 16.5 in. Courtesy of Fundação de Serralves—Museu de Arte Contemporânea, Porto, Portugal.

PLATE 19.
Anna Bella
Geiger, *Brasil
nativo/Brasil
alienígena*
(*Native Brazil/
Alien Brazil*),
1977. Series
of nine pairs
of postcards.
Courtesy of the
artist.

PLATE 20 (details). Anna Bella Geiger, *Brasil
nativo/Brasil alienígena* (*Native Brazil/Alien
Brazil*), 1977. Postcards, 3 x 5 in. Courtesy of
the artist.

PLATE 21. Sonia Andrade, *A obra/O espetáculo/Os caminhos/Os habitantes*
(*The Work/The Spectacle/The Paths/The Dwellers*), 1977. Installation shot. Courtesy of the artist.

PLATE 22. Sonia Andrade, *A obra/O espetáculo/Os caminhos/Os habitantes*
(*The Work/The Spectacle/The Paths/The Dwellers*), 1977. Installation shot. Courtesy of the artist.

PLATE 23. Sonia Andrade, portraits from *A obra/O espetáculo/Os caminhos/Os habitantes* (*The Work/The Spectacle/The Paths/The Dwellers*), 1977. Sepia postcards of women and children alongside a xerox copy. Courtesy of the artist.

PLATE 24. Sonia Andrade, map from *A obra/O espetáculo/Os caminhos/Os habitantes* (*The Work/ The Spectacle/The Paths/The Dwellers*), 1977. 1923 Map of São Paulo courtesy of the artist.

neighborhood]).³² Meireles explained, "In reality, I was proposing to sell the Amazon."³³ Most certainly the artist was referring to the complex politics of the government's occupation and sale of territories within the Amazon, discussed in further detail in chapter 1. The fanciful language of his ad, expressed in terms frequently used to describe Amazonian territories, can be read as an allusion to the arbitrary process of taking possession of land (which is, after all, extensive and faraway) via a document or a government decree, as was the case.

After the second classified ad, Meireles became disillusioned with the newspaper, frustrated with the fact that it was so tightly censored. Yet, in a unique way, Meireles's classified ads are provocative not only because they infiltrated the tightly controlled space of the newspaper, but also because his process both imitated and transgressed the bureaucratic official language associated with the government's censorship mandates. In her detailed study on press censorship in Brazil, Anne-Marie Smith claims that the "regime conducted its censorship in a notably bureaucratic, formalized, officious, and routinized way."³⁴ She interprets the overstated formality and "the procedures and language of the restrictions" as part of the regime's "pursuit of political legitimacy."³⁵ One of the ways in which such media censorship was carried out was through the delivery of *bilhetinhos*, or notes, sent from Brasília to the federal police throughout the country and then distributed to media outlets (later the restrictions were also communicated by telephone).³⁶ Here is but one example of a note delivered to the *Jornal do Brasil* on July 13, 1973: "By superior order, it is definitively prohibited to disseminate via any media, press, radio, or television, the protest of the Brazilian Bar Association against the arbitrary imprisonments and kidnappings of persons, which have been occurring."³⁷ Some variation of this kind of language can be found in the majority of the mandates, which typically stemmed from an anonymous yet "official" point of origin. The notes were then hand delivered, remitted to the first person the police encountered at the editorial office, after which the unfortunate individual had to sign a note of receipt, acknowledging that the newspaper was now informed and responsible for the consequences of not heeding the instructions of the decree.³⁸

Though the language surrounding the restrictions was sometimes definitive, such instructions were also open to interpretation, and different newspapers responded to them in a variety of ways. Consider, for example, the September 12, 1973, edition of *Jornal do Brasil*. In response to the restriction on releasing any images related to Chilean president Salvador Allende's death, the *Jornal*'s cover page that day lacked images of any kind. Instead, the editors chose to fill the front page with text about the event, veering away from the usual format and calling attention to the absence of any of the expected visuals (figure 17).³⁹ This was the only cover page of its kind

during that year. The different tactics that the editors made use of to communicate cases of censorship attested to the malleability of each newspaper to negotiate the form that such communication should take.

The procedure guiding the administration of censorship and its acknowledgment by newspapers is operative in Meireles's *Insertions* into newspapers as well. For instance, it begins with the administrative transaction of filling out the required paperwork for the printing of a classified ad, which involves the transmission of instructions. This is then followed by editorial manipulation of what will appear in the newspaper's pages, conducted with a fair amount of interpretive freedom, as we saw in the case of Meireles's ad. Additionally, Meireles's deliberate invocation of the official tone of the *bilhetinhos* through a forced formality in the language he uses is confounding. His classified ads imitate such official language but do so through words that do not communicate coherently, their obscurity acting instead as a kind of parody.

Though subtle in Meireles's work, parody is a rhetorical device characteristic of many of the periodicals associated with the alternative press during this time, but perhaps nowhere as brazenly as in *O Pasquim*. Known for its pointed political humor and highly satirical, ludic tone, *O Pasquim*

was the best-known and longest-lived of the alternative publications that surfaced during the time of the dictatorship—the first issue came out on June 26, 1969, and the last issue, number 1072, on November 11, 1991.[40] In my conversations with the artists working at this time (particularly those hailing from Rio de Janeiro), most not only were familiar with this publication but also eagerly awaited its weekly release. It survived for twenty-two years and over a thousand issues despite government vigilance, censorship, and bomb threats.[41] The first issue of *O Pasquim* was printed at the graphic offices of *Correio da Manhã*, a widely read daily Rio de Janeiro newspaper that one author called "the single most important opposition voice in Brazil" for having "systematically denounced the regime."[42] The fact that *O Pasquim* had the same typographic layout and used the same font as *Correio* also influenced its highly critical editorial agenda. *O Pasquim*'s first run of 14,000 copies sold out in two days, and within a short period of time it was regularly printing 225,000 copies.[43] It was by far the most popular of the three most important alternative newspapers, surpassing both the weekly *Opinião* in Rio de Janeiro (which sold 40,000) and later *Movimento* in São Paulo (whose more modest print run of 13,000 was due to censorship), not to mention the other eight hundred publications making up the alternative press.[44] The editors jointly embraced the title *O Pasquim*, or "a pasquinade," which refers to satirical writing in a publication of poor quality that is cheaply made.[45]

The first instance of censorship at *O Pasquim* came shortly after a year of its existence when an issue from November 1970 (when the print run was 200,000 copies) featured an altered version of a foundational history painting by the renowned academic painter Pedro Américo (1843–1905), *Independence or Death (The Ipiranga Shout)*, which depicted Dom Pedro, the first emperor of Brazil (r. 1822–1831), declaring Brazil's independence from Portugal. In *O Pasquim*, the famous icon of Dom Pedro appeared with a speech bubble alongside it declaring instead "Eu quero mocotó!!" (I want *mocotó*!!), which was not only the Tupí term for a popular dish in the Northeast made of cow's feet but also an allusion to "Eu também quero mocotó" (I also want *mocotó*), a song composed by Jorge Ben (figure 18).[46] The resulting image caricaturized a nationally revered symbol of Brazilian independence. What is particularly interesting about invoking Dom Pedro at this historical juncture is that he was the first to establish freedom of the press, on August 28, 1821, thirteen years after the Portuguese royal family landed in Brazil and a year before Brazilian independence from Portugal on September 7, 1822. Until then, any attempt to publish within a Portuguese territory was considered a crime and immediately censored. Censorship functioned to reinforce absolute Portuguese control of its Brazilian colony, and in particular its economic and political stakes, immediately repressing any oppositional voices.

Before 1821, censorship was overseen by the Junta Diretora da Im-

FIGURE 18.
Caricature of
Pedro Américo's
*Independence
or Death (The
Ipiranga Shout)*
in *O Pasquim*,
November 1970.
Photograph by
author.

pressão Régia (The Board of the Royal Printing Press), which examined all published material to prevent any text that was against religion, the government, and "bons costumes" (good manners).[47] Thus the infrastructure for censorship during the nineteenth century became the model for its administration a century later. On September 6, 1972, the military government published a decree prohibiting any mention of or commentary on Dom Pedro's original decree abolishing censorship.[48] Dom Pedro was thus a controversial figure, on the one hand a hero of Brazilian nationalism, and on the other a precursor to freedom of the press.

O Pasquim's citation of the controversial song was not well received, and the editor, Sérgio Cabral, and the whole editorial team was arrested, with ten of the main editors remaining in prison for two months.[49] *O Pasquim* continued to poke fun at all sectors of Brazilian society through daring provocative content disguised in flippant, witty, and funny caricatures, texts, and comic characters. Its existence unquestionably sustained a space where a countercultural presence could be voiced throughout the 1970s. In her illuminating study of countercultural production, the literary and cultural critic Heloísa Buarque de Hollanda explained that one way *O Pasquim* and other magazines like it functioned was by intentionally employing a subjective tone, one that aired their preconceptions openly, in an exaggerated and humorous way, distinctly differentiating their tone from the objective, impartial language of the traditional press.[50] The jocular tone, geared at

conservatives and liberals alike, made it difficult to identify these publications as a threat to national security. Though *O Pasquim* was under constant surveillance by government censors, a 1978 study compiled by the Centro de Informações do Exército (Brazil's National Intelligence Service) suggested that the authorities did not classify the alternative press as an immediate threat. The report cited the small print runs and the absence of a clear ideological agenda, despite the fact that such an agenda was marked by a critical tone, as two of the reasons for the lack of concern. The recommendation for dealing with the alternative press was to impose strict economic sanctions (rather than military interventions), alleging that many of these publications were not likely to survive fiscal measures such as added taxation and audits, which indeed turned out to be the case.[51]

What is memorable about *O Pasquim*, however, is that it resisted all measures aimed at eradicating it, and thus left behind an unparalleled visual and textual archive of the history of Brazilian counterculture.[52] In this chapter, my interest in *O Pasquim* and other newspapers and magazines like it is their deployment of parody, strident humor, and ideological caprice to incessantly and daringly critique the practice of censorship—and get away with it. Few issues are without some form of aggression toward government policy, both in the choice of articles and in the many illustrations, including blatant comparisons to fascist regimes. An early issue from May 1970, for example, has a cartoon by Millôr Fernandes, one of the magazine's founders, with the title "Censura lendo o material do Pasquim" (Censors reading material from *O Pasquim*), which depicts all the censors distracted from their purging duties by *O Pasquim*'s seemingly hilarious content (figure 19). Humor aside, the carving out of a graphic space where such critique could be enacted week after week had a profound impact on artistic practice at the time and certainly shaped the direction of graphic interventions in the newspaper.

In Meireles's classifieds, using the newspaper for his *Insertions* project related his practice to efforts by both the mainstream and the alternative press to communicate information in spite of government sanctions that defined the form and content that communication could take. The choice of the classifieds as a space for an artistic intervention is both curious and noteworthy. More of a public service by the newspaper to its readers, the ads lack obvious political or social commentary and were most likely to go unnoticed by the censors. On the other hand, they accounted for the reason a majority of readers at the time bought the newspaper: in search of an object, a service, or a relationship. The *Jornal do Brasil*, for example, was well known for its classified ads, which were advertised on the front page and were frequently sought out by people looking for a job or trying to sell something.[53] Thus the ads constituted a graphic space for active exchange, often soliciting the reader's participation in some kind of shared transaction.

AS DICAS DUCA

CENSURA LENDO O MATERIAL DO PASQUIM.

FIGURE 19.
"Censura lendo
o material
do Pasquim"
cartoon by
Millôr Fernandes
in *O Pasquim*,
May 1970.
Photograph by
author.

Meireles was not alone in seeking out such a space. The artists and visual poets Paulo Bruscky and Daniel Santiago orchestrated interventions in a similar vein with their *Arte classificado*, or *Classified Art*, series.[54] The first of these, from September 22, 1974, took place in their hometown newspaper, the *Diário de Pernambuco*, one of Brazil's oldest newspapers, as well as one of the most conservative in Recife. The ad stated the following: "Arteaeronimbo. A random composition of colored clouds in Recife's sky. The team Paulo Bruscky—Daniel Santiago, responsible for the idea, would like to get in contact with a chemist, meteorologist, or any other person capable of coloring the sky. Correspondence for Arteaeronimbo—P.O. Box—Diário de Pernambuco" (figure 20).[55] A later iteration of this idea appeared in the *Jornal do Brasil* on December 24, 1976 (figure 21). The second time around, the artists proposed exhibiting an artificially induced, colorful tropical aurora and claimed they were looking for someone to finance

Rui Carneiro diz que

Polícia Militar proíbe concorrência desleal aos motoristas de Caruaru

Várzea terá nova avenida pavimentada

...griamse fomalha dos quais se verifica que o arquitamento deve ter ocorrido em 1719. Os pesquisadores ficaram espantados com o kronograma, não tendo conhecimento de outros casos dessa natureza.

...com ligacões a outros pontos. No próprio mosteiro de São Bento, três vezes restaurado foi descoberta saída que vai ter ao Museu d eArte Contemporânea, onde existiu no século passad ouma cadeia.

uma campanha suja, apregoando que não haverá outro candidato à presidência do Sindicato dos Contabilistas, fato que é destituído de verdade".

Declarou que sua plataforma eleitoral é séria e a aquisição da sede própria é sua principal meta, bem como prosseguir com todas as obras do presidente Murilo Canavarro. A instalação de uma biblioteca especializada, a implantação de serviços médico-odontológicos e a realização de cursos profissionalizantes em convênio com o Conselho Regional de Contabilidade e com o Instituto dos Auditores Independentes e repartições públicas fazem parte da plataforma eleitoral do contabilista Rui Pires.

ARTEAERONIMBO

Composição aleatória de nuvens coloridas no céu do Recife

A Equipe Paulo Bruscky — Daniel Santiago responsável pela idéia deseja entrar em contacto com Químico, Meteorologista ou qualquer pessoa capaz de colorir uma nuvem. Correspondência para ARTEAERONIMBO — Posta Restante — Diário de Pernambuco.

(21943)

"this contemporary art event," which they humorously assured would not "pollute the space, alter the temperature, or influence astrology."[56] These ads invoked a sense of humor. Consider a subsequent classified from 1977, which offered the service of an "ex-intellectual, specialized in salon games," who could liven up teas and get-togethers of "High Society."[57] This was followed by another in the *Diário de Pernambuco* on Sunday, July 3, 1977, which stated: "For sale—A project for a machine that records dreams using film (black and white or color), with sound, brand name Bruscky. Watch your dreams while eating breakfast. Inventor Paulo Bruscky . . ." (figure 22).[58] Though this last announcement is intentionally comical, the political dimension should not be overlooked. The notion that the newspaper was selling a product capable of recording dreams speaks to the subtle ways in which surveillance occurs, to the extent that even dreams can be monitored and thereby controlled.[59] Bruscky and Santiago stated that their artistic objective was to provide "options to the middle-class reader," or an alternative

FIGURE 20. Paulo Bruscky and Daniel Santiago, classified ad in *Diário de Pernambuco* on September 22, 1974, *Arteaeronimbo* from *Arte classificado (Classified Art)* series, 1974–1977. Courtesy of Paulo Bruscky.

FIGURE 21. Paulo Bruscky and Daniel Santiago, classified ad in *Jornal do Brasil* on December 24, 1976, Caderno B, page 6, *Composição aurorial* (*Auroral Composition*) from *Arte classificado* (*Classified Art*) series, 1974–1977. Courtesy of Paulo Bruscky.

to the existing literary selections, and at the same time seek out a different kind of public, a goal that artists and poets alike shared during the 1970s.[60] The duo achieved a certain degree of notoriety when the popular weekly magazine *Veja* published an article entitled "Desclassificados" (Declassifieds) promoting the artists' classified series.[61]

In her monograph on Bruscky, the art historian Cristina Freire has described Bruscky and Santiago's *Classified Art ads* as "creating noise in the control mechanisms of information."[62] One would not argue that the bizarrely playful propositions are somehow boisterous, but they are also akin to the kind of text one would have encountered in *O Pasquim*, and their political dimension becomes more apparent when considering some of the objectives of the alternative press. One of the many emphases of alternative publications was graphic experimentation resulting from collaboration between artists and poets seeking out new and more diverse audiences by pursuing alternative spaces for expression. But while countercultural publications had a much more limited audience, the newspaper was particularly attractive because of its widespread readership and reach, which is what also led to its increased scrutiny. So important was the newspaper for artists and poets that one of the most well-known voices of marginal poetry, Glauco Mattoso, a São Paulo poet and frequent collaborator at *O Pasquim*,

created his own alternative newspaper in January 1977, which he entitled *Jornal Dobrabil* (he continued this project until 1981).[63] The title parodies *Jornal do Brasil* but also plays with the meaning of *dobrável*, which means "foldable." *Jornal Dobrabil* was in fact foldable, though it consisted of only one sheet folded in half (figure 23). It also imitated *Jornal do Brasil*'s format, typography, and layout. The poet printed one hundred copies and sent the "newspaper" free of charge by mail to readers, or "subscribers," whom Mattoso randomly selected.[64] The newspaper featured all manner of politically motivated content, which included pornographic, scatological, and homoerotic humor that constantly pushed at the limits of acceptable social and political content through experimental language and typography (figures 24 and 25). The literary scholar Charles Perrone has claimed that countercultural writing made the act of writing a type of "behavioral deviance."[65] Mattoso's newspaper, though largely nominal in reach, set a precedent for graphic deviance, a rhetorical device that pushed at the limits of acceptable expression.

Given the legal dictates regarding "good behavior," behavioral deviance took on a more overt political connotation that was operative in Bruscky and Santiago's unorthodox propositions. It is therefore not entirely surprising that the directors of the newspaper censored the artists for their use of "dubious language," a preemptive act of self-censorship of text that was not only openly subversive but also ambiguous.[66] Parody, humor, behavioral deviance, and deliberate ambiguity were all dominant within the alternative press and the work of artists working within alternative publications. The classified ads by Meireles and Bruscky and Santiago were very much a part of this legacy. Their interventions into the newspapers were not meant to be interpreted literally; instead they were conceptual exercises with language, a verbal distraction that would have caught the eye of readers and made them wonder or question meaning and its presentation in an unexpected graphic space.

NEWSPAPERS, CENSORSHIP, AND THE VISUAL ARTS

While censorship was rampant in print media, the visual arts had been relatively protected from the kind of repressive government censorship sanctions directed at newspapers, television, and other arts such as music and cinema. Nevertheless, there were a few notable incidents between visual artists and the military regime that marked a whole generation of artists. For example, the government's attempt in 1969 to root out any traces of leftist thought in education led to the forced expulsion of esteemed artists and art professors, among them Abelardo Zaluar, Quirino Campofiorito, and the art historian Mário Barata, from the Escola Nacional de Belas Artes (School of Fine Arts).[67]

In May of the same year, one of the most notorious cases of government

FIGURE 23. Glauco Mattoso, *Jornal Dobrabil*, 1977–1981. Courtesy of the artist.

"O inimigo publico numero um é o Numero Um."
MARX ZWEI
Cr$ 0,00
ALLA

NÃO O CAGAR É UM ATO POLÍTICO

IZquERda

trabalho cricri-ticotico pamphle-sectario materialectico de g.m. & p.o.p. // supplemento inseparabil do jornal dobrabil

PUBLICAÇÃO AUTOMINORITARIA DA THEORIA DA MENOSVALIA

eidar é uma liberdade democrática; mijar é um direito humano; esporrar é terminantemente Pedro, o Podre. ...

POESIA JA NÃO TEM CESURA!!!

publici-dade

UM SERVIÇO DE UTILIDADE PRIVADA DA AG. JD
- Não vote em branco. Vote em LUTHER KONG
- FIAT na viagem e não corras
- Sob neblina use LUBRAX

ORDEM DE PALAVRAS

DEMOCRACY ainda que LATE

"Não é preciso inventar. Basta errar."
PEDRO O PODRE

```
República                    Revolução
    regime               respeito
    reconstrução restauração
República responsável
                          Revolucionário
                          Revolução
            revolucionário Revolucionário
República representar
            Revolução revolucionária
    Revolução Revolução revolucionária
    responsabilizaram
resolve República
                    recesso
República
            recesso recesso recesso
                          respectivo
responsáveis
República República respectivamente
                    Revolução
República
            restrições relativamente
            República
    remover referidas reserva
    reformar República
    respectivo República
    restituição República
                    Revolução
                    respectivos
                    revogadas
                    República
                          GLAUCO MATTOSO
(Atos, capítulo 5)
```

VOCÊ CONHECE UM BOM JORNAL PELAS OPINIÕES QUE ELE NÃO PRESTA
- A política de um bom jornal é a objetividade não identificada.
 - A religião de um bom jornal é a neo-autenticidade.
 - A honestidade de um jornal é o bom negócio.
 - E um bom jornal só segue uma ideologia: irrisão.
 - E uma linha de opinião: o non-sense.
 - Sem distensões, sem marcialidade.
 - Com infamações e não afirmações.
 - Sem opiniões compradas ou descoloridas.
 - Procurando dizer suavidades na página editorial, que é a parte mais dispensada de um jornal.
- E deixando a opinião do eleitor nascer do resultado do puro extrato de tomate.
UM JORNAL É TÃO VERDADEIRO QUANTO AS BONDADES QUE ELE NÃO TEM

JD — UM JORNAL DE MENTIRA
 (agradável a coxos e kardecistas...)

"Há dois tipos de apolíticos: aquele pra quem interessa o atual estado de coisas, e aquele pra quem não interessa o atual estado de coisas. Ao primeiro dá-se o nome de gestapistas; ao segundo, de escapistas."
PEDRO O PODRE

FIGURE 24. Glauco Mattoso, *Jornal Dobrabil*, 1977–1981. Courtesy of the artist.

JORNAL DOBRABIL

organ da arcademia brasileña de lettras germinadas & do dce livre
na faculdade de orthographia phonetica da universidade gamma phi,
um trabalho dobrado de glauco mattoso & pedro o podre

numero hum!!!　　　　　　　　　　　　　　　　　　　　　　　　anno xiii!!!

AMASSABIL RASGABIL INFLAMMABIL PERMEABIL CORTABIL CARTABIL DESCARTABIL SUJABIL LIMPABIL & ATÉ MESMO LEGIBIL

editorial

CULTURA
CULXURA
CUXXURA
CXXXURA
X
XXXXXXX
XXXSXXX
XXNSXXX
XENSXXX

ERRATA

onde se lê

leia-se

leia-se

onde se lê

na77oso

CURREIO

§§§ Tenho recebido seu JORNAL DOBRABIL. Vejo que vocês sabem manipular non-sens e avant-garde com inteligência e sutileza. Temo que, por causa disso, a publicação passará despercebida à maioria dos destinatários. Apenas uma observação a fazer: do cabeçalho sempre consta "nº 1, ano 1]". Acho ótimo, mas talvez fosse conveniente acrescentar algum dado que situasse o jornal no tempo, para orientação dos leitores e colecionadores. §§§
ORLANDO MARQUES DE PAIVA, São Paulo, SP
(Não ha necessidade de chronologias. O proprio leitor situará o jornal no tempo attentando aos themas alludidos em cada numero. Obrigados pela intelligencia e pela subtileza.)
GLAUCO MATTOSO

§§§ Debo advertir que cuando alguna cosa de este periódico parezca estúpida, será estupidez con mucha miga. §§§
SALVADOR DALI, New York, USA
(Engano seu. É que quando algo parece muito intelligente, sahiu por descuido. A gente também cochila.)
PEDRO O PODRE

§§§ I have received four different issues of JORNAL DOBRABIL. I have noticed that all of them are numbered with "number one" although this pamphlet has been published for thirteen years... Moreover to make matters worse I did not see any indication of periodicity.
MARSHALL McLUHAN, Toronto, Ontario, Canada
(A periodicidade do JD é a inopportunidade. JD não circula ha 13 annos mas pode durar mais que isso si for conservado em logar fresco e livre de bolores. JD será sempre "numero hum" ainda que appareça outra publicação com o mesmo nome. There is no darkness but ignorance, já dizia Shaxpeare.) G. MATTOSO

§§§ The newspaper, Sir, they are the most villainous... licentious... abominable... infernal... Not that I ever read them... no... I make it a rule never to look into a journal. Notwithstanding, as far as it concerns JORNAL DOBRABIL... §§§
GEORGE McGOVERN, Mitchell, S. Dak., USA
(É o tal negocio: quand je me considère, j'ai une bien médiocre idée de moi-même; mais tout change dès que je me compare. Sirva-nos isto de aerocrítica.)
PEDRO O PODRE

§§§ ...Isso é brincadeira de quem não tem o que fazer. Onde já se viu perder tempo com tanta bobagem?... Acho que vocês dois têm qualidades para se dedicar a coisa mais meritória e proveitosa... Larguem de lado essas idéias infantis, é o meu conselho. Leiam mais, aprendam, amadureçam. E quando quiserem fazer jornalismo ou literatura, façam-no a sério... Recuso-me a desperdiçar minhas preciosas horas vagas examinando material desse tipo... Peço-lhes que não mais me enviem esse papelucho... §§§
J. G. de ARAÚJO JORGE, Franco da Rocha, SP

(Leia-se "papeluxo". A carta foi abbreviada por razões de espaço e clareza. Será futuramente reproduzida na integra, em forma de folhetim. Aguardem.)
GLAUCO MATTOSO

——oO()Oo——

§§§ The JORNAL DOBRABIL ("Bendable Journal", allusion to the JORNAL DO BRASIL) is a publication of the "Arcademia Brasileña de lettras Germinadas" and the "Faculdade de Orthographia Phonetica da Universidade Gamma Phi". The "Arcademia" was created in 1969 by Glauco Mattoso to undertake nihilistic solutions to the problems of the Brazilian literature and poetry. Since its founding, the "Arcademia" has been quite active in the publication of iconoclastic manifestoes, including several periodicals. A fourth "Arcademia" publication to be initiated was the JORNAL DOBRABIL. Begun in January 1977, nine issues appeared on an irregular basis, and without consecutive numbering, till July. The journal is decidedly satirical, as its title indicates, and that focus is reflected in the subject matter of its three alternate "supplements": ZERO ALLA IZQUIERDA (political), JORNAL DADARTE (avant garde), and GALERIA ALEGRIA (gay). In conclusion, the journal is well edited and well made. It represents the most significant source of current information on the foolishness of Brazil. §§§
THE WASHINGTON POST

§§§ Glauco Mattoso criou o JORNAL DOBRABIL, que tem, por enquanto, uma tiragem de dez exemplares. É distribuido à Anima, Club dos Amigos do Marceninho, Escrita, GAM, Jornal do Brasil, José, O Pasquim, Qorpo Estranho, O Saco e Totem. §§§
ESCRITA

JD

: CORRESPONDENTES
no paiz:
Pedro de Lara, Mario Chamie, Adelino Moreira, Millor Fernandes, Zé Bettio.
no exterior:
Alfredo Stroessner, J.P.Sartre, Pelé.

jornal dobrabil.../jornal dadarte.../zero alla izquierda.../galeria alegria.../arcademia brasileña.../faculdade de orthographia.../and marx zwei are registered marx (c) by glauco mattoso//sollicita-se & permitte-se permuta & reproducção // type design (c) by pedro o podre.

marretado numa

olivetti

FIGURE 25. Glauco Mattoso, *Jornal Dobrabil*, 1977–1981. Courtesy of the artist.

infringement on the visual arts occurred when the military closed down the entire exhibit at the Museum of Modern Art (MAM) in Rio de Janeiro. Brazilian artists invited to exhibit at the Sixth Biennial of Young Artists to be held at the City Museum of Modern Art in Paris (October–November 1969) were invited to first show their work at the MAM, where a local jury would judge them.[68] Niomar Moniz Sodré, one of the jury members and the former director of MAM, described the details of events on May 29, 1969, the day of the closure, recalling that the military police simply barged into the museum on the day of the exhibit opening without prior warning; secured the entrance, prohibiting anyone from entering; and then proceeded to take down the offending works, which were then hidden in the museum's storage vaults.[69] The closure of the biennial preview was due to the alleged subversive nature of the works, and one of the offending pieces was by Antonio Manuel, whose *Repressão outra vez—Eis o saldo* (*Repression Again—This Is the Consequence*) from 1968 was among those fingered by the military. The five canvases composing the work are quite large (roughly 4 × 3 feet), and when viewing them, one is confronted, if not assaulted, by texts and images (culled from different newspapers, including *Correio da Manhã*, *Globo*, and *Última Hora*) highlighting military repression (figure 26).[70] Manuel's artworks with the newspaper provide some of the richest examples of the intersections between artistic practice and the newspaper as a system, and his works were repeatedly censored, pointing to the growing presence of censorship within the visual arts.

Moniz Sodré, fearing the destruction of Manuel's work (particularly given the offending title), chose to hide his canvases in her office at the headquarters of *Correio da Manhã*, where she was the director.[71] Her memory of the event is linked to her own history with the military police. *Correio* had a record of irritating the regime, and Moniz Sodré had been arrested following a provocative January 7, 1969, issue, which led to her imprisonment for seventy days (twenty-three of which she spent incommunicado and the rest under house arrest).[72] Only two months after her release in March, she was once again caught up in a censorship scandal with the closure of the biennial's preview. This confluence of events led Moniz Sodré to give up her role as director of the newspaper, and in a public resignation, published as an editorial in *Correio*, she condemned the lack of freedom of expression, stating, "We have all become machines . . . only allowed to transmit that which is permitted us."[73]

It is unclear if the museum became particularly vulnerable to surveillance as a result of its former director's parallel role at *Correio*, or if censorship had escalated to include artistic practice. Regardless, the closure of the biennial preview had a number of repercussions: First, it brought attention to the museum as a site of potentially subversive activity and from then on attracted closer military vigilance; second, the suspension of the pre-Paris

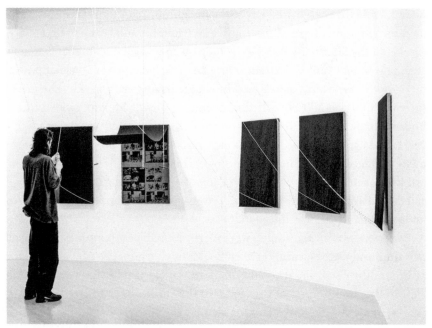

FIGURE 26.
Antonio Manuel,
*Repressão outra
vez—Eis o saldo*
(*Repression
Again—This Is
the Consequence*),
1968. Wood,
cloth, rope, and
silkscreen (set
of five canvases,
each 48 x 31.5 in.).
Courtesy of the
artist.

biennial solicited worldwide attention and galvanized the art community in an international boycott of the Tenth São Paulo Biennial (due to take place three months later in September of 1969). The French document "Non a la Biennale de São Paulo," drafted in France, detailed cases of abuse of power by the military toward artists and intellectuals and reasons why the artistic community should boycott the biennial.[74] The document, signed by an international roster of 321 well-known artists and intellectuals, made its way to the United States, where György Kepes, the organizer of the US segment of the São Paulo Biennial, also withdrew.[75] In return, most Brazilian artists continued to boycott the São Paulo Biennial during the following decade, until 1978, when the political process of democratization (otherwise known as *abertura*) was initiated.[76]

Experiences with censorship were unquestionably formative for artists at this time and were certainly critical for Manuel, who was a repeat offender of the military's visual sensibility. Before the closure of the biennial preview in Rio, he had been at the center of the closure of the Bienal da Bahia (Bahia Biennial), held in Salvador at the Convento da Lapa in December of 1968 (around the same time as the passing of the AI-5). The exhibit was closed down a day after it opened on the grounds that the censors found the works therein subversive. The censors confiscated ten of the offending works, among them a large-scale diptych (the two panels measured about 13 feet) by Manuel that condensed many of the same images he later used in *Repressão* into two large panels.[77] Unfortunately, no trace of Manuel's contribution to the Bahia Biennial exists today, and the artist later heard rumors that the authorities burned it.[78]

The newspaper was foundational for Manuel's artistic practice in a number of ways. The artist explains that in the early stages of his career he was very involved with the student movements and participated in demonstrations armed with the utopian vision that making art would help bring about social change. Much of his practice during the late 1960s and 1970s was engaged with voicing political opposition through alternative means, many of which were informed by student activism. He has often stated that faced with censorship, his goal was to act as both an activist and an artist, communicating the unsaid. As part of this activism he also acted in a movie about military violence against students entitled *Manhã cinzenta*, directed by his friend Olney São Paulo and released in 1969. Curiously, the film was first shown at the Cinemateca at MAM in Rio only a few months after the closure of the biennial preview at the same place, highlighting just how uneven the application of censorship sanctions was.[79]

Repression Again—This Is the Consequence was informed by an activist impulse but also highlights how Manuel manipulated the newspaper aesthetic. The five large canvases composing the work were displayed covered with black denim fabric to which white string was attached. The string cre-

ated a pulley system that allowed the spectator to pull the fabric up at will, as if opening a curtain. Once lifted, the fabric exposed a red surface onto which Manuel had screen-printed newspaper images of Brazilian military police violence toward students. The red surface provided an ominous background for the black images and text, not only because of its association with blood and violence, but also because of the regime's mistrust of the color red and its evocation of communism. The canvases were designed to imitate a newspaper page. Lifting the black screen, the viewer performed the covert operation of defying censorship, uncovering that which was meant to stay concealed. One of the canvases prominently features the headline that is the title of the work, "Repressão outra vez" (Repression Again), followed by an image of the military police with batons beating down a group of students as they stumble in their efforts to run away. The headline and image are repeated a second time toward the bottom half of the canvas, a serial sequence that mirrors the serial violence.

Another of the five canvases made direct reference to the death of Edson Luís de Lima Souto, featuring the headline "Eis o saldo: Garoto Morto" (This Is the Consequence: A Dead Boy). Luís was a seventeen-year-old student who was shot at and killed on March 28, 1968, when he was part of a group of students protesting the rising cost of meals at the university canteen. This protest was one of many that the newly radicalized leftist student groups led at the time, largely in response to government cuts in education, rising fees, inadequate facilities, and other issues. With Luís's death, the student groups had a martyr and a cause, and they responded en masse. Large-scale demonstrations with thousands of people were held in Rio and throughout the country, protesting government violence. Though a law was established making it a criminal offense for minors (those under eighteen) to participate in any activity "against national security," the student movement continued to grow.[80] On June 26, 1968, one of the biggest manifestations against government violence thus far, known as the Passeata dos Cem Mil, or the March of One Hundred Thousand, took place in Rio's downtown. The newspaper images of this event reveal masses of citizens mobilized in protest holding banners with handwritten slogans such as "Down with the dictatorship," "Power to the people," and "Artists against the dictatorship"—all in defiance of the ruling regime. The defiant energy of the thousands participating in the march is articulated in Antonio Manuel's *Repression Again*, and it is clear that his artistic agenda at the time was motivated by the vigor of protests against military wrongdoing.

Manuel recalled that he made *Repression Again* at the Industrial Design School (ESDI) in Rio de Janeiro with the help of Julio Plaza, a student who had recently arrived from Spain and went on to become a well-known artist. Among the founders of ESDI, the first school of its kind in Brazil, was Alexandre Wollner, a renowned graphic artist who had also been responsible for

the graphic reform in the visual layout of the newspaper *Correio da Manhã* in 1959. ESDI was also where Manuel met Décio Pignatari, the first to teach courses in information theory (discussed further in chapter 1).[81] Manuel claims to have frequented ESDI casually, mainly for lunch, but his acquaintance with Plaza gave him access to the school's equipment, and his friend also helped him silk-screen the canvases in *Repression Again*. Manuel has stated that he ended up hiding several of the other pieces for *Repression Again*, fearing the censors, and as a result he lost some of them.[82]

It is also likely that the graphic reform of newspapers during the late 1950s, initiated by Wollner and the sculptor Amílcar de Castro (1920–2002), influenced artists who adapted the newspaper aesthetic. Manuel, for example, declared that he admired de Castro, an artist associated with the Neoconcrete group and responsible for redesigning the layout of the weekend supplement of the *Jornal do Brasil*, known as the *Suplemento Dominical*, or the Sunday supplement (from 1956 to 1961). De Castro approached the pages of the newspaper's supplement and its gridlike space with a sculptural sensibility, forging a space for graphic manipulation as artistic practice, one that certainly would have resonated for someone like Manuel, who later followed in his footsteps.[83]

Describing the appeal of the newspaper, Manuel wrote: "These works were born of my passion for the newspaper as a medium that captures immediate reality, making poetic creation possible and above all as an idea of synthesis between the verbal and visual as contained in the vehicle."[84] Additionally, "the way in which the newspapers were exhibited in newsstands, the layout and pagination, have a poetic and dramatic appeal that served as material for the elaboration of these works—visual poems—, that in the beginning were developed in the studio and later in the newspaper's offices, along with the constant noise of the editorial department and the presses."[85]

Manuel's early works from 1966 to 1968 display an interest in the newspaper as a material support, one that was very inexpensive and readily available. For example, an untitled work from 1966, before the events of 1968 hardened the tenor of his political content, is a page of newsprint filled with a mass of anonymous characters drawn using black crayon. The newspaper text and images are left intact inside the bodies, shaping their core, as if to comment on the pervasive effect of newspapers on people. His first solo show, at the Galeria Goeldi (Rio de Janeiro) in 1967, debuted his artistic career with just such a series of works, made using crayons and India ink on newsprint. Writing for the two-page pamphlet accompanying the exhibit, the critic Roberto Pontual called Manuel's work "Arte Bala" (Bullet Art), a pun on the more common terminology, Arte Bela (Beautiful Art) and perhaps foreseeing the violence Manuel would later depict.[86] A few years later, *Jornal*, or simply *Newspaper*, from 1968, is decidedly more political. In-

FIGURE 27.
Antonio
Manuel, *Jornal*
(*Newspaper*),
1968. Crayon
on printed
newsprint.
Courtesy of
the artist.

tentionally exposing the words "Cavalarianos cercaram o povo na saída da igreja" (Troops surrounded the people at the church exit) in the left-hand corner, he covered the rest of the newsprint with hand-drawn images of anonymous bodies, and as in the earlier work, newsprint peeks through the black outlines of bodies (figure 27).[87] The slightly wider center panel has soldiers wearing helmets, some mounted on their horses, others holding what seem to be weapons.

Few works on newsprint remain due to the fragility and ephemerality of the medium, which eventually led Manuel to turn to *"flans,"* the French word for flongs, or stereotype matrices, as his support.[88] A much sturdier support, the *flan*, or matrix, is a thick sheet of paper, similar to cardboard, used to make lead stereotype molds, which were used in the rotary letterpress for printing newspapers.[89] After the lead molds were cast, the paper matrix, or *flan*, was no longer needed and was often discarded (or sometimes recycled). Manuel recalls seeking out the discarded *flans* in the waste bins of a variety of Rio's newspapers, including *Jornal do Brasil, Correio da Manhã, O Globo*, and *O Paiz*, in the early morning between 2:00 and 3:00 a.m., selecting the ones that interested him. The *flans* that Manuel used contained the residue of the text and images printed in the news on that day, which created a textured surface of high and low relief on the *flans*. Manuel would reconfigure the *flan*, highlighting selected images and text using ink while blacking out other sections. By adapting the same matrices used in publishing the news, Manuel assimilated the journalistic process into his work, endowing his artworks with the feel and graphic spacing of actual newspapers. Manuel worked with *flans* from 1967 until 1975 (the *Flans* series), and he believes he made around fifty altogether.[90] Many of the early works, made in his studio, were related to the student movement with images of military violence. *Marcha reúne cem mil (March Unites One Hundred Thousand)* from 1968, for example, makes direct reference to the protest of the same name, maintaining the grid-like composition of the original newspaper.

In 1973, Manuel was able to make his *Flans* in the offices of *O Dia*, a popular Rio newspaper, due to his friendship with Ivan Chagas Freitas, whose family owned it.[91] While in the offices, the artist had access to the *flans* as well as to personnel who would typeset text for him, allowing him to become more adventurous and experimental with the series. For the *Flans* from this period, he wrote his own articles, created his own headlines and images, and then worked with the newspaper's graphic designer on the visual design. Manuel was in and out of *O Dia*'s offices for two years — generally completing a *Flan* in one day — and his presence in the offices was not questioned because he was the boss's friend. Eventually, though, he was discovered by Freitas's father, who ordered them to stop in 1975. The *Flans* created in the newspaper's offices tended to be more ludic and colorful, moving away from the theme of military violence; the visual and verbal puns that he incorporated are closely related to the work of visual poets in the alternative press.

Several of Manuel's works with *flans* foreground their relationship with visual poetry more explicitly. One example is a *Flan* from 1975 entitled *Alab atam emof*, a reverse anagram for "Bala mata fome" (Bullets Kill Hunger; figure 28). The statement, written in bold capital letters, is followed by an-

ALAB ATAM EMOF

FIGURE 28.
Antonio Manuel,
Alab atam emof
(anagram for
"Bullets Kill
Hunger") from
the *Flans* series,
1975. Ink on
papier-mâché
stereotype
mold, 22 x 15 in.
Courtesy of the
artist.

other, "O pão nosso de cada dia" (Our Daily Bread), visible only in the tex-
tured relief left by the indentation of letters from typecasting. These state-
ments are accompanied by an image of bullets occupying the lower half of
the page (a nod to Pontual's assessment of the artist's work as Arte Bala).
The message is a kind of word puzzle that sought to be solved, but it also
highlighted the predominance of both hunger and bullets in Brazil at the
time. Despite the subversive content, the aesthetic form of this particular
Flan is more playful than that of earlier *Flans* dealing with student violence.
 Such playfulness is also operative in Manuel's final *Flan*, *Poema clas-*

FIGURE 29.
Antonio
Manuel, *Poema
classificado*
(*Classified Poem*)
from the *Flans*
series, 1975. Ink
on papier-mâché
stereotype
mold, 22 x 15 in.
Courtesy of the
artist.

sificado (*Classified Poem*), from 1975 (figure 29). The larger-font headline *Poema classificado* is located at the top and is followed by text that the artist cast himself, which is only perceivable through the texture of the high and low relief on the paper; there is no color. The poem, configured as a page of classified ads, has eight columns, each featuring one of the following terms: "*Corpo, Gráfico, 8 Colunas, Massificadas, Espaço Cheio, Redundante, Ponto, Final*" (Body, Graph, Eight Columns, Overcrowded, Full Space, Redun-

dant, Full, Stop), possibly terminology for classified ads used in newspaper circles. Each column's title is repeated vertically twelve times. The composition imitates the layout for classified ads, a format Manuel worked with in three other *Flans* from 1969: *Classificados (Vermelho) (Classifieds [Red])*; *Cruzadas (Crossword Puzzles)*; and *Classificados (Imóveis—aluguel)*, or *Classifieds (Real Estate—For Rent)*. All three of these leave the page of ads largely intact, but they are painted over, the first covered entirely in red, and the other two covered in white, though barely, leaving the background text and grids intact but the text blurred. The one *Flan* that is painted in red makes direct reference to the red screen-printed canvases in the censored work *Repression Again* (1968). In all four works, the text is barely legible and requires close viewing to make out the texture produced by the low relief. Pontual responded to the classified *Flans*, calling them "a symptom of the suffocated silence preceding the scream," alluding to all that went unsaid in newspapers. Such strategies could also be visible in newspapers as they struggled to fill the spaces that had been censored, some leaving the space of a censored story blank, others blocking out columns in black. But even more than a reference to censorship, Manuel's work with classifieds recalls the use of this graphic space in the classified ads by Meireles and Bruscky, discussed earlier in this chapter, which highlighted the graphic space of the newspaper as one of visual interest where text can be manipulated to meet an aesthetic, political, and poetic agenda.

Manuel's series of *Flans* entitled *Super jornais—Clandestinas (Super Newspapers—Clandestines)* from 1973 went even further in pushing such an agenda. With access to the printing equipment at *O Dia*, the artist began to design his own cover pages, incorporating *O Dia*'s logotype and headlines but substituting his own text and images. He then surreptitiously included these doctored editions at newsstands, where they were sold to unsuspecting customers who would have no way of knowing they were buying an artwork.[92] Like the other journalists, Manuel worked within the confines of the editorial agenda existent at *O Dia*, which focused on crime stories, urban violence, and soccer.[93] As one media studies scholar described, the newspaper had a formula for its success with readers: "70% crime or police stories, 20% politics and worker demands, and 10% sports and entertainment."[94] This recipe made *O Dia* the second most consumed newspaper in Rio de Janeiro, where it was particularly popular among working-class readers. Manuel's goal of reaching a more diverse audience was certainly met with his *Clandestines*, which went out to readers who had no idea that they were buying something that had been manipulated. The artist recalls having worked on ten separate *Clandestine* covers at *O Dia*, printing two to three hundred copies to be placed in circulation.[95] Eight of them were created between May and July of 1973, while the other two were from 1975. The title of the work reflected not only the furtive process of altering newspaper

information but also the illicit circulation of said information. Manuel described the work as "the marginal, clandestine side of the structure of an industrial vehicle of the masses."[96] In this way, this work finds a parallel in Meireles's furtive circulation of his banknotes and Coca-Cola bottles (discussed at length in chapter 1), incorporating the tension between concealing and revealing information. Without knowing it, Manuel was also employing a strategy frequently used by the editorial staff at *Tribuna da Imprensa*, one of the more censored news organs in Brazil during the dictatorship. While the censors would review five hundred to six hundred copies of the daily, the editors would furtively keep five or six issues hidden and take them intact and uncensored directly to the newsstands, so that, on occasion, an unsuspecting reader would find an unadulterated version of the news.[97]

Playing with the newspaper's editorial formula and its commitment to rhetorical strategies that relied on "hyperbole, dense description and incisive language," Manuel crafted stories that meandered in and out of reality, weaving together improbable cover pages that featured sensationalist headlines, news and political events alongside stories of vampires, goats, and the artist's own work.[98] The fact that Manuel was able to concoct his own stories could be attributed to the unusual position of *O Dia* in the media landscape. As a newspaper geared toward the working class, and known in particular for influencing the popular vote, it was notorious for featuring scandalous stories. In her case study on *O Dia*, the communications scholar Marialva Barbosa remarked that during the 1970s it functioned as a tabloid with a heavy dose of urban violence, crime, and human violence stories, alongside comprehensive coverage of soccer and issues related to worker tribulations, including retirement, pensions, cost of life, and other concerns.[99] Barbosa suggests that the reality proposed in *O Dia*'s pages, through what she identifies as the newspaper's "narrative typology," depicted an alternative world, one in which fantasy and reality collided and made possible a dream state. Though Manuel has not commented on the tenor of *O Dia*'s narrative agenda as having influenced his own work, it is important to think about the *Clandestines* series not only as part of his own work with newspapers and *flans* but also as building on *O Dia*'s existent tendency to emphasize urban violence.[100] His earlier work *Repression Again* and the *Flans* series had already demonstrated his need to underscore military violence, but his later work suggests a less direct approach to doing so. In fact, Manuel's later *Flans*, as well as his *Clandestines* series, seem more engaged with the kinds of strategies adopted by *O Pasquim* and the alternative press, which had become increasingly popular by 1973, relying instead on parody, satire, and humor, as well as a more poetic engagement of language.[101]

The *Clandestine* dated June 26, 1973, for example, features a series of headlines about the soccer team's loss to Sweden (the first story on the page), the death of a Peronist leader, a corruption scandal, a bar brawl that

ended in death, and amid this mosaic of news events is a large headline, taking up the most graphic space, stating: "Madness, a Man Displays Himself Nude in the Museum—As a Work of Art" (figure 30). Just underneath is a photo of Antonio Manuel posing nude in (or as) his renowned work *O corpo é a obra* (*The Body Is the Work*) from 1970 (figure 31).[102] The spectacle of this work, reconstructed as a front-page news story, brings attention to but also parodies Manuel's own artwork, drawing on the tradition of lampooning that was the trademark of *O Pasquim*. The artist adopted the ludic tone in other *Clandestines* as well as later *Flans*, particularly those from 1975, incorporating himself as the protagonist of bizarre, dramatized situations. Another *Clandestine*, for example, features the headline: "Confusion at the MAM, Painter Exhibits Post Art," followed by an image of Manuel's torso, nude and strategically positioned among stories of death, conflict, and money scandals (figure 32).

What is unique about Manuel's *Clandestines* series is that by seeking out an alternative distribution network, one influenced by the circulation of more politically subversive alternative or marginal publications, he went beyond registering and restaging his artworks within the graphic spaces of sensationalist news stories. Much like Meireles in his banknote and Coca-Cola series, Manuel avoided the traditional spectator of artworks in a museum or gallery, targeting instead the unsuspecting newspaper readers who bought the daily without realizing it was a work of art.

This concept was also behind one of Manuel's most far-reaching projects, *De o a 24:00 horas* (*From 0 to 24:00*) from 1973, in which the newspaper became both a support for his work and the vehicle for its exhibition (figure 33). Ironically, the project emerged in response to museum censorship. Initially Manuel had proposed seven or eight projects for an individual exhibit at the Museum of Modern Art in Rio de Janeiro, but the only one approved was *O bode* (*The Goat*), which involved the display of a living goat.[103] In the end, fearing that the work might cause problems for the museum and for the artist, the institution abandoned *The Goat* proposition as well, preferring instead to cancel the whole exhibit so as to avoid any undue attention, particularly given Manuel's prior experience with censors there. In response to the cancellation of his work, Manuel conceived of using the newspaper as the exhibition space, documenting the intended series of projects graphically. Manuel pitched his idea to publish his exhibit as the Sunday supplement in the newspaper *O Jornal* to the journalist Washington Novaes, who was enthusiastic about the proposal. Manuel claims to have chosen *O Jornal*, which belonged to one of the most powerful media empires in Latin America, Diários Associados, owned by Assis Chateaubriand, because of its national distribution (as opposed to the more local Rio papers).[104] Like many other newspapers struggling to maintain their readership and appease the censors, *O Jornal* was facing financial struggles

FIGURE 30. Antonio Manuel, *Clandestinas* (*Clandestines*) series, June 26, 1973. Newspaper, 22 x 15 in. Courtesy of the artist.

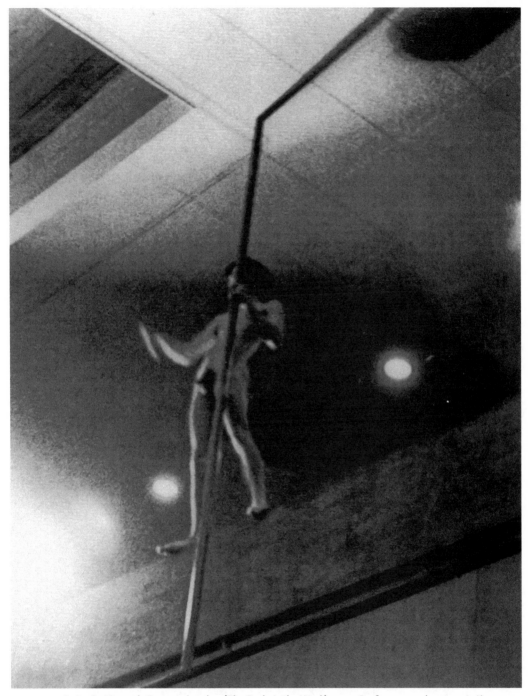

FIGURE 31. Antonio Manuel, *O corpo é a obra* (*The Body Is the Work*), 1970. Performance documentation. Courtesy of the artist.

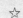

FIGURE 32. Antonio Manuel, *Clandestinas* (*Clandestines*) series, May 26, 1973. Courtesy of the artist.

after 1968, and it is likely that in 1973, the year of Manuel's exhibition proposal, Estácio Ramos, who was brought on to revive the newspaper's coverage, was more open to bold graphic experimentation and therefore more open to Manuel's request to take over the Sunday supplement.[105] The fact that it came out as a Sunday supplement was possibly in homage to Amílcar de Castro's graphic innovation at *Suplemento Dominical* at the *Jornal do Brasil (SDJB)*. Manuel's newspaper exhibition was announced twice, first on the cover page of Saturday's issue, and then on the cover of the Sunday edition on July 15, 1973 (figures 34 and 35). The newspaper had a run of 60,000 copies, which were distributed to newsstands throughout Brazil and were sold during a period of twenty-four hours, the typical lifespan of a daily (however, twelve to sixteen hours is more likely, or at least while the newsstand was open).[106]

FIGURE 34.
Newspaper
announcement
tomorrow for
Antonio Manuel,
*De 0 a 24:00
horas (From 0 to
24:00)*, 1973.
Courtesy of
the artist.

Though it was unique as an artistic endeavor, and one of the only instances that I know of where a work of art sought refuge within the pages of a circulating newspaper, Manuel's newspaper exhibit was akin to the activities of alternative publications during the 1970s, with the exception that its distribution was achieved via a mainstream mechanism. Manuel's graphic exhibit claimed the space of the newspaper to defy the authority of the institution, manifested as censorship, to determine what could be shown within its walls. His proposals interspersed comic texts and images,

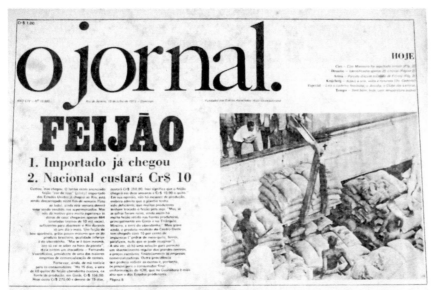

FIGURE 35.
Newspaper
announcement
today for
Antonio Manuel,
*De 0 a 24:00
horas (From 0 to
24:00)*, 1973.
Courtesy of
the artist.

including playful poems, with more serious commentary surrounding the restrictions Manuel encountered within the museum space. The cover featured a still from an earlier 16mm film by Manuel entitled *O galo (The Cock of the Golden Eggs*, 1972), which captured Manuel emerging nude from a straw nest surrounded by sand and seashells (there was also a *Flan* with the same headline from 1973; figure 36). The second page referred to a former

FIGURE 36. Antonio Manuel, *De 0 a 24:00 horas* (*From 0 to 24:00*), 1973; page 1. Newspaper, 22 x 15 in. Courtesy of the artist.

FIGURE 37.
Antonio Manuel,
*De 0 a 24:00
horas (From
0 to 24:00)*,
1973; pages 2–3.
Newspaper,
22 x 15 in. (each
page). Courtesy
of the artist.

work, *The Body Is the Work* (1970), and alongside images of Manuel posing nude is the transcription of a conversation between Manuel, Alex Varela, and Hugo Denizart (friends who accompanied the artist after the 1970 performance) and the admired critic Mário Pedrosa (figure 37). Manuel's *The Body Is the Work*, Pedrosa claimed in the featured text, was "a legitimate act of communication," or what he called "authentic art," that did not rely on representation but on action. On the lower half of the page are hand-drawn sketches for the purported layout of the works within the museum space, with dedicated areas for each of the works, including the live goat in the center of the room, and an area called "Capim p/ intelectuais" (Pasture for Intellectuals).[107] Included with the sketches is a small paragraph explaining that this supplement supplants the museum as the exhibition space for this series of artistic proposals. While there is no explicit reference to the museum's censorship, it is implicit in the line "should have opened this week at the museum," without further clarification, leaving one to ponder the details of why it did not. The emphasis on this page is on different acts of communication, from Pedrosa's assessment of Manuel's work to the more oblique text by Lygia Pape (who signed her text Janaína), and to the text that clarifies the transference of the exhibit into the pages of the news-

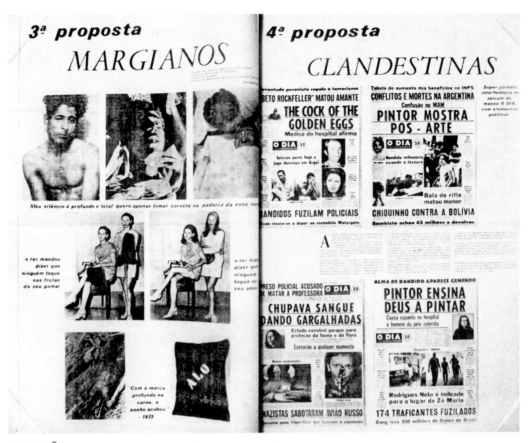

3ª proposta

MARGIANOS

4ª proposta

CLANDESTINAS

FIGURE 38.
Antonio Manuel,
*De 0 a 24:00
horas (From
0 to 24:00)*,
1973; pages 4–5.
Newspaper,
22 x 15 in. (each
page). Courtesy
of the artist.

paper, itself a mass medium of communication. The following four pages "display" the six proposals, a graphic retrospective of prior and future works rejected by the museum.[108]

Unlike his earlier newspaper and *Flans* series from 1968 documenting and dramatizing military clashes with student activists, the six proposals in this 1973 exhibition incorporate the kind of eccentric, comical, and outlandish situations more likely to be encountered in *O Pasquim* or other alternative publications proliferating at this time. Three of the six pages feature Manuel's body in different stages of nudity. Even page three, with the headline for Proposal Two, *O bode*, or the goat project the museum was initially willing to take on, makes reference to the body.[109] "*Bode*," the word for goat, when pronounced in Portuguese, is phonetically similar to "body" in English, a semantic quip that Manuel is quick to reveal in interviews and is the kind of phonetic diversion that is endemic to poetry. Pages four and five headline Manuel's third proposal, *Margianos*, and the fourth, *Clandestinas*, each of which was extracted from material for prior *Flans* (figure 38). *Margianos*, another wordplay on "martians" and "marginals," united isolated instances of media representations of otherness, including criminals, the insane, and transvestites. Marginal identity had already been idealized

during the dictatorship in 1968 with Hélio Oiticica's famous work *Seja marginal, seja herói* (Be Marginal, Be a Hero), a large red banner created in homage to Cara de Cavalo, one of the most famous outlaws in Rio, who had been gunned down by the police. For Oiticica, the work was a commentary on the abuse of authority, and the artist took the side of the bandit, a social marginal. Marginal culture was concurrently gaining ground among filmmakers, musicians, and artists. Manuel, for example, stated that he considered himself a cultural marginal, and he identified marginal expression as what he and other artists of the time were producing.[110] The focus on marginality drew on the psychic entropy resulting from social violence and political repression channeled into an allegory for freedom of expression, that is, the freedom to act outside of prescribed social norms. In *Margianos*, the military violence underscored in earlier *Flans* and newspaper drawings was directed into more emotive photographic documents of tortured, lifeless bodies, accompanied by Manuel's poem "Com a marca profunda na carne, o sonho acabou" (With the deep mark on the flesh, the dream was over). Marginality, here as in Oiticica's banner, was positioned alongside death as if it were its antidote and the possibility for escape or freedom.

Clandestinas, the fourth proposal in the exhibit, included a text by Pignatari, originally meant to accompany the exhibit at the MAM and now printed in the newspaper. It is not hard to imagine that Manuel's works with newspaper would have interested Pignatari, who himself was writing about the role of media in the transmission of information, and who was engaged with McLuhan's idea of "The medium is the message." Pignatari's short text is performative, poetic, and cryptic, but he makes reference to the newspaper as a system and the artist, here Manuel, as one who is working with the three attributes of this system: news, behavior, and public or, as he put it, "anti-notícia, de um anti-comportamento para um anti-público" (anti-news, of anti-behavior for an anti-public).[111] Manuel, he wrote, manipulates representation by inserting himself into the system, but—and here comes his critique—his work is ultimately limited to a specific public, "os chamados marginais de um público maior," the so-called marginals of a larger public, an argument often directed at conceptual artists working with ideas that were not easily understood.

The final page of the supplement presents the fifth and sixth proposals, *Eden* followed by *O galo* (*The Cock*). *Eden*, which depicts an image of a five-meter map of Latin America made of dirt, with the word "EDEN" written in capital letters three times, takes up the top half of the page (figure 39). The text alongside the map states that the map is covered with cloth, which a viewer is meant to lift to discover Eden, a reference to the "discovery" of the New World. In the bottom half of the newsprint, used for the sixth proposal, the image of Manual emerging from a nest in *The Cock* is repeated from the first page of the supplement. But rather than a bird's-eye perspective, we

5ª **proposta**

EDEN

mapa de
cinco metros
feitos com
terra e panos
para serem
levantados
- descobre-se
o eden
1969/1973

6ª **proposta**

O GALO

A impossibilidade - a impotência
1972

EXPOSIÇÃO DE ANTONIO MANUEL
DAS 0:00 AS 24 HORAS
- NAS BANCAS DE JORNAIS
DOMINGO DIA 15 DE JULHO DE 1973
ATRAVÉS DE O JORNAL

see the image as if looking up at it from below, seeing only the artist's head and torso and beyond those a vast, empty territory (echoing the territory of Eden from above) and underneath the words "O galo, A impossibilidade–a impotência" (The Cock, Impossibility and Impotence). Although Manuel has claimed that this was a reference to "the impossibility of showing our work, the impossibility of a better life, even though we did not stop fighting for it," he has not addressed the more playful, if not erotic, undertones of the phrase.[112] The fact that the cover and the back page act as self-portraits of Manuel posing as a cock, and an erect one, reads as a sexual innuendo, suggesting virility and potency instead of impotence, a visual pun that is repeated in the other scenes of Manuel's nude body heroically posing. Such double entendres and sexual allusions were notoriously employed in *O Pasquim* to redirect the content of a politically sensitive nature into farcical and comical situations, which would often go unnoted by the censors. As we have seen, this became a kind of coping mechanism that we can also identify in Manuel's later insertions into newspapers, particularly in his newspaper exhibition, *From 0 to 24:00*.

Manuel's oeuvre with newspapers underwent a series of changes from his late 1960s *Flans* to the later *Flans* created at *O Dia* during the first half of the 1970s, where the tone of his work was in dialogue with narrative and graphic models disseminated via the alternative press. The ardent drive to document student activism against military repression was channeled instead into a more personal, playful, and even erotic approach that challenged museum, artistic, and societal dictates, a hallmark of countercultural energy of the 1970s. As he sought out a broader audience, he relied on inserting his work into the newspaper, one of the most important systems of mass media communication. Through his insertions, Manuel constructed a unique visual and textual record that conflated the journalistic process with artistic practice. Particularly during this time of press restrictions, Manuel's labor resembled that of a journalist, as in many of the newspaper works he both exposed and concealed information at the same time. However, he did so by re-presenting what had already been reported in the media, repackaging the news to fit a particular aesthetic and ideological agenda. As art, Manuel's newspaper works were able to evade many of the censorship dictates and get away with brazen critiques of the military.

It is indisputable that newspapers were manipulated to shape the ideological needs of the military government during its more than twenty-year reign, and much has been written about the role of the press in defying through unusual means the dictates of the government administered via censorship. The newspaper became a locus where the tension between restriction and creative freedom coexisted, paving the way for unique graphic strategies that had a profound impact on artistic practice. Regrettably, artworks that actively engaged the newspaper as a social system are, for the

most part, absent from scholarship about the press during this period. Yet it is clear that from the 1950s on, when reformatting the graphic presentation of newspapers such as *Jornal do Brasil* and *Correio da Manhã* was prioritized, visual artists have been actively involved with shaping both the graphic presentation and the content of both the mainstream and the alternative press. My objective in this chapter has been to identify artists who went beyond using the newspaper as a material within their work, and instead engaged the journalistic process through a variety of perspectives. All three artists discussed, Meireles, Bruscky, and Manuel, pushed at the limits of acceptable journalistic behavior by employing parody, humor, and ambiguity within the confines of the mainstream press. All three also experimented with different means of inserting their work into the newspaper as a means of communicating with a more diverse audience. Such insertions were both literal and symbolic, both physically penetrating the newspaper and also allegorically redirecting politically sensitive material and finding a home for it.

TV will not work as background. It engages you. You have to be with it.
—Marshall McLuhan[1]

One of the earliest instances in which a television was incorporated into Brazilian art happened in 1967 with *Tropicália*, the pièce de résistance, if not the most notorious work, from the *New Brazilian Objectivity* exhibition at the Museum of Modern Art in Rio de Janeiro (figure 40). *Tropicália*, the term artist Hélio Oiticica invented for this multimedia installation, was later taken up to designate one of the most well-known musical and cultural movements of the late sixties in Brazil: Tropicalism.[2] In the wake of neoconcrete art, a movement with which Oiticica was intimately associated, the artist shied away from the creation of art objects for display, moving instead toward the creation of environments in which the viewer was encouraged to participate. In *Tropicália*, Oiticica included a series of *penetráveis* (penetrables), spaces that were meant to simultaneously activate the viewer's tactile, olfactory, auditory, and visual senses through kitsch objects associated with Brazilian culture (what Oiticica called "Carmen Miranda imagery . . . pineapples, plastic flowers, parrots, macaws").[3] Upon entering or, more accurately, "penetrating" the uncovered labyrinthine structures, one immediately recognized the markers of favela architecture: the unfinished structures made from leftover wood, decorated with bright, flower-printed fabrics, arbitrary bricks, and recycled plastic.[4] The penetrables were made of urban detritus, while the paths that led the viewer to the enclosed spaces were surrounded with plants, pebbles, and sand, or tropical props that purposefully invoked Brazilian fauna.[5] Proceeding to the second penetrable, one meandered through no set course and encountered hand-written poem-objects along the sandy paths of the installation. Oiticica wrote that these poem-objects (created by Roberta Oiticica) were inscribed in other objects—"the brick, Styrofoam, concrete, wood"—surrounding the penetrables, making it difficult to distinguish the poetry from the materials.[6] The crunch of pebbles and the sound of gawking live parrots would have accompanied the viewers, who felt their way through the unlit passageway until they encountered the flickering light of the television set. The television, one of the most powerful symbols of modernization, was lodged in a space meant to recall favela constructions, where basic services such as water, trash collec-

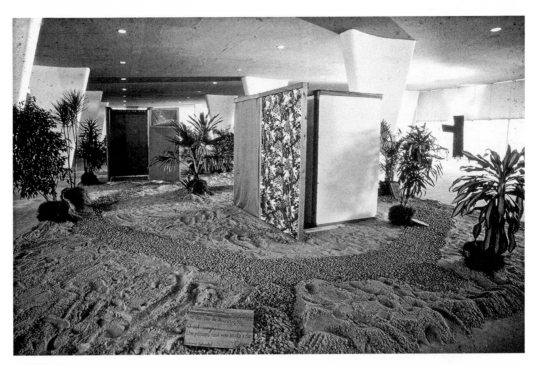

tion, and electricity were precarious at best, but where, paradoxically, the television reigned supreme. This disjuncture highlighted the uneven unfolding of modernity in Brazil and elsewhere in Latin America, particularly with regard to access to technology, the kind of contradiction that the artists discussed in this book were quick to embrace in their work.[7] The incongruous juxtaposition of the television in this impoverished setting highlighted the widespread reach of the television apparatus by 1967, but also spoke to a pressing concern of the Brazilian avant-garde. In Oiticica's seminal text "Esquema geral da Nova Objetividade" (General Scheme of New Objectivity), he articulated the challenge of the avant-garde artist as "how to, in an underdeveloped country, explain and justify the appearance of an avant-garde, not as a symptom of alienation, but as a decisive factor in its collective progress?"[8] In the same text, Oiticica declared that the artist was tasked "not simply to create, but to communicate on a large scale, and not only to a limited group of elite experts."[9] The television in *Tropicália* and the avant-garde artist were both positioned to become apparatuses of communication, evening out the incongruities of modernity in Brazil.

The artistic discourse of the moment surrounding communication and the emphasis on reaching expanded sectors of the population had a parallel in the government's approach to communication policies, which is surprising, given artists' pronounced hostility to the regime. In concentrated efforts to validate its continued grip on power and disseminate its conservative principles, the Brazilian government adopted a similar focus on com-

municating with broader audiences and expanding the reach of the military complex by mobilizing the television to do so.[10] Impressive advances in communications and satellite technologies accounted for the ubiquity of television in even the most remote Brazilian households. By 1970, television became the most effective system of communication, a focal point of interest for both artists and the military regime.

In this chapter I elucidate not only the history of television and the context for its phenomenal growth but also its position within the work of those Brazilian artists who sought to communicate with more widespread audiences. More specifically, I examine the system of television as an object inserted into works of art and as an effective means of broadcast for artists working with the medium of video to propose alternative modes of communicating with the public. As I will elaborate, the focus on communication within artistic practice gained a sense of urgency during the dictatorship, particularly as a counterpoint to government propaganda dominating television broadcasting. While the stakes of political and aesthetic attention to television were decidedly disparate, both the regime and artists sought to exploit its capacity as a mass media mechanism. This chapter reveals the points of divergence and convergence in the relationship between political and artistic spheres with regard to television, foregrounding how an emphasis on communication provided the context for the widespread expansion of television and, later, the emergence of video art in Brazil.

THE HISTORY OF TELEVISION IN BRAZIL

On September 16, 1965, shortly after the inauguration of the military government, the Empresa Brasileira de Telecomunicações (Brazilian Telecommunications Enterprises), most often referred to as Embratel, was established to oversee the expansion of telecommunications technology throughout Brazil's vast territories.[11] Embratel's motto was "Communication is integration," signaling the drive to unite all of Brazil via new technologies.[12] In 1967, just two months before *Tropicália* was exhibited, a new government entity, the Ministry of Communications, was created to administer telecommunications expansion and aggressively pursue satellite infrastructure. This activity coincided with the government's efforts to take advantage of the territories of the Amazon through the construction of the Trans-Amazon Highway, elaborated on in chapter 1. The newly extended communications network enabled the government to access all corners of Brazil, and television became the apparatus through which the state was able to broadcast and promote its ideological agenda remotely. Television thus became an unparalleled vehicle for mobilizing mass audiences on demand, a characteristic that is as viable today as it was during the late 1960s and 1970s.

The idea of a mass audience, however, only became feasible with the

more widespread consumption of television, particularly among the poorer classes. Ironically, during the 1950s and 1960s, Brazilian television was dismissed as a plaything of the elites. The first television channel, TV Tupi-Difusora, then Channel 3, was first introduced in São Paulo on September 18, 1950, by Assis Chateaubriand (also the patron and cofounder of the São Paulo Museum of Art, MASP, in 1947) and was the first commercial television broadcast in South America.[13] However, in 1950 when TV Tupi debuted, there were only two hundred television sets in Brazil, the majority of which had been imported by Chateaubriand himself.[14] This was quickly rectified by Invictus, a São Paulo factory that began to manufacture a 17-inch television model in Brazil in 1952 for the newly emerging market.[15] For the better part of the 1950s, the television was a gadget predominantly owned by Brazil's wealthier class and continued to be a luxury item imported from the United States. During its early years, as people familiarized themselves with the new technology, many misconceptions circulated about television. One urban legend was the belief that the television functioned more like a surveillance camera, monitoring what was going on inside people's homes. Much of the lore concerned the monitor and, more specifically, determining the boundaries between who was watching and who was being watched. For example, one cartoon that circulated depicted the animated character Jeca Tatu, portrayed as a wealthy plantation owner, comfortably seated in front of his monitor watching laborers from his coffee fields at work while he, conveniently, oversaw them from the comfort of his home. Another myth, described by an Invictus factory employee, concerned women viewers and their fear that if they sat too close to the monitor, they would be offering those on the outside an inappropriate view of their legs.[16] It was not until the 1960s, when the television became a more common household item, that the more outlandish stories surrounding television began to subside.

The number of homes that owned a television grew at an accelerated pace, from two hundred sets purchased in 1950 to three million in 1965 (by which time the majority were manufactured in Brazil), to well over six million by the early 1970s. According to a 1970 census, televisions had become as common as refrigerators in the Brazilian household, with 27 percent owning one, rivaled only by radios.[17] In fact, a 1970 article in the popular weekly *Veja*, entitled "Twenty Years of Television," opened by documenting television's ubiquitous presence in remote, impoverished, and isolated areas; the article was illustrated by the newly wired landscape of TV antennas in different locations—a working-class tenement in Brasília, a favela in Belo Horizonte, and a rural street in the interior of São Paulo.[18] The tone of the article was optimistic, citing the enthusiasm of an impoverished family pictured on the opposite page as they stood in front of a precariously assembled dwelling with nothing surrounding it except dirt roads and TV antennas. What is most striking about this illustrated article is how much

it mirrored the art-world setting presented in Oiticica's *Tropicália*. When interviewed, the family extolled the virtues of television: "Bem-vindo seja êste instrumento que não serve apenas para divertir, mas para incentivar o progresso e a paz, a pureza e a virtude" (We welcome this instrument that is not only for entertainment, but is also an incentive for progress, peace, purity, and virtue). Though the reality presented in the article was reminiscent of Oiticica's installation, the artist did not share the family's optimism about television and its relationship to progress and instead positioned the omnipresent television as if it were a contaminating, all-consuming force.

TELEVISION AS MEDIUM: MCLUHAN IN BRAZIL

The coexistence of opposing reactions to television was not unique to Brazil, and the question of how it would advance culture if not all of humankind was hotly debated by philosophers and scholars worldwide. Among them, the most well-known media scholar was Marshall McLuhan, a Canadian whose 1964 book, *Understanding Media: The Extensions of Man*, included a brief but influential chapter on the cultural impact of television. Although abundant scholarship on television and academic departments dedicated to its study exist now, at the time the field of media studies was nascent, and McLuhan, among its first theorists, sought to identify television's capacity for social change. His *Understanding Media* was widely read in the United States, where it was published, as well as in Latin America and Brazil.

McLuhan's chapter on television was wedged, tellingly, between his writings on radio and weapons, and in it he venerated the medium's possibilities for viewer participation with the goal of fomenting the spread of democracy. He extolled the "extraordinary degree of audience participation in the TV medium," boldly suggesting that in Fidel Castro's postrevolutionary Cuba, "What the Cubans are getting by TV is the experience of being directly engaged in the making of political decisions."[19] Although his assessment of Cuba proved to be overly optimistic, many of McLuhan's terms describing audience engagement with television are still in use today. Drawing on terms unrelated to media, McLuhan posited that "hot" and "cool" could qualify the degree to which an audience participated with a specific medium. According to McLuhan, TV was a cool medium, in contrast to newspaper or film, which were "hot." "Any hot medium," he explained, "allows less participation than a cool one, as a lecture makes for less participation than a seminar and a book for less than dialogue."[20] The "cool" used to describe television, he claimed, "promotes depth structures in art and entertainment alike, and creates audience involvement in depth as well."[21] From McLuhan's perspective, the TV image, which is low density and low definition as compared to film, does not provide detailed images or reveal sufficient information about the objects it projects, forcing the viewer to slow down and become more engaged in the process of viewing.

In his words: "TV will not work as background. It engages you. You have to be with it."[22] In contrast, the process of viewing for those media that McLuhan identified as "hot," such as newspaper, radio, and film, which furnish a lot of information, encouraged uniformity and passivity. "The movie viewer," McLuhan wrote, "is more disposed to be a passive consumer of actions, rather than a participant in reactions."[23] Curiously, McLuhan and Oiticica both privileged ideas of participation over passive consumption, but they adopted contrasting approaches to the function of television in society. Whereas Oiticica made the television function to promote passivity, consuming the viewer in *Tropicália*, McLuhan saw television as a tool that encouraged active participation not only during viewing but also through its repercussion in social life.[24]

Though they were widely read and written about in the mass media, McLuhan's theories of media literacy had a mixed reception in Brazil. The poet and communications theorist Décio Pignatari translated *Understanding Media* in 1969, making it de rigueur reading in artistic circles (all of the artists interviewed for this book knew about him and his famous line "The medium is the message" during the 1970s). His theories were also important in many university communications departments, providing fertile ground for controversy and debate about the promise of television. However, McLuhan's emphasis on the media specificity of television had a number of critics, among them the British media and cultural studies theorist Raymond Williams. Pointing to McLuhan's strict emphasis on medium as formalist and ahistorical, Williams emphasized that television was "at once an intention and an effect of a particular social order," and thus had to be analyzed within the social and historical context in which it emerged.[25] In Brazil, the sociologist and journalist Muniz Sodré published a seminal study of television in 1977, *O monopólio da fala: Função e linguagem da televisão no Brasil* (The monopoly of speech: Function and language of television in Brazil), in which he, too, was openly critical of McLuhan. For Sodré, television could not be considered a medium in isolation, but instead had to be theorized as part of a larger linguistic, informational, and economic complex, which included, among other things, publicity, sales, telecommunications, equipment, and—equally important—the press and radio used in advertising television.[26] He believed that the device does not signify on its own and that it is only by understanding the network of codes that it adopts, as well as the institutional context in which it is embedded, that one can begin to understand how it can wield power. He claimed that McLuhan's logic about the medium was tautological, and instead declared television a homogenizing political force in Brazilian society, directly opposing McLuhan's idea that with TV "came the end of bloc voting in politics."[27] For Sodré, television's only politics was to be in the service of the market and the state.[28]

Even Pignatari did not adhere to McLuhan's optimism about the role

of television in society. In a 1970 interview, Pignatari described television in Brazil as "confused, disorganized, and paradoxical," and how else could it be, he asked, "in a country that has cities like São Paulo . . . and the immense unexplored territories of the Amazon" or the coexistence of the newest in avant-garde art and a 40 percent illiteracy rate.[29] Oiticica had already captured in *Tropicália* the multiple contradictions signaled by Pignatari, presenting the paradoxical layers of signification relating to television in Brazilian society, including its adherence to an ideology of consumption. In *Tropicália*, one witnesses the performance of modernity via the inclusion of television, but its presence in the impoverished homes of the favela is far from optimistic. Instead, *Tropicália* crystallized the uneven and contradictory reception of modernity in a country marked by grossly uneven patterns of modernization and development. The television set one encountered in the penetrable entitled *Imagetic* was one that Oiticica described as devouring the viewer: "É a imagem que devora então o participador" (It is the image that devours the participant).[30] The idea of television as all-consuming is one that many artists would continue to voice, and it is discussed at length later in this chapter with regard to the emergence of video art.

TELEVISION, CENSORSHIP, AND A UNITED NATION

The skepticism that Brazilian artists and media theorists voiced vis-à-vis the potential of television was entirely dismissed by the military officials who quickly and enthusiastically endorsed television as a means to carry out their expansionist telecommunications projects and reach Brazilian audiences in distant places. Embratel's motto, "Communication is integration," was put into place through the pervasive reach of television, giving credence to the idealistic aim of a unified and peaceful Brazilian nation. In a 1972 speech given just before the launching of color television in Brazil, the minister of communications from 1969 to 1974, Higino Corsetti, specified what was expected of television stations in Brazil. "TV is not only a medium in action, it is also a factor of development, a precious instrument of social and economic integration. It is necessary to reconcile the interests of the stations with what must be done in terms of the national interests."[31] Television was an effective means to promote the regime's inflated patriotic agenda and also to unite audiences in collective celebrations of national triumph. It is perhaps no wonder, then, that one of the most remembered and talked-about events in the history of Brazilian television broadcasting, second only to the televised broadcast of Apollo 11's landing on the moon on July 20, 1969, was Brazil's victory over Italy during the 1970 World Cup in Mexico City, a feat that had also made Brazil the only nation in history to have won three World Cups. The 1970 World Cup games were the first to be broadcast live, and this feat alone had people in Brazil lining up to buy

thousands of television sets during the months preceding the games. Pride and jubilation accompanying the Brazilian national team's achievements permeated nationalist slogans that were championed by the military regime in its campaign to attain political legitimacy and displace the noise of the opposition. Songs with such titles as "Eu te amo, meu Brasil" (I love you, my Brazil) and "Este é um país que vai para frente" (This is a country that moves forward) and the musical theme played at the opening of the 1970 World Cup, "Pra frente, Brasil" (Go forward, Brazil), proliferated alongside sayings such as "Brasil, ame-o ou deixe-o" (Brazil, love it or leave it).[32]

Optimism in Brazil's future reigned supreme in the mass media, corroborated by news of the purported "economic miracle." All manner of development and modernization projects were proposed, many of which relied on the expanded role of telecommunications. President Emilio Garrastazu Médici was steadfast in maximizing the promotional possibilities of television in advocating a united Brazil. In what is now an often-quoted statement, he pronounced:

> I am happy every night when I turn on the television to watch the news. While the news talks about strikes, agitations, murder attempts, and conflicts in different parts of the world, Brazil moves ahead in peace toward the path of development. It's as if I took a tranquilizer after a day of work.[33]

Thus, the state eagerly invested in costly telecommunications technology, particularly as it concerned broadcasting.

Raymond Williams had pointed out in his 1975 study on television that state investment in broadcasting was part of a strategy to construct a "new and powerful form of social integration and control."[34] Where Brazil differed from other countries, however, was not just in the state's control over broadcasting, but in the regime's heavy hand in shaping television content by way of censorship, promptly concealing discontent or any news that portrayed the nation in a negative light. The little-known 1970 work by the artist Artur Barrio, 1. De dentro para fora. 2. Simples . . . (1. From Inside Out. 2. Simple . . . ; figure 41), uniquely commented on the state of censorship with regard to television.[35] The work was composed of a television set that was turned on and displayed inside a room with a transparent white sheet covering it. The draping of the sheet outlines the monitor's visual qualities, reminding one of more traditional sculptural works, but the sheet also distorts the television image, thus denying the viewer an unobstructed view of the content. The timing of Barrio's installation corresponded to the triumph at the World Cup, shrouding the monitor at a moment of heightened national fervor over Brazil's victory and the new possibility for simultaneous transmissions from abroad. The casual act of covering the television with a sheet, something one might do to furniture in one's house, is converted

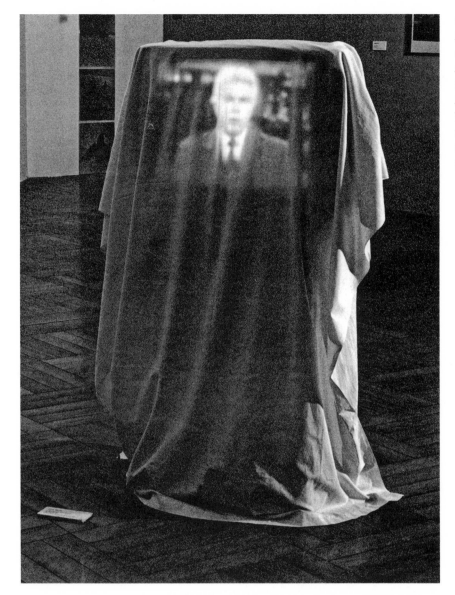

FIGURE 41.
Artur Barrio, *1. De dentro para fora. 2. Simples . . .* (*1. From Inside Out. 2. Simple . . .*), 1970. Television covered with white sheet. Courtesy of the artist.

into a deliberate act of concealing information, a veiled (literally) reference to censorship.

Throughout the 1970s, television censorship was facilitated by the regime's tightly bound relationship with TV Globo, by then a leader in television programming. In fact, the relationship between television and society in Brazil is intimately linked with the history of TV Globo, the most well-known entity of the Globo media conglomerate.[36] Supplanting Chateaubriand's pioneering channel TV Tupi of Diários Associados, TV Globo, with Roberto Marinho at the helm, dominated the media landscape of the 1970s, and arguably still does today.[37] Venicio de Lima, among numerous communications scholars, has claimed that TV Globo's rise to power and its com-

plete control of the media arena during the 1970s was due not only to an economic monopoly but also to the support of the military regime, which saw in Globo an ally and collaborator.[38]

TV Globo was launched in 1965 with the technical expertise and financial backing of the US company Time-Life, a relationship that ended in 1968 but officially continued until 1971 when Marinho finally paid off his financial obligation to Time-Life.[39] By 1970, Globo had the highest audience ratings in the country, and it was able to achieve this by supporting programs that focused on national integration and "positive messages" that reinforced the success and legitimacy of the authoritarian regime.[40] In 1973, Corsetti declared Globo to be "the only television [network] to meet the demands of the Federal government—'the electronic transmission of recreation, information, and education by a private entity grounded in the solid structure of a modern company.'"[41] TV Globo was constantly portrayed as working in the interest of the nation and in promoting modernity, development, and triumph. This also meant that programming was based on an illusion that was not grounded in the concrete social, physical, and economic reality of Brazil. As one executive of the Globo network explained: "Globo became a bastion of the middle class, floating above reality and selling to the viewer a pretty Brazil, a well-succeeded [sic] country, a Brazil of the miracle . . . Globo made concrete an abstraction: Order and Progress."[42] To further ground the idea of national integration, the state and Globo collectively adopted several measures. One in particular was known as the "Padrão Globo de Qualidade" (Globo Standard of Quality) and among its main goals was to establish "identification with a Brazilian way of life" through the promotion of lifestyle models that originated in Rio and São Paulo but were to be emulated by the rest of the country. Lima described Globo's "Standard of Quality" as characterized by "visual opulence, the sanitizing of pictures, and the expulsion from television screens of any facts that could be viewed as negative to the life of the country," thus presenting a Brazil "without social conflict, repression, or poverty."[43]

In addition to broadcasting behavioral patterns, television was expanded to include education. Médici's government embraced a number of initiatives to provide educational programming on TV Globo with the objective of creating an in-home classroom. One such initiative, Prontel, or Programa Nacional de Telecomunicações (National Program of Telecommunications), was issued by a government decree in 1972.[44] Prontel's aim was to oversee the standardization of educational activities broadcast on radio and television, leading to the program *Telecurso Segundo Grau*, a series of daily classrooms, each fifteen minutes long, televised on TV Globo and its affiliates throughout the whole country.[45] Famous actors conducted the classes using colorful images in classrooms that looked a lot better than those in actual schools. Maria Rita Kehl described these courses as a means to "inte-

grate/standardize/unify the process of information/formation of the so-called 'public opinion' in Brazil."[46] The same principles were operating in the televised classroom as in the marketplace: the standardization of mass-produced citizens as if they were consumer products.

The launch of *Jornal Nacional*, the first news program broadcast live from Rio de Janeiro to the rest of the country, was yet another example of an initiative leading toward national integration. Aired on TV Globo for the first time on September 1, 1969, the newscast was transmitted to six Brazilian state capitals, including São Paulo, Belo Horizonte, Curitiba, Porto Alegre, and Brasília. Simultaneous transmission became possible after the installation of satellite systems, administered by the state-owned Embratel, which first expanded to Brasília in 1968 and later that same year to the Amazon.[47] By 1969, Embratel had expanded internationally, allowing it to transmit the World Cup games live from Mexico, for example. For the newscast's first night, the anchormen opened with the often-quoted statement: "Globo Network's *National Journal*, a news service integrating the new Brazil, is airing at this moment: the image and sound of the whole country."[48]

The journalist Elisabeth Carvalho has argued that *Jornal Nacional* introduced a new style of news broadcasting that highlighted the country's successes and, most of all, Brazil's economic miracle—a period when Brazil's economy was experiencing one of the fastest growth rates in the world—by televising only beautiful, healthy, and well-nourished people.[49] Globo even hired the good-looking host Cid Moreira as a tactic to attract female audiences. Adhering to Globo's aesthetic pattern, Carvalho pointed out that *Jornal Nacional* deliberately avoided people with handicaps or those who looked sad or poor, such as people who were wearing torn clothes or missing teeth.[50] Major world events were also manipulated to conform to censorship restrictions prohibiting mention of certain events. Censorship instructions for television were most often administered via telephone calls from the government censors who were communicating prohibitions about local and international news events.[51] One restriction, for example, made it illegal to comment on the publication of anything dealing with themes that were in any way offensive to Brazil, or any of its authorities, in the foreign press.[52] Others were more arbitrary, prohibiting the mention of a 1970s phenomenon of streaking in Brazil, or even more absurdly, preventing any mention of an interview with the minister of health about the spread of meningitis. Thus, televised journalism, Carvalho specified, "consisted in diluting to the fullest the true impact of the news."[53] Despite its obvious failure to report accurate information to its viewers, *Jornal Nacional* was hugely successful, garnering the biggest audiences in television history, with a potential of 56 million viewers daily. Its success foregrounded the contradictory nature of communications policies during the 1970s: the coexistence of telecom-

munications technology, which expanded the possibility of broadcasting information, and the concurrent withholding of information to meet the regime's political needs. This paradox surrounding expanded communications technology and censorship, as has been argued throughout this book, spawned artistic practices engaged with the concept of information, including its interface and transmission.

VIDEO ART, AN ALTERNATIVE TELEVISION

Both Oiticica's and Barrio's work with the television set as an object staged some of the contradictions surrounding communications technology and its capacity for informing the public. But as the dictatorship became more repressive and the political stakes of communication were heightened, artists sought to intervene more vigorously into the system of television and more specifically into the act of communication itself. The advent of video art in Brazil afforded artists the opportunity to do so. Video technology was adapted to artistic practice following the commercial availability in 1965 of the Sony Portapak, a portable video recording device that could be operated by an individual (figure 42).[54] Video art adapted the basic ontology of television, streaming recorded content to the viewer via a monitor. However, one major point of divergence was that artists using video did not have access to a centralized broadcasting system and the attendant audiences that such a system could and did generate. In Brazil, this distinction resulted in a limited spectatorship for artist videos; however, this also meant that artists retained control over their content, allowing them to evade the strict censorship measures reserved for television. The earliest video artists during the 1970s thus launched the existence of an alternative network of televised communication, one whose quest could be aligned with that of alternative publications, discussed at length in chapter 2.

There was little critical or positive reception for video art at the time of its emergence. In 1978, the art critic Frederico Morais published a particularly scathing critique. "Video art," he said, "never really existed in Brazil. The few works that were made with this medium are profoundly tedious, badly made, and almost never took into account our cultural and economic reality."[55] Indeed, looked at in isolation, the existing works of video art during the 1970s do not compose a mass, and the variety of propositions makes it difficult to synthesize one consistent or dominant thematic trend. However, the works that do exist should be examined, not in isolation, but rather in their relationship to the system of television. Within a systematic investigation, several works of video art, contrary to Morais's claim, prove revealing, not only about the cultural and economic reality but also the political one. In this chapter, I detail the history of Brazilian video art and foreground its relationship to broadcast television by citing specific examples of artist videos.

FIGURE 42.
Sony AV-3400
Portapak
advertisement.
Photograph by
author.

A definitive history of early Brazilian video art has yet to be written, par-
tially because the entirety of video production has yet to be recovered or
restored and many of the early works have been damaged or misplaced.
Unlike the abundant video art produced in the United States during the
1970s, as well as the institutional complex that accompanied it, including
a multitude of exhibition spaces, critical reception, and theoretical writing,
video art in Brazil was limited to short-lived spurts of decentralized activity.
Artists were also faced with limited access to technological paraphernalia,
such as the Portapak, which often came at a prohibitive price. As a result,

Brazilian video artists and their audiences were limited to a confined sector of the population, a fact that led critics to dismiss video as an elitist mode of communication. It did not help that there were few institutional and gallery spaces dedicated to the exhibit of video art. Following the 1973 Bienal de São Paulo, the eighth iteration of *Jovem Arte Contemporânea (JAC)* at the Museum of Contemporary Art in São Paulo (MAC-USP) hosted the first public exhibit of Brazilian video art in 1974.[56] Brazilian artists were also included in the *Encuentros Internacionales de Video*, a series of ten international exhibitions organized by the Argentine critic Jorge Glusberg through his Centro de Arte y Comunicación (CAyC).[57] Other prominent venues were the Museum of Modern Art in Rio de Janeiro and Espaço B (B Space, 1977–1978), conceived of by Walter Zanini at MAC-USP. Both spaces were relatively active during their few years of existence. MAC-USP also offered a class for people interested in learning video art (June 1977). Finally, the Museum of Image and Sound in São Paulo (founded in 1970) hosted another important exhibit in 1978.[58]

Despite the lack of a developed institutional and critical apparatus, the early period of Brazilian video art during the 1970s provides an insightful platform for examining alternatives to state-sponsored broadcast television. Not only did artists' videos in Brazil encourage a critical attitude vis-à-vis the transmission of information on television, they also presented the viewer with access to an alternative media network that was for the most part ignored by media censors. Brazilian video artists thus aspired to create a space where the public could reflect critically on the political and social implications of media apparatuses and apply this critical acuity to other aspects of social life.

Video technology was first conceived of to record live events and then broadcast them via television stations for governmental and commercial purposes. Its first official use was to transmit the inauguration of the new capital city Brasília (in April of 1960), as well as the attendant government ceremonies, to the rest of the country. At that point, only Rio de Janeiro, São Paulo, and Belo Horizonte were linked by a public system of telecommunications, so in order to transmit government ceremonies they had to be taped and quickly shipped by airplane to other cities, laying the embryonic groundwork for the more complex and sophisticated broadcast network.[59] The media scholar Arlindo Machado, one of the first to systematically write about Brazilian video art, has also clarified that the commercial use of video took place when Japanese portable video equipment was introduced to Brazil for use in private companies as a means to train employees.[60] Television stations made several initial attempts at using video in the late 1950s, but not until 1962 did it become regularly deployed, not only for simultaneous transmission of programming but also to allow for taping and editing content before transmission. In his study of the rise of TV Globo, the

film scholar Richard Paterson recounted how the investment in portable video equipment facilitated the growth of Brazilian soap operas (*telenovelas*) and resulted in a shift away from the transmission of theatrical productions.[61] By the late 1960s, *telenovelas* garnered mass audiences when the show *Beto Rockfeller* first aired on TV Tupi in 1968.[62] After that, *telenovelas* became a dominant force in television programming, both throughout the 1970s and still today.

Within artistic circles, video was championed by such figures such as Vilém Flusser (1920–1991), a Czech philosopher who resided in Brazil for a long period beginning in 1940 and taught at communications departments in a number of São Paulo universities, including Fundação Armando Álvares Penteado (commonly referred to as FAAP) and the University of São Paulo's School of Art and Communications (Escola de Comunicações e Artes da USP).[63] Flusser directed attention to European video art in his capacity as professor at FAAP in Brazil, where he and his students—most notably his assistant, the artist Gabriel Borba Filho (b. 1942)—conducted a series of electronically documented performances using 1-inch videotape, one of the earliest formats, but unfortunately none have survived.[64] Additionally, Flusser had an important role in conceptualizing the section Art and Communication for the Twelfth São Paulo Biennial (1973), to which he invited three European artists (Gerald Minkoff, Jean Otth, and Fred Forest) to exhibit their video work.[65] The exposure to international video art was undoubtedly critical in instigating an awareness of the medium in Brazil.

The artist Rubens Gerchman (1942–2008) was another important figure in the emergence of video art in Brazil, though his role is rarely talked about. Gerchman was active with Oiticica in the *New Objectivity* exhibition at the MAM in Rio and was awarded a prize that allowed him to travel to New York in 1966. He studied video at New York University in 1970 and returned to Brazil in 1971, bringing with him video works on ½-inch videotape (a newer format) for which he had to borrow Sony equipment in order to exhibit them. In one interview, Gerchman recalled: "When I got here [to Brazil] there was nothing . . . no one wanted to know anything about video, there was a complete lack of interest. We didn't realize what would end up happening."[66] Nevertheless, encouraged by Gerchman's enthusiasm, the gallerist Ralph Camargo of Galeria Arte in São Paulo bought a Portapak that used ¼-inch videotapes (the latest format at the time). He used the equipment as a means to register the events, artists, and public of his gallery, and it is rumored that Camargo, Gerchman, and fellow artist José Roberto Aguilar participated in these video documents. Unfortunately, only anecdotal evidence remains of the tapes' existence, and no information is available about the precise nature of their content.[67]

Additional information suggests that in isolated instances, artists used video in Brazil as early as 1971,[68] but the medium became a more constant

presence in artistic circles with a group of artists from Rio de Janeiro who met regularly in an informal workshop environment at artist Anna Bella Geiger's house.[69] The group had been interested in experimentation with new media and was likely familiar with video art. Geiger in particular recalled having seen the video exhibit at the São Paulo Biennial: "I found it entirely natural that those works were made using video, but we were totally outside of the circuit since we did not have the equipment."[70] Having ignited a consciousness of the possibilities of this medium, Geiger and the group of artists she met with were ready a year later when equipment became available.[71] Prompted by an invitation to participate in a 1975 international exhibition of video art at the Institute of Contemporary Art in Philadelphia, this group of artists submitted a series of works created with a borrowed Sony Portapak, using ½-inch open-reel black-and-white tapes.[72] In the early experiments with the medium, conducted by Sonia Andrade (b. 1935), Angelo de Aquino (1945–2007), Fernando Cocchiarale (b. 1951), Miriam Danowski, Anna Bella Geiger (b. 1931), Paulo Herkenhoff (b. 1949), Ivens Machado (b. 1942), and Leticia Parente (1930–1991), video was used to document a variety of performances that were staged specifically for the camera. Ranging in tone and content from humorous to bitingly critical, the surviving works are a testament to the possibility of video intervening in the system of television.

For the most part, Brazilian artists who ended up working with video did not have exposure to training in the technological specificities of the medium and thus approached it as a conceptual proposition. There are few works probing the technical possibilities of the medium; instead, the artists were more focused on the possibility of expanding the range of critical content for broadcasting. Arlindo Machado rightfully pointed out that in Brazil, artists turned to video as they did to other media, looking for new and innovative supports for their ideas that would break with established aesthetic traditions, all the while eschewing the art market's demand for easel painting.[73] This involved the turn to conceptual art, performance, and street interventions as much as to video, so that early video experiments did not constitute a movement per se. It would certainly be difficult to construct a movement of video art during the 1970s from the limited number of available works and the diversity of their aesthetic propositions.

Although Brazilian video art was not a cohesive movement, and artists or critics did not theorize their activity in any formal sense, the work they produced was very much aligned with the concept of feedback. The art historian David Joselit has argued convincingly that video art in the United States proposed an intervention into the mechanisms of television via feedback.[74] "Video art," he claimed, is "one dimension of television's 'social life,'" one that allowed "artists and activists to produce aberrant or utopian pathways across the locked-down terrain of television."[75] "Feedback," a term

originating in biological discourse and cybernetics (in the work of Norbert Wiener and Ross Ashby), became folded into the social and cultural spheres during the 1970s, along with systems theory. In the United States, attributes of feedback and its application to video art were elaborated in detail within the pages of *Radical Software*, a journal first published in 1970 that was dedicated to video art and its potential for democratizing society.[76] Explaining the stakes of feedback in his book *Guerrilla Television*, Michael Shamberg, one of the founding editors of *Radical Software*, wrote: "A system is defined by the character of its information flow. Totalitarian societies . . . are maintained from a centralized source which tolerates little feedback. Democracies, on the other hand, respect two-way information channels which have many sources."[77] *Radical Software* included theoretical texts about the topic and a concluding section entitled "Feedback" in the last few pages of its issues, which served to perform the concept by featuring a hodgepodge of thoughts, citations, slogans, and advertisements by major theorists as well as institutions. Within the pages of *Radical Software*, making videos became synonymous with redesigning what Shamberg called the "information architecture."

Shamberg's *Guerrilla Television*, which expanded his project at the journal, was a "how to" manual to artists (and others) looking to impact the production of information outside of the strictly controlled space of broadcast television. Shamberg touted the unbounded possibilities of the Portapak and provided a step-by-step guide to the technical details of setting up and using the video recorder, instructing the reader to integrate the Portapak into everyday-life situations. Shamberg encouraged the reader to "tape everyday ordinary events: eating, walking, sleeping, talking, making love."[78] Videotape, according to Shamberg, proposed an alternative to the one-sided directionality of television broadcasting. Shamberg's book had a decidedly utopian tone, with statements like "Making videotape with and about yourself is . . . just plain fun. But it is also a tool for . . . combating the superstar behavioral patterns of the media."[79] The title of Shamberg's book, *Guerrilla Television*, and the radical social actions it proposed are reminiscent of Carlos Marighella's *Minimanual of the Urban Guerrilla* (discussed in further detail in chapter 1), which was published in English in 1970. The organization and tone of the book, itself a manual, including the numerous descriptions of the videographer as a "media-guerrilla," suggest an affinity with Marighella's text, relating experimentation with video to revolutionary and activist thinking.[80]

For Brazilian artists, televisual information flow and its monopolization by TV Globo was certainly something they were actively responding to, but the stakes of this flow and the value of information in a dictatorship added a sense of urgency to their work. So, like video artists elsewhere, Brazilian artists sought pathways that, as Shamberg described, would allow them to

"sculpt information-space," but they also used those spaces as a means to acknowledge and denounce the violence perpetrated by the military regime, information that was censored in traditional channels. One way they did so was by projecting their own reality into televisual space, a form of feedback. Paul Ryan, one of the video activists involved with *Radical Software*, explained this power over screen space as "self-cybernation."[81] In the journal's first issue, the contributors described what they called the "Alternate Television Movement," which was defined as "reversing the process of television, giving people access to the tools of production and distribution, giving them control of their own images and, by implication, their own lives" which in turn would "accelerate social and cultural change."[82] Such an activist stance aligned the Alternative Television Movement's mission with that of Latin American video artists.

In one of the earliest essays written about video art produced in Latin America, the Argentine critic Jorge Glusberg wrote: "Europeans engage in theoretical discussions of political problems," whereas "Latin Americans necessarily include these problems in their works, since they live them daily."[83] Like the video activists at *Radical Software*, Glusberg also referred to video as an "alternative television," but he called Latin American video artists "operators" who would "convert their lives and their art into testimonies of the struggle for liberation in the countries in which they are working."[84] Though it is difficult to identify a committed and shared revolutionary esprit de corps among Brazilian video artists that would accurately support Glusberg's assessment, there was certainly a tendency among artists living under the stifling conditions of dictatorship (in Argentina, Uruguay, and Chile, among others) to strive toward freedom of expression in the media. This was not necessarily manifested as direct denouncements of these governments or of their oppressive tactics but more through symbolic allusion to the institutionalization of violence, torture, and censorship practices by such governments. Additionally, the early video works coalesced around a critique of television and its relationship to the regime, often using the electronic register of their body on the screen in an effort to counteract passive conformity and consumption.

Letícia Parente's work *Marca registrada* (*Trademark*), made in 1975, is a compelling example of how artists performed such a bodily critique (figure 43).[85] Parente moved to Rio de Janeiro and began her artistic career during the 1970s (she was formerly a chemist), joining Geiger's informal group in 1974. Though she worked across different media, her video work, and specifically *Trademark*, the second video she ever created, are some of the most provocative and haunting artist videos made at the time.[86] The narrative unfolds as we follow the artist to a seated position; the camera then focuses on her disembodied foot, which becomes the focal point of activity for the next nine minutes. We watch her thread a needle, presumably for a mun-

dane domestic chore that involves sewing or perhaps embroidering. Viewer expectations, however, are abruptly thwarted when the needle pierces through the skin on the sole of the bare foot, which becomes a canvas for the slow and methodical process of stitching a series of letters, an uncomfortable tension the viewer must endure for the duration of the work. Though this is seemingly a painful process, it takes place in the calmest of surroundings, inside a domestic interior, with no sign of hesitation on the part of the artist, despite the pain this action must have caused her. It is as if pain or torture had become normalized. A few minutes into the work, it becomes apparent to the viewer that Parente is sewing the words "Made in Brasil" onto her foot, literally branding herself as a Brazilian product. The practice of branding human bodies goes back to colonial times when it was the punishment doled out by landowners to runaway slaves. But the fact that the title of Parente's work refers to a trademark links it more closely to the branding of consumer products, insinuating that Brazilian identity or, more accurately, Brazilian citizens were industrially manufactured.

During the late 1960s, the nationalist slogan "Made in Brazil" became the object of countercultural critique, indirectly hinted at in Oiticica's *Tropicália* and more directly expressed in music. Consider the song "Parque industrial" by the celebrated Tropicália musician Tom Zé, with the refrain: "Just heat and reuse / Because it is made, made, made, made in Brazil" (É somente requentar e usar / Porque é made, made, made, made in Brazil), mockingly suggesting that Brazilian identity comes prepackaged,

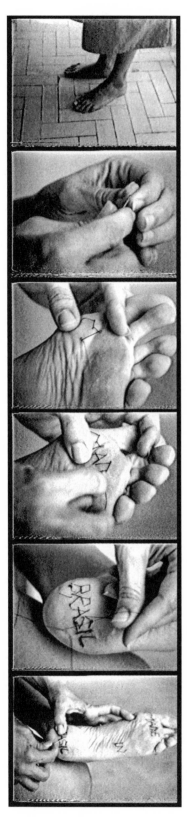

FIGURE 43.
Letícia Parente,
Marca registrada
(*Trademark*),
1975. Video stills.
Courtesy of
André Parente.

like the many products bearing the label. Christopher Dunn has argued that "Parque industrial," first released in 1968 on the *Tropicália, ou Panis et circensis* album, "satirizes the redemptive promises of consumerism."[87] Set to the music of a military band, "Parque industrial," Dunn suggests, performs nationalism and citizenship through "a civic ritual," celebrating development and progress.[88] Dunn argues that Tom Zé's music was instrumental in revealing contradictions about consumption, which "constituted and limited modern forms of citizenship."[89] But while consumerism was equated with national progress and vigorously promoted through television advertising, consumption itself was still not a viable option for the majority of Brazilians, especially given the dramatic rise of social inequality toward the end of the 1970s. As one study concluded, consumerism was an illusion in which luxury items were promoted through television to those who lacked even the basic goods necessary for survival.[90] Television was the ideal vehicle for promoting such an illusion, uniting people across different geographic, social, class, and gender realities in a contrived idea of national pride: a shared desire for products many could not afford to buy.

In Parente's work, however, the literal (and painful) branding of her body as if it were a product adds complexity to her allegiance to a Brazilian identity, defying the relationship between nationalism, modernity, and progress. The operation of labeling her body is carried out through the manual, and decidedly unmodern, process of sewing, a procedure that does not lend itself to facile (mass) reproduction. Additionally, Parente's "Made in Brasil" logo is achieved via an incredibly tortuous method, which could be read as an allusion to the dictatorship's torture practices, widely known about but little talked about in Brazilian society at the time. Furthermore, the fact that the words are written in English (with the exception of "Brazil," which is written with an "s," as it would be in Portuguese) suggests the pervasive influence of American products, a concern voiced by other artists at the time.[91] *Trademark* stands for the impossibility of creating model (uniform) Brazilian citizens, challenging TV Globo's many attempts to do so.

The same year that Parente created *Trademark*, a standardized Brazilian identity was becoming solidified not only through Brazilian television but also through the foundation of a government-supported agency known as CNRC, Centro Nacional de Referência Cultural (National Center for Cultural Reference) in 1975. The CNRC was led and later directed by the renowned designer and visual artist Aloísio Magalhães—discussed earlier as having redesigned the cruzeiro currency in 1966—along with Severo Gomes (then minister for the Ministry of Industry and Commerce) and Vladimir Murtinho (the minister of culture). Based at the University of Brasília, the CNRC was located in close proximity to the seat of the government in a capital that had been founded in 1960.[92] According to Magalhães, the impulse for the creation of the CNRC was the absence of a strong Brazilian

identity in the country's product design, a lack he proposed to address by developing a database, or an indexing system, that would identify characteristics particular to Brazilian culture.[93] Unlike a museum, the "Center would not collect objects but rather the references to them."[94] Fearing for the survival of the specificity of Brazilian culture, the CNRC would preserve those cultural areas that were most at risk of the homogenizing effects of mass media.[95] Though there is no question that Magalhães's intentions were more anthropological than fiercely ideological or dogmatic, the founding of the CNRC coincided with other projects carried out by the military to instill an artificial sense of Brazilian cultural unity. An inflated sense of patriotism and national unity would imply national stability, concealing the widespread discontent and stifling the opposition brewing in all corners of society at the time, and in turn legitimize the military regime.

Quite contrary to Magalhães's proposal for the CNRC, the regime did deploy the mass media to homogenize identity through "enforced conformity."[96] Television programming complied with the government posture, either involuntarily through persistent censorship or willingly, as in the case of Globo. The "Globo Standard of Quality" was one means for a "Brazilian way of life" to be projected onto Brazilians, many of whom had no way of realistically fulfilling the unattainable lifestyles promoted. Given Globo's monopoly on television spectatorship, the first generation of video artists, in Brazil as elsewhere, saw themselves as introducing an alternative.

One way in which an alternative was articulated was through bodily gestures. The cultural critic Nelly Richard, in her study on corporeal expression in authoritarian contexts, presents the body as a site for exposing tension in repressive societies. Richard claims that "under circumstances where censorship is applied to vast areas of meaning in language, any superfluous discourse or unspoken pressure which escapes or undermines the syntax of the permitted can only surface as bodily gestures."[97] And further, that "the corporeal not only lies at the frontier of the sayable, it also becomes the domain of the unsayable."[98] Though her argument references the context of the Chilean dictatorship (1973–1990), it is a claim that is apt for the Brazilian context as well, and it is particularly palpable in works by Sonia Andrade, where corporeal gestures supplant language in relaying censorship and other restricted topics.

Coming to the visual arts later in life (like Parente), Andrade joined Geiger's group in the early 1970s and was among the first generation of artists to create videos. Her *Untitled* series of eight video segments from 1974 to 1977 is among the most openly transgressive works made using portable video equipment.[99] The focus in Andrade's work is on her own body and its relationship to the medium of video. Her attention to the political and social body aligns her work with feminist artwork made in the United States during the 1970s, but this is an affinity that Andrade has refuted. She is quick

to disassociate her work from the gendered politics of US feminist art on the grounds that she did not feel she had experienced discrimination either as a woman or as an artist.[100] But within Andrade's critique of mass media and the political situation in Brazil lie embedded basic feminist strands claiming representation as personal and, even more explicitly, the personal as political. More specifically, like other feminist artists, she questioned the mechanisms by which the televisual image came to dominate daily life, as well the authority of television in presenting models of acceptable behavior, particularly those targeted toward women.

Though the feminist movement was slow to take off in Brazil, the role of women was scrutinized during the 1970s, and the regime had strict ideas about the shape that role should take, applying censorship to endorse what was deemed gender-appropriate behavior. In January of 1970, President Médici had issued his famous decree prohibiting the broadcast of programs or printed material that could be considered offensive to morale and good manners.[101] Thereafter, nudity and sex were strictly censured, but then, oddly, so was a 1972 commercial for sanitary napkins so as not to offend family values.[102] Ironically, much of the prohibited nudity was filtered into a new and wildly popular genre of films known as *pornochanchadas*, a Brazilian version of sex comedies featuring explicit sexuality, which flourished during the 1970s and promptly declined after strict censorship measures on film were lifted in the 1980s.

The role of women in family life was not the only issue at stake during the 1970s; instead, women viewers were integral to the growth of television in Brazil, constituting a critical majority of its spectatorship. In a 1976 interview, the director of research at Globo stated that all programming was geared toward the "default television viewer" (*telespectador padrão*), who was a married Catholic woman in her thirties, and who, among other things, made all the purchasing decisions for her household.[103] During the 1970s, the most watched television programs were the news and *telenovelas*; in 1972, the news made up 42 percent of programming and the *telenovela* 30 percent.[104] The well-known journalist Fernando Barbosa Lima remarked that intellectuals dismissed television "as a factory for *telenovelas*."[105] For advertising agencies, "the daily *telenovela* became . . . the most prized product of Brazilian television . . . All big manufacturers of toiletries, cosmetic and home products sponsored at least one daily novela."[106] At this time, US- and European-owned multinational corporations such as Colgate-Palmolive and Gessy Lever were responsible for producing the *telenovelas*.[107] It is not surprising, then, that companies specializing in hygiene and household products had a vested interest in targeting a female audience, not only through programming but also through the products they were quite aggressively advertising.

Despite the stereotypical gender roles promoted on *telenovelas*, women

during the 1970s were not relegated to a peripheral position in many facets of society. Within Brazilian art, women had occupied a distinguished position throughout the twentieth century, and many of the celebrated leaders of modern and contemporary art during that century were women. Women were also prominent in Marxist urban guerrilla groups and as leading figures of the resistance movements opposing the dictatorship, among them Brazil's president at this writing, Dilma Rousseff.[108] Thus, in Brazil, the question of gender was not immediately linked to traditional feminist concerns, as it was in the United States or certain countries in Europe. For example, notable feminist revisions of art history, such as Linda Nochlin's essay "Why Have There Been No Great Women Artists?" (1971), would have been inapplicable in the Brazilian context. As a result, many women artists in Brazil were resentful of feminist discourses they deemed inappropriate to their work. Andrade, for example, is quick to deny any allegiance to a feminist agenda.

One possible reason for women artists' negative response to feminism was its reception in Latin America during the 1970s. On the one hand, the International Women's Year in 1975 was celebrated in Brazil and brought attention to women's achievements, inevitably highlighting certain gender inequalities.[109] On the other hand, there was still an aversion to and rejection of the word "feminism." Ibrahim Sued, a well-known Brazilian syndicated columnist and television personality, fired up the debate by expressing what was likely a popularly held belief: "This feminism business is a lot of bull . . . It's something that bored, badly loved and ugly women who are single and mad about it are doing to turn the heads of the women who are the real women."[110] The Mexican anthropologist and feminist Marta Lamas accounted for the resistance to a doctrinaire approach to gendered politics by explaining that in many Latin American countries, feminists were "seen as 'agents of Yankee imperialism' by the left, as 'criminal abortionists' on the right, and as 'lesbian anti-males' by the mass media"; it was only in the 1980s that feminism in Latin America gained respectability, in both political and academic spheres.[111] Fighting not only gender-based discrimination, women in Brazil did unite against social injustice and human rights violations perpetrated by the regime. In political circles, for example, women founded the Movimento Feminino pela Anistia (Feminine Movement for Amnesty), or the MFPA, in 1975, using the momentum behind the International Women's Year to further the rights of and grant amnesty to political prisoners and those in exile.[112]

Despite a circumscribed set of gender-appropriate behaviors promoted by Globo and the state, the daily experience, both public and private, of women artists interviewed for this book varied widely. In Andrade's case, for example, she was adamant that as a woman she did not feel restricted by gender codes, quipping that she did not have to burn her bras, she simply

FIGURE 44.
Sonia Andrade,
Untitled (T.V.),
1974–1977.
Video still.
Courtesy of
the artist.

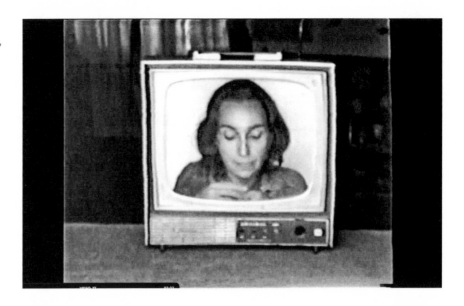

did not wear them.[113] "These issues," she said, simply "do not have the weight of a social question."[114] Despite these allegations, there are undeniable parallels between the performance and video work created by the more radicalized feminist artists in the United States and that of women artists in Brazil, particularly with regard to the centrality of the body and its representation in media. In fact, a number of revisionist exhibitions of feminist art of the first decade of the twenty-first century have included the work of Brazilian women video artists and have represented them as having ascribed to a widespread and international feminist agenda.[115]

For Andrade, it is clear that the subject of media representation has a broader stake in her work, and she cites television as the pivotal reference for the conception of her videos. In fact, the screen of the television monitor, as a mediating factor between the artist and her viewer, is constantly summoned and confronted. In *Untitled (T.V.;* 1974–1977), for example, the artificiality of the screen, and its incapacity to contain the artist's unruly body, is brought to the viewer's attention (figure 44). Throughout the three-minute work, an old television monitor frames the artist as she performs the act of brushing her teeth. The cue for Andrade's performance was taken from a television commercial for toothpaste, of which there were bound to be many, given the popularity of *telenovelas* and the interests of their corporate sponsors. However, Andrade's staged version of this daily ritual is deliberately unappealing and cheeky, urging the viewer to home in on the more realistic, albeit unsightly, details. As she flosses and brushes, the camera lingers on the monotony of the repeated actions, capturing the viewer off guard when the artist's hand accidentally escapes the frame of the monitor, an action repeated more deliberately when she drops the used floss by reaching outside of the screen, and again when she grabs a towel

to dry the spittle that has formed—all slips she makes no effort to conceal. There is a constant focus on what happens within and outside of the frame of the apparatus. Though Andrade mimics the superficial gestures of actors promoting certain products, she never allows her viewer to see the name of the product she is using, thus frustrating the raison d'être of commercial television. She closes the performance by smiling, exaggerating the duration and artificiality of the smile, to signal the performative nature of the gesture. Like Parente's *Trademark*, this work and, specifically, the artist's forced smile, once again summon the lyrics of Tom Zé's "Parque industrial": "Pois temos o sorriso engarrafadão / Já vem pronto e tabelado / É somente requentar e usar" (We have the bottled smile / It comes ready-made and catalogued / Just heat and reuse). Once again Andrade, like Zé, mocks the adaptation of prepackaged identities in the form of bodily gestures culled from television. The relationship between Andrade's video and Tom Zé's music is even further established with another song on his album from that same year (1968), "Catequismo, Creme Dental e Eu" (Catechism, Toothpaste, and Me). As Dunn points out, "The promotion of consumer products for the management of the body (i.e., the teeth) is described as a quasi-religious doctrine backed by repressive force: catequismo de fuzil / E creme dental em toda a frente ("catechism by gun / and toothpaste leading the way."[116] Like Zé, Andrade brings our attention to the consumption habits promoted on television with a product like toothpaste as a way to contest the indiscriminate or passive reception of a culture of commodities.

In fact, Globo allocated much of its resources to researching and shaping the consumer habits of its viewers. The director of marketing explained Globo's tactics with regard to the viewer: "We are interested in his daily behaviour, his habits, his tendencies, in his life as a human being."[117] Because of their extensive research, Globo introduced a new way of advertising: inserting products directly into their programs, or merchandising. One Brazilian author complained, "The *telenovela* today makes a dangerous compromise with merchandising and is becoming just a long ad. Merchandising took control of the narrative, and now it commands the plot. Today [authors] think about a theme in terms of the merchandise that it will be related to, rather than the reality it will deal with."[118] Andrade's *Untitled (T.V.)*, on the other hand, deliberately adapts the commercial format as the content of the work, spotlighting its prominent role in shaping television content. In her caricature of a televised hygiene ritual, she parodies the idea that television commercials can model appropriate behavior.

Andrade carries the critique to more disturbing lengths with a grooming ritual enacted in *Untitled (Pelos [Hair])* in which she awkwardly attempts to contain bodily excess for electronic display, and thus further question the idealized (and gendered) bodily routines encountered in televisual space (figure 45). The action unfolds with an image of the nude artist using

FIGURE 45.
Sonia Andrade,
*Untitled (Pelos
[Hair])*, 1974–
1977. Video
stills. Courtesy
of the artist.

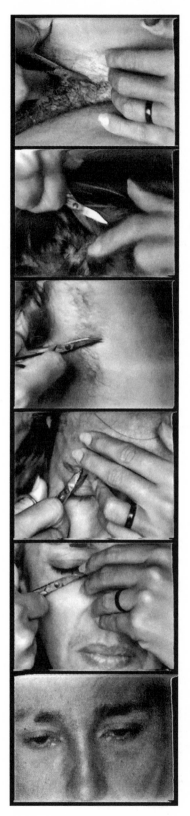

a pair of small scissors to cut away at her bodily hair. The first and most risqué shot is of the artist trimming her pubic hair, in what would certainly be deemed unacceptable behavior under the watchful eyes of the censors. The camera zooms in on the most intimate and vulnerable corners of her body as she continues to cut the hair under her arms, on top of her head, her eyebrows, and finally her eyelashes. The clip of the scissors signals looming peril, dramatized by the fact that Andrade's eyes are closed, forcing her to rely exclusively on her sense of touch. Countering passive viewing, the performance demands sustained and active visual attention as the ritual becomes increasingly disturbing for an audience caught in the anticipation of a misstep and the resulting bodily pain. The anticipation of random acts of bodily violence, just a misstep away, mirrors the societal ethos surrounding torture techniques and its countless victims. In her work, Andrade's attention to torture brings to the forefront topics that were deliberately avoided by not only television programming but also the general viewing public living under the dictatorship. Although everyone knew what was going on around them, they had to close their eyes to the reality to avoid the high risks of denouncing it.

The other works that make up the *Untitled* series (1974–1977) also posit the body as the site of certain irresolvable tensions, probing its limits as subject and object of electronic display as well as its tolerance for violence. In three vignettes from 1977, *Fio* (*Wire*), *Gaiolas* (*Cages*), and *Pregos* (*Nails*), Andrade continues to push at the limits of censorship. The short video with cages (*Gaiolas*), like *T.V.* and *Hair*, confronts bodily excess and electronic display

(figure 46). In it, Andrade is seated on the ground surrounded by five birdcages of different sizes, which she clumsily struggles to place on her feet, hands, and head. Though the cages constrain her, she overcomes the challenge to her balance and mobility and slowly stumbles forward. During the period of the dictatorship, a number of artists worked with cages as a way to metaphorically reference imprisonment and containment of the body.[119] But in Andrade's video, the logic of the cage is converted so that instead of holding her back, it signals a future in which she moves forward despite the hurdles in her way.

The subtle optimism of *Gaiolas* is attenuated in *Wire*, where the artist wraps a wire tightly around her head until she is no longer recognizable (figure 47). The ensuing face, unidentifiable and disfigured, deliberately summons the victims of torture and the painful violence that bodies were exposed to during the dictatorship. By self-inflicting pain and disfiguration in this way, the artist places herself in the ambiguous position of an active perpetrator who is also the passive recipient of bodily violence. Impressing the concrete reality of violence into the viewers' realm ironically implicates them as well, since by watching the apparent suffering, they are left feeling helpless, or even guilty, about their incapacity to deter it. The duality of this experience reflects on people's lived experience of torture and its constant proximity to their lives. Elaine Scarry, in her

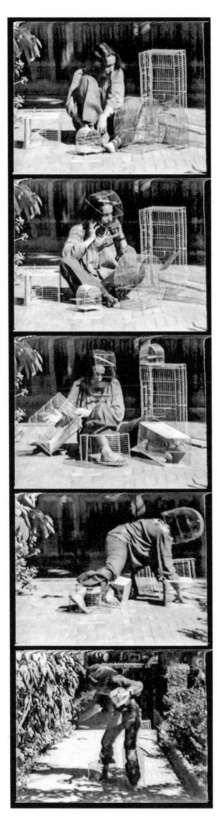

FIGURE 46.
Sonia Andrade,
Untitled (Gaiolas [Cages]), 1974–1977. Video stills.
Courtesy of the artist.

FIGURE 47.
Sonia Andrade,
*Untitled (Fio
[Wire])*, 1974–
1977. Video
stills. Courtesy
of the artist.

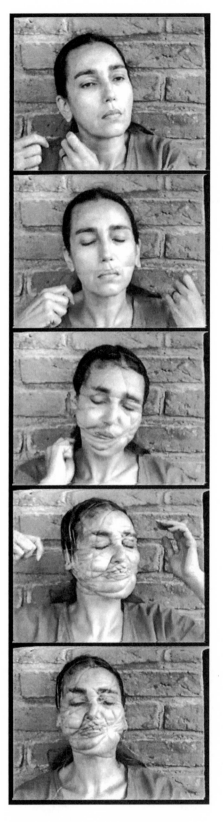

analysis of torture and bodily pain, has written: "Physical pain happens, of course, not several miles below our feet or many miles above our heads but within the bodies of persons who inhabit the world through which we each day make our way, and who may at any moment be separated from us by only a space of several inches."[120] Andrade intimates that physical pain is indeed not a distant reality but rather an experience that exists, quite literally, in the distance between the viewer and the television screen. The work thus complicates facile distinctions between passive and active viewing.

The theme of active viewing and its relationship to video in contrast to the passive consumption encouraged by television is one that is often raised in Andrade's oeuvre. It is most directly addressed with another video from her *Untitled* series in which the artist stands facing the viewer, with four different-sized television sets directly behind her (figure 48). The image is composed to simulate the many advertisements for television sets circulating in the mainstream press. However, rather than promote television, Andrade turns the set off and implores the viewer to do the same, continually repeating the phrase, "Turn off the television" (Desligue a televisão). The work is disarming, beguiling the viewer into watching while appealing for a decision either to comply with the artist's instructions or to disregard them, a choice between taking an active or a passive stance with regard to television.

Ironically, the work highlights the contradictory relationship between video art and television: its reliance on the same viewing apparatus.

Estômago embrulhado/ Jejum/Sobremesa (Upset Stomach/Fast/Dessert) by Paulo Herkenhoff, a former artist (now curator and critic) and participant of Anna Bella Geiger's group during the 1970s, addresses censorship and consumption from a different angle, albeit still one that relies on the body (figure 49). The narrative of the video unfolds as the nude artist, seated in profile, sifts through a stack of newspapers covering his pubic area. He methodically scans the dailies in search of articles dealing with government oppression and censorship, all the while brandishing a pair of scissors that loom dangerously close to his body. As soon as he chances on a germane headline, the camera zooms in just enough for the viewer to catch a glimpse, after which he cuts the article out, crumples it up, and stuffs it in his mouth.[121] Ironically, one of the articles he consumes bears a headline about how the cele-

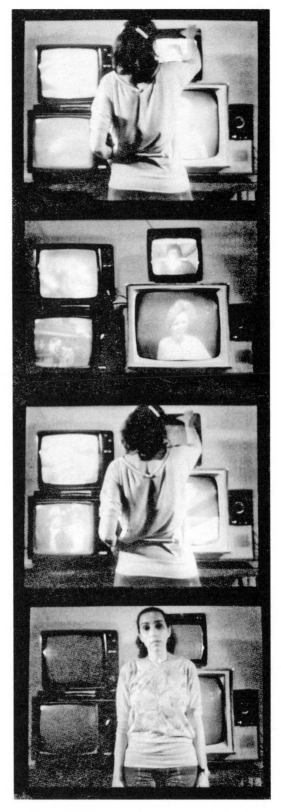

FIGURE 48.
Sonia Andrade,
*Untitled
(Desligue
a televisão
[Turn off the
television])*,
1974–1977.
Courtesy of
the artist.

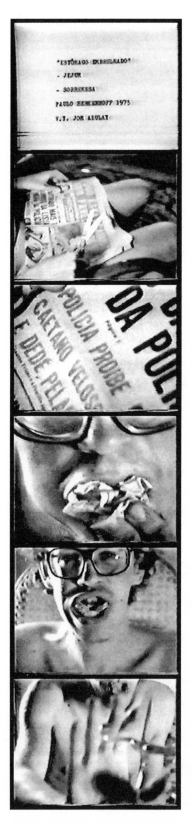

brated musician Caetano Veloso (of the Tropicália movement) and his wife Dede had been prohibited from appearing in the nude in public, an incident that takes on greater weight, as the artist presents himself nude for his audience. The performance ends with a close-up of the artist's face as his mouth is overflowing with newsprint, his body incapable of taking it all in, while he reaches his hand toward the camera, concealing what is displayed, in an act of self-censorship.

The title of the work suggests a disturbed gastrointestinal state, the physical and emotional result of literally digesting newspaper information in this way. It is as if news about censorship had a disturbing and direct internal effect on the body. Further, Herkenhoff's consumption of the news gestures at *antropofagia*, or anthropophagy, a dominant cultural model that emerged during Brazilian modernism in the late 1920s and has inspired several generations of artists.[122] The work performs an often-cited phrase from the "Anthropophagite Manifesto": "Cannibalism. Absorption of the sacred enemy. To transform him into totem."[123] Anthropophagy as a mode of cultural practice was revived by the Tropicália musical movement and was operative in Oiticica's installation where the television set is depicted as devouring the participant.[124] In Herkenhoff's *Estômago embrulhado*, the news is consumed in such a way that the "enemy" can be redeemed, as it is recast via video. Like the symbolic digestion in anthropophagy, consuming the harmful news results in the creation of the video, thereby suggesting an optimism about the regenerative possibility of the medium.

In this vein, Geraldo Anhaia Mello's

work entitled *A situação* (*The Situation*) from 1978 is also relevant (figure 50). In *The Situation*, the artist is seated in front of the screen, dressed in a suit and tie, cues taken from televised newscasts such as Globo's popular program *Jornal Nacional*. Next to Mello there is a bottle of *pinga*, a cheap sugarcane alcohol, which he drinks from while repeatedly toasting the Brazilian political, economic, social, and cultural situation.[125] During the nine minutes of the video, Mello gets progressively more intoxicated on the *pinga*, drinking a life-threatening amount, slurring the words of the toast, and laughing hysterically as he gradually loses control of his body. In this obviously ironic celebration of Brazil's "situation," Mello threatens his own body by ingesting such a large quantity of alcohol in so short a time span, and the impending bodily peril taints the humor of his outlandish behavior. While his alcohol-induced laughter becomes progressively rowdier, it becomes clear that the humor of the situation is not entirely redemptive. Seated alone and facing the viewer, Mello appeals to the spectator's sympathy as he slowly crumbles under the effects of the alcohol. As his speech slurs, the critique of Brazil's political, economic, and social situation is incisive, as if it were the situation, and not the alcohol, that inebriated and violated his body. By adapting the format of the newscast, Mello also mocks the transmission of news, which saluted Brazilian development and celebrated the "economic miracle" while equivocating on such topics as censorship and regime violence. Mello's bodily language gets distorted much like the content of the news, presented to millions of television viewers on a nightly basis.

CONCLUSION

During the 1970s, a piqued interest in communications technologies and the ca-

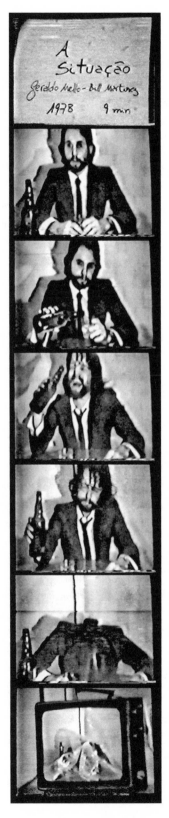

FIGURE 50.
Geraldo Anhaia Mello, *A situação* (*The Situation*), 1978. Video stills. Photograph by author.

pacity to reach broader and more remote audiences was one shared by artists and the military regime alike, albeit with different ends in mind. The role of television in facilitating this communication is crucial to understanding the government's ideological and political stakes as well as artists' critical reevaluation of television's cultural and social impact. In his *Tropicália* installation, Hélio Oiticica positioned the television as a ubiquitous and all-consuming force, devouring the viewer. As the regime became more repressive, television became synonymous with censorship and government propaganda, brought to the fore in Barrio's 1970 artwork *1. From Inside Out. 2. Simple . . .* , in which the viewer is confronted with a television set that is shrouded with a white sheet. Distorting the content that is being transmitted, the sheet acts as a veiled symbol for the way censorship functioned: by preventing the viewer from clearly seeing what is broadcast.

Seeing an opportunity to merge the state's political and economic interests with the commercial ones of Globo, the regime facilitated the rise of Globo's extensive media monopoly, and TV Globo became and still is the principal face of television in the history of Brazil. During the 1970s, not only did TV Globo control television programming through extensive censorship, but it also adopted measures to help construct an idea of a model national citizen through the introduction of the "Globo Standard of Quality," which promoted cosmopolitan ways of life to be emulated by the rest of the country. The Globo standard sought to present Brazil as a country where there was no social or economic strife and no military violence. In contrast to TV Globo's and consequently the regime's agenda, Brazilian video artists offered viewers an alternative to prescribed identities. The artist videos discussed here stage psychic, solitary, and silent dramas that are critical parodies of the social and cultural habits dominating television programming. Rather than continue to support the broadcast of content promoting depoliticized subjects, lacking any individual agency, Parente, Andrade, Herkenhoff, and Mello perform uncomfortable and often tortuous confrontations with their bodies to communicate and denounce the violence of the regime and activate the viewer to reflect on their surroundings. While the early artist videos did not compose an artistic movement per se, when analyzed within the context of television as a system dominating social life in Brazil during the 1970s, they reveal the ways in which artists absorbed communications technologies into their work.

During the 1960s and 1970s, three crucial events transformed the spatial orientation of the Brazilian citizen. First among these was the speedy construction of the new capital city, Brasília, between 1957 and 1960, on the formerly barren scrubland of the interior central plateau, directing political as well as economic and cultural attention inland and away from the more densely populated coastal regions. Second, the eagerly anticipated moon landing by the United States' Apollo 11 spacecraft in 1969, broadcast globally to millions of television viewers, expanded the possibilities for navigating and dominating space. Finally, the forced resettlement of the Amazonian rainforest in the 1970s, carried out by the military government through the construction of the Trans-Amazon Highway in 1972, among other initiatives, extended the physical and conceptual boundaries of the Brazilian nation albeit with grave consequences for the region's inhabitants.

Framed by these events and particularly by the state's presence in the Amazon, this chapter concentrates on exploring spatial boundaries through the system of maps by elucidating how cartography was deployed in the service of the regime's expansionist ethos at the same time that a pronounced mapping impulse influenced artistic production. My aim in this chapter is to look closely at mapping strategies at this time by homing in on the technological, cartographic, and aesthetic apparatus surrounding the definition and representation of territories. Maps have a long history in Brazil and in the New World more broadly, having paved the way for fifteenth-century European colonization. The vestiges of historical mapping projects clearly resonate in the regime's integrationist politics of exploiting the vast and isolated Amazonian territories during the 1970s. In contrast to the maps generated for government purposes, artworks incorporating maps and mapping operations, such as those by Cildo Meireles, Anna Bella Geiger, and Sonia Andrade, signal the ways in which artists advanced alternative forms of understanding territorial identity. Merging a variety of media, including drawing, sculpture, video, and installation, the artworks featured in this chapter proposed unique models for the organization and depiction of space within urban, regional, and national boundaries. Central to these artists' mapping practices was an attempt to adapt and subvert official modes of mapping space by introducing different strategies for representing topographic data.

MAPPING THE AMAZON

The founding of Embratel (Brazilian Telecommunications Enterprises) in 1965 ensured the spread of telecommunications technologies, particularly television, into the most remote corners of Brazil. This was facilitated by the creation of a new government agency, the Ministry of Communications, in 1967, which not only administered the technologies but also aggressively pursued satellite infrastructure.[1] By 1970, the new satellite technology was also mobilized in the service of mapping, aiding the compilation of more accurate geographic and topographic data about Brazil's vast territories. In 1970, for example, the Comissão de Levantamento Radagramétrico da Amazônia (CRADAM, or the Commission for the Survey of Radargrammetry in the Amazon), sought to identify the natural resources of the Amazon by collecting airborne radar images and later using them to create three-dimensional relief maps of the Brazilian areas.[2] The aerial mapping of the region, an initiative known as RADAM (Radar Amazon), resulted in a photographic survey of the entire Amazon basin with detailed information on its topographical features.[3]

By 1975, the initiative expanded throughout the entire Brazilian territory and was led by geographers and cartographers from the University of São Paulo.[4] It is worth mentioning that geography as an academic discipline underwent significant changes in the 1970s.[5] Although the 1960s had been fertile ground for developing new directions toward a critical urban geography by the likes of Pedro Geiger (*Evolução da rede urbana brasileira*, 1963) and Milton Santos (*A cidade nos países subdesenvolvidos*, 1965), President Médici introduced a law in 1971, Lei No. 5.692, instituting widespread educational reforms that curbed the growth of the discipline. The new law stifled intellectual developments, as students could no longer study geography independently and instead had to take a combined course in the disciplines of history and geography under the rubric of social studies, a development that pushed professors to cover too much ground without the possibility of in-depth analysis. One author, Márcio Willyans Ribeiro, described the new course of study for geography as "imposing passivity on the student," and thus preventing any kind of critical examination.[6] According to Ribeiro, this made the students easy to manipulate and efficient laborers for the state, which suited the goals of the regime and likely accounted for the collaboration of academics (traditionally resistant to such alliances) on the state's satellite imaging projects.

At around the same time, an agency known as Superintendência do Desenvolvimento da Amazônia (SUDAM, or Superintendancy of Amazonian Development) began a campaign offering attractive government subsidies to spur economic investment in the region and publicize its unbridled entrepreneurial possibilities. The agency, founded in 1966 as part of a broader initiative to integrate territories of the Amazon into the national economy,

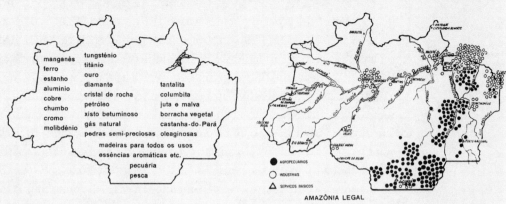

FIGURE 51.
Two side-by-side
maps of the
Amazon from the
SUDAM brochure,
1971. Courtesy of
Superintendência
do Desenvolvimento
da Amazônia
(ASCOM–SUDAM)

propagated slogans such as "The Amazon is your best business."[7] Compa-
nies endorsed by SUDAM not only were beneficiaries of ten-year tax breaks
but also received substantial federal funds. Cattle ranchers, for example,
benefited the most from such subsidies, receiving over one billion dollars,
despite the fact that they were the most important contributors to Ama-
zonian deforestation.[8] In 1971, SUDAM published a thirty-two-page pro-
motional pamphlet titled *A SUDAM revela a Amazônia* (SUDAM reveals
Amazonia). The booklet depicted the Amazon as "the El Dorado that you
need to discover," a blatant colonial reference to the countless expeditions
to the Amazon basin during the sixteenth century in search of the "Lost
City of Gold." In the middle of the pamphlet was a two-page spread featur-
ing two maps of the region with the title: *AMAZÔNIA: o Eldorado que sur-
preenderá o mundo* (*Amazon: The El Dorado That Will Surprise the World*;
figure 51).[9] The maps, on adjoining pages, contained strategic information
for both Brazilian and foreign investors. The first depicted a textual inven-
tory of twenty-seven of the region's most abundant natural resources, in-
cluding manganese, iron, tin, aluminum, copper, iron, titanium, and wood.
Shortly after the coup in 1964, the military regime began to publicize Bra-
zil's mineral wealth to the international community, eliminating all previ-
ously held limits on foreign investment in the region as well as elsewhere in
the country. From 1968 to 1975, mining activity increased astronomically,
and mineral claims requested from the government jumped from 2,000
to over 20,000 in 1975.[10] The map on the following page depicted impor-
tant topographic features, including rivers and ports of entry, as well as
information on where agricultural and industrial activity could be found.
It is clear that the inclusion of rivers, which could be used for the trans-
port of materials, was strategic and meant to illustrate the ease with which

commodities could be exported from the region. Below the maps, the text "ESTA É A HORA E A VEZ DA AMAZÔNIA," in capital letters, or "Now is the moment of the Amazon," emphasized the message. What is of particular relevance about these illustrations in the pamphlet is that SUDAM referenced the symbolism deployed in sixteenth-century colonial maps of Brazil. The maps featured in this pamphlet, as well as the propaganda they were disseminating, alluded to European visual representations of Brazilian territory created after the Portuguese explorer Pedro Álvares Cabral's first encounter with it in 1500. For example, the conflation of the land with the goods it produces witnessed an early iteration in *Cantino's Planisphere* (1502), the first map to use the name Brazil to identify the Portuguese territory in the New World.[11] Cantino's map depicted the expedition to find Pau-Brasil, or Brazilwood, a tree species known for the red dye it produces, a highly sought-after commodity and, more importantly, the reason for naming the territory Brazil.[12] A later map from 1519, the *Carta do Brasil* from the *Miller Atlas*, by the Portuguese cartographer Lopo Homem-Reinéis, more widely known for its comprehensive illustration of geographic names along the Brazilian coast, also focused attention on Brazilwood, abundant along the coast, as a vital commodity (figure 52). The map depicted a group of indigenous people harvesting Brazilwood and preparing it for export to Europe, a loaded image that signified the symbolic clearing of the territory for the new inhabitants through deforestation, setting the precedent for future exploits of the region. The echo of these two widely known maps—depictions of Brazilian territories in terms of the commercial potential of its raw materials—in SUDAM's pamphlet highlighted not only the colonial nature of the military regime's incursion into the Amazon but also its conspicuous economic interests in the region. Any doubts about the role of the military's intentions in the Amazon were erased when a prominent government minister declared: "Brazil has resolved to accept the Amazon challenge and is going to occupy and exploit the area."[13]

One of the reasons that Cantino's map would have been familiar to Brazilians was because it appeared on a cruzeiro banknote in 1972.[14] The bill, known by the title Evolução étnica, or Ethnic Evolution, illustrated, from right to left, Brazil's "progress" through five historical and profoundly Eurocentric stages of development (discovery, commerce, colonization, independence, and integration), each corresponding to a different map. The last stage, integration, is depicted by a series of intersecting lines, graphically uniting all the territories.[15] The matrix of lines has a double meaning; not only do they symbolically link the different regions of Brazil's territories, but they also represent the ever-expanding national highway system then under construction.[16]

Yet, there is one important distinction between SUDAM's map (and the whole pamphlet for that matter) and the sixteenth-century *Carta do Bra-*

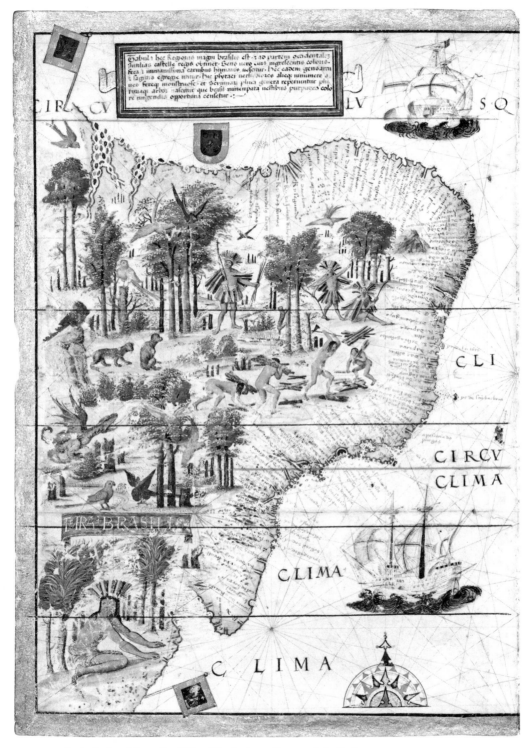

FIGURE 52. *Carta do Brasil* from the *Miller Atlas* by Lopo Homem-Reinéis, from 1519.
Courtesy of La Bibliothèque nationale de France.

sil: the conspicuous absence of any reference to the many indigenous tribes inhabiting the lands where the raw materials and minerals were found. While it is not unusual for maps not to feature people or references to them, the territory depicted in the pamphlet comprised predominantly indigenous territories. While all manner of detail about the area is included in the pamphlet—there are sections devoted to transport, energy, telecommunications, health, and education—there is no mention of any indigenous groups living there. The omission of any reference to the tribes was particularly notable, considering the publication of a 1967 report detailing scandalous instances of corruption and atrocities, which included murder cases and torture, regularly acted out against the more than 397 indigenous groups living in the Amazon. This report, compiled by a public attorney, Jáder Figueiredo, and accusing the Indian Protection Service (Serviço de Proteção ao Índio, or SPI) of these atrocities, was well publicized in both national and international media sources in 1968. Even more shocking was the fact that the crimes were perpetrated by the agency created to protect these groups, the SPI.[17] The cause for many of the violent incidents was the unwillingness of the indigenous people to cede the territory they inhabited for the economic interests of lumber and cattle barons. Indeed, much of the land that was bought and sold in the Amazon was done so without any legal certainty about who owned it. A number of cases in the media at the time described the tensions and culture shocks between the "hostile Indians" and the land speculators. The absence of affected groups on SUDAM's maps was one way to prevent concerns that the indigenous people would "get in the way," a sentiment echoed by President Médici's minister of the interior, José Costa Cavalcanti, who declared: "We will take all precautions with the Indians, but we will not allow them to hamper the advance of progress."[18] Just as during the colonial period, progress was conflated with development, the route toward civilization. Consider the call to "inundate the Amazon forest with civilization," proclaimed by General Golbery do Couto e Silva, the first chief of the intelligence service in 1964 and later chief of staff until 1981.[19] The general's overture is eerily reminiscent of the discourse from the civilizing missions during the early modern period justifying all nature of brutality and violence. As one physician working in the region during the 1970s expansion pointed out: "All my work as a doctor among the Indians of Brazil was oriented to a single idea: that the rapid process of civilizing the Indian is the most effective form of killing him."[20] This heady assessment by Dr. Noel Nutels, who had over twenty-five years of medical experience working with indigenous tribes in the Amazon, recalls the countless historical accounts of mistreatment of indigenous people that have proliferated since the colonial era. But it also highlights the contradiction and disconnect surrounding the state's purported goals of progress and order and the brutality used to attain them.

The friction surrounding the regime's mapping of the Amazon serves as a point of departure for investigating the social system of maps and its intersection with art by those Brazilian artists who incorporated a mapping impulse in their practice at this time. Artists not only negotiated Brazil's colonial history of mapping but also positioned their work as a critique of exploitative interests from both the past and the present. Unlike the other systems addressed in this book, currency, newspapers, and television, maps and their design have long been dependent on anonymous artistic labor. However, the artists discussed in this chapter were not just the unnamed designers of maps; rather, they worked as the conceptual architects of spatial and territorial representation. While the scholarship on mapping and its historical impact in the New World is well-charted terrain, there is still a dearth of studies on the mapping impulse in the work of artists, despite its ubiquity in artistic practice throughout the twentieth century, particularly in Latin America.[21] Joaquín Torres García's *Inverted Map of South America*, from 1943, is one of the most widely known and cited examples in this vein.[22] Based on his manifesto for the "School of the South" (1935), *Inverted Map* urged South American artists to stop looking north for inspiration, inverting the more traditional north-to-south routes of influence and repositioning the south as the point of origin for artistic experimentation.[23]

Other artists have worked with printed maps as ready-made objects, redesigning mapping conventions to meet particular ideological needs. For example, under the authoritarian regimes dominating the Southern Cone countries of South America from the 1960s to the 1980s, artists like Horacio Zabala (b. 1943) from Argentina employed maps to bring attention to the geographical sites where abuses of power were taking place but where citizens were prevented from speaking out, particularly through more direct print media sources. In the hands of artists, maps were often allegories, symbols for signaling local violence to the world.[24] In the remainder of this chapter, I examine three variations of mapping projects in the work of Cildo Meireles, Anna Bella Geiger, and Sonia Andrade, all of whom incorporate and transgress mapping conventions.

MAPPING AND THE INDEX: CILDO MEIRELES'S *PHYSICAL ART*

In his salient analysis of cartography and power in New Spain, the historian Raymond Craib argued that European mapping and naming practices codified the landscape as their own, replacing ambiguity with a spatial order and thus allowing colonization to take place.[25] The conceit of colonial European mapping strategies and the inability of a map to accurately portray geographical complexity are taken to task in Cildo Meireles's *Arte física* (*Physical Art*), a series of graphic works and installations that position conceived space—that is, the map—in tension with lived space, or the daily, capricious, and unconventional uses of it.[26] I turn first to an unfinished

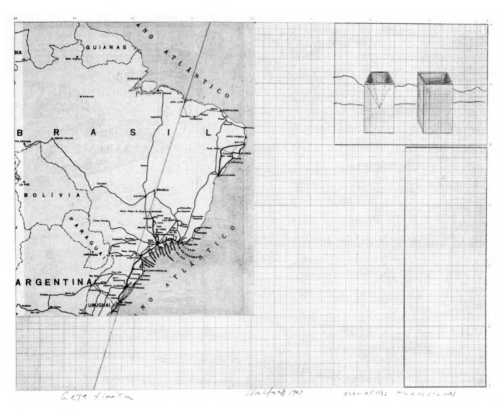

project within the *Physical Art* series, a graphic proposal entitled *Marcos: Tordesilhas* (1969) in which the artist conceived of re-creating the demarcation created by the Treaty of Tordesillas, unquestionably one of the most important foundational documents in Latin American history (figure 53). Signed in 1494, the Treaty of Tordesillas was the first to geographically delineate the division between Spanish and Portuguese territories in the New World before Cabral's encounter with the land that would become Brazil in 1500. Having preceded the Portuguese arrival to Brazil, the treaty itself was a fraught document that underwent a number of modifications throughout the centuries, with the line dividing the Portuguese territory moving progressively west. Despite the presence of the treaty, boundary disputes around the Brazilian border continued between the neighboring republics well after their independence from Spain and into the twentieth century.[27]

In *Arte física: Marcos: Tordesilhas*, often translated as *Marks: Tordesilhas* (although the Portuguese *marcos* can also refer to landmarks or boundaries), the artist's proposal is laid out on graph paper, which stands in for the graticule, a grid of intersecting longitude and latitude lines used in making maps.[28] A map of Brazil is collaged onto the surface of the graph (the fact that it includes Brasília suggests that it was a map created after 1960) but provides no topographical detail, listing only the names of cities

and countries bordering Brazil. A diagonal, straight red line, traversing the map and extending out onto the graph paper, represents the borderline enacted by the Treaty of Tordesillas. Meireles's proposal was to physically trace the territory partitioned by the treaty by walking along it and marking it with a red line, made of either wire or string; this trek would take him from the city of Laguna in the southern state of Santa Catarina to the northern state of Amapá.[29] With this proposal, Meireles conceptualizes the kind of physical encounter with territories that is difficult to register on a map, identifying the body, and not mapping technology, as the compass. Though never realized, the work *Marks: Tordesilhas* foregrounded not only the arbitrary ways in which land was (and continues to be) partitioned but also the complications of using a line or grid to represent topographic complexity—not to mention the diversity of the inhabitants—of a territory.

Among other works that probe the tension between space and its cartographic representation is Meireles's *Arte física: Cordões/30 km de linha estendidos (Cords/30 km of Extended Line)*, also from 1969 (figure 54). In *Cords*, Meireles used industrial string, which he extended along 30 kilometers of coastline in Paraty, a town located in the state of Rio de Janeiro.[30] He then collected the string, which looked like a tangled mass of cotton, and exhibited the jumbled ball of string inside an old wooden box. On the top half of the box he placed a map of the state of Rio de Janeiro, with the site that he had partitioned off circled in pen. As these projects have demonstrated, Meireles sought to challenge the linear representation of space as it is depicted in mass-produced maps by exploring instead the physical configuration of cartographic coordinates. In *Cords*, Meireles's knotted mass is in fact a more accurate representation of the geographical and physical reality of the area, challenging the primacy of maps in representing space. Moreover, if one makes the conceptual leap from tangled mass to a tangled mess (it works with the Portuguese word for both, *emaranhado*, as well), then one encounters a subtle if not humorous jab at the state of Brazilian geography.

The performative element embedded in the work, that is, the fact that the artist physically walked the area that was to be represented, begs a number of considerations. The act of walking so as to fix a boundary line, for example, aligned Meireles's work with that of land surveyors who were employed to determine the peripheries of particular territories. Such an act brings to mind the political consequences of surveying territories, which in the case of the Amazon resulted in ongoing strife for the livelihood of its indigenous inhabitants. However, what is unique about the military's mapping of the Amazon during the 1970s was that it was based on aerial photographic surveys, without any physical familiarity with the region's topography. Thus decisions about where to carve out the Trans-Amazon Highway were based on data, making it untroublesome for the state to de-

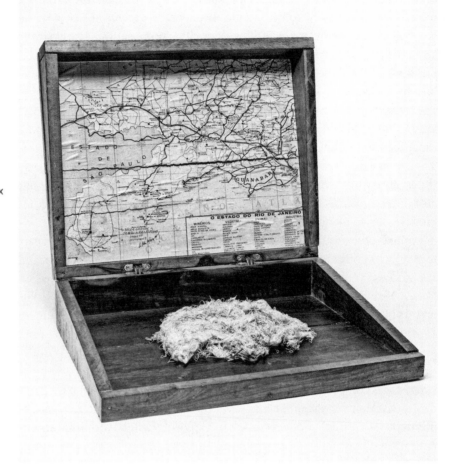

clare that in addition to the land claimed for the construction, it would also partition 100-kilometer stretches of land on each side of the highway, from north to south, to be used for relocating impoverished settlers from the Northeast. As a result, when it came time for the construction of the highway, one of the major hurdles the regime encountered was hostility from people affected by the partitioning of this vast territory. Newspapers and news programs broadcast a number of instances in which indigenous people, portrayed as resisting modernity and civilization rather than as protecting their rightful territories, injured highway construction workers. In one newspaper article, for example, indigenous tribes were depicted as attacking the workers with bows and arrows, symbols of backwardness and savagery dating back to colonial depictions. Despite the fact that the indigenous tribes were ruthlessly encroached upon, their resistance to the military occupation gave rise to unthinkable brutality and violence, which included rampant murder, pillaging, and cases of rape, not to mention exposure to viruses and sexually transmitted diseases that extinguished many

communities. Though the FUNAI agency was engaged to mediate between the indigenous groups and the regime's presence in the region, the director of FUNAI at the time, Antônio Cotrim Soares, publicly resigned over what he declared was a one-sided imposition of the government needs onto the people living in the Amazon. In an unusually candid interview published in *Veja*, Cotrim stated that the major problem was that all the decisions and planning for the regime's project were made in Brasília, without any attention to the peculiarities of each tribe or the critical regional differences.[31] He cited, for example, the fact that indigenous groups displaced by the construction were divided, with sectors of the population later resettled alongside enemy tribes. Cotrim's assessment highlights how catastrophic the repercussions of land surveys can be when based on data culled from satellites.

Meireles, who had commented on the shocking treatment of the Amazon's indigenous people in other works (see chapter 1), would likely have been aware of the regime's operations in the area. Though Meireles has never claimed that he was directly responding to the military occupation, his work suggests a reorientation away from the convention of mapping and its reliance on navigational tools, including the newly expanded satellite technology, toward mapping strategies that are mediated by an individual experience and a physical body. In Meireles's work, for example, it is the physical relationship with the land that is foregrounded *as* the mapping procedure. The cord that is exhibited is indexical of the object it is representing through the physical connection it had established with the 30 km stretch of land on the coastline it had touched. The art historian Rosalind Krauss, in her well-known essay on American art of the 1970s, identified the index as a dominant feature of the diversified art practices defining the decade in question. Within a semiotic reading that privileged the Peircean theory of signs, Krauss explained that "indexes establish their meaning along the axis of a physical relationship to their referents. They are the marks or traces of a particular cause, and that cause is the thing to which they refer, the object they signify."[32] I would argue that the indexical relationship registered by Meireles's physical presence in the representation of the boundary line, both in his conceptual proposal *Marks: Tordesilhas* and in *Cords/30 km of Extended Line*, a project he carried out, differentiated his mapping procedure not only from historical maps depicting Brazilian territories but also from the maps of the Amazon created by agencies such as SUDAM that were circulating at this time. While he incorporated the basic tenets of conventional cartography, that is, tracing, surveying, and representing land, the artist also inserted his own body into the action, resulting in a mapping practice that was dependent on his physical experience of space.

Meireles's inquiry into geographic configuration continued with an-

FIGURE 55.
Cildo Meireles,
Mutações
geográficas:
Fronteira Rio-
São Paulo
(Geographical
Mutations:
Rio-São Paulo
Border). Leather
case and dirt,
16.5 x 16.5 x
16.5 in. Courtesy
of Fundação
de Serralves—
Museu de Arte
Contemporânea,
Porto, Portugal.

other closely related series, *Mutações geográficas* (*Geographical Mutations*), which the artist described as "a confrontation between man and territory, the relationship that constitutes this country or state."[33] In the works composing this series, the artist sought to physically mutate or transform Brazilian territories by proposing actions such as physically moving mountains or shifting boundaries. A telling work from this series is *Fronteira Rio-São Paulo* (*Rio-São Paulo Border*) from November of 1969 (figure 55). As implied by the title, the work took place along the border of two neighboring cities, Paraty (just as in the *Cords* project) in the state of Rio de Janeiro, and Cunha, a small colonial city in São Paulo. The first stage of the work involved digging an identical hole on each side of the border. The contents of the excavation, which included the soil and its debris, were then placed into a square black leather carrying case, which was divided by a diagonal partition separating the case into two triangular sides, imitating the existent boundary between the two states. The rather large leather carrying case, 2 feet high and wide, resembled a suitcase, or a big briefcase, the kind that would be used to transport official documents. On each side of the diagonal border, Meireles also created smaller square compartments facing

each other, into which he placed the soil he had originally dug up from the opposing sides of the border. The resulting symmetry between both sides of the diagonal line made it impossible to distinguish the origin of the soil on each side. Meireles explained that the case he had originally used for this work was made of uncured leather, which began to decay from rain and humidity.[34] By the end of 1969, he had made the definitive suitcase, with a clasp to shut it closed and handles on each side. In this work, Meireles paired two seemingly opposing concepts: on the one hand, the suitcase and its association with travel and itinerancy, and on the other, dirt taken from a border site often taken for granted as an immutable and fixed feature of a landscape. This juxtaposition instead suggested the borderline as something not only portable but also mutable, which was more faithful to the national and international events that were constantly reshaping the physical and conceptual boundaries of territories and thus people's spatial imaginary.

Another distinctive, albeit unacknowledged, feature of this work is how it staged the regional differences between the states of São Paulo and Rio. Though the physical properties inside the case look the same, with one side identically mirroring the other, the doubling obscures an enduring rivalry between artists from the two states. One of the points for the enduring antagonism had to do with the separation of the Rio-based neoconcrete group from the São Paulo-based concrete group, both of which were formed by artists, poets, musicians, architects, and designers. The parting of ways between the two groups was first publicly announced in a manifesto published in the Sunday supplement of the *Jornal do Brasil* newspaper on March 23, 1959, and the most significant reason for the rupture hinged on the role of the body in art. The manifesto highlighted the Rio group's commitment to a more intuitive way of working, emphasizing experimentation, the body, and freedom in art. They accused the São Paulo group of being overly dogmatic, rational, and mechanical in their approach to artistic creation. Neoconcretists encouraged the creation of artistic environments that summoned the viewer's senses to participate in an array of phenomenal experiences. Ronaldo Brito, one of the leading scholars on the topic, described the theoretical transition as one that moved away from the concretist emphasis on Peircean semiotics and Norbert Wiener's information theory to the more speculative and phenomenological philosophy of Merleau Ponty.[35] Following the separation of the two groups, a back-and-forth exchange of publications was launched, in which each side defended the superiority of their position, and the resulting conflict persists today.[36] Meireles, who moved to Rio in 1969, was more closely aligned with and regularly exhibited with the community of artists residing there, and it is clear from this work that he embraced many of the tenets heralded by the neoconcretists. But in *Rio-São Paulo Border*, he appears to be challenging

the regional divide by literally and physically leveling out the differences. In fact, despite the declared separation, there was and continues to be a significant exchange of ideas between the artists in the two states, suggesting that the boundary has worn thinner, and just like the original uncured leather case that Meireles had conceived of for *Rio-São Paulo Border*, has begun to erode.

Although I have identified Meireles's *Physical Art* and *Geographical Mutations* as exhibiting a mapping impulse particular to Brazil's political and social context, these two works have most often been included in exhibitions devoted to land art, an art movement that emerged synchronously within a number of international contexts but perhaps most visibly in the United States.[37] There is unquestionably an affinity between Meireles's projects and those of artists associated with land art (also referred to as earthworks, among other labels), particularly in the conceptual nature of his approach to space, distance, and the critical apparatuses of mapping.[38] The exhibit *Do corpo à terra* (*From Body to Earth*), a three-day event organized by Frederico Morais in April of 1970, supported the concurrence of ideas surrounding the artistic turn to land in Brazil.[39] Held in Belo Horizonte, the capital city of the state of Minas Gerais, *From Body to Earth* staged the artworks in places people frequently gathered within the city: the Parque Municipal, a park; the Serra do Curral, a mountain range; and the Riberão Arrudas, a river. The event accompanied the exhibition *Objeto e participação* (*Object and Participation*) taking place at the Palace of Arts. However, *From Body to Earth* encouraged leaving the museum for the street, part of a more widespread turn away from art objects on display in institutional settings to artworks incorporated into experiences of everyday life. The works included in *From Body to Earth* occupied publicly transited spaces in an effort to engage broader audiences, but within the political climate of the day, this also meant raising the political risks of the work. In fact, police intervention was recorded in a number of instances during the event. So while the works in *From Body to Earth* displayed a shared artistic vocabulary with earthworks associated with land art, they were also more politically incisive and contextually bound. Meireles himself has acknowledged the likeness between his works and those within land art, but he has also claimed that he was interested in the contextual information of the site he was working on, more so than other artists working with land art. For example, rather than create a straight line in a landscape, he invoked the specific history of the line (the motive for his *Tordesilhas* project) or regional boundaries and their attendant identities (as in *Geographical Mutations*).[40] When looked at through the system of maps, works by artists exhibiting a mapping impulse as well as a turn toward the land reveal the nuances of Brazil's unique colonial history with mapping and the regime's expansionist politics in the

Amazon during the 1970s, bringing into sharper focus the political as well as the aesthetic stakes of their work.

SPACE AND PLACE IN ANNA BELLA GEIGER'S
ELEMENTARY MAPS

Cildo Meireles's work with maps was guided by a critique of the historical operation of mapping, identifying the underlining tensions between conceived and lived space. The work of artist Anna Bella Geiger, whose oeuvre with maps is by far the most far ranging within contemporary Brazilian art, is also critical of the foundations of the historical procedure of mapping.[41] Though her work with different mapping strategies has spanned decades and a wide range of media, in this chapter I focus on a series of artist videos known as *Mapas elementares* (*Elementary Maps*). The series comprises two short videos, *Mapas elementares 1* (1976, 3 minutes) and *Mapas elementares 3* (1977, 10 minutes), both of which reorient and recode mapping away from its conventional use as a tool for marking and depicting space.[42] The fact that both were made using video, a time-based medium, is of significance, emphasizing the mapping procedure as one that is continually in progress and in the making. With *Elementary Maps*, Geiger positioned the operation of charting space as not only organizing a priori knowledge but also as a conceptual exercise linked to the mapmaker's vision, and thus intimately dependent on the artist's hand and intention.

Geiger begins *Elementary Maps 1* by drawing the outline of a world map on paper, a generic, quickly sketched version of the mappa mundi (figure 56). Geiger's activity is accompanied by the musician Chico Buarque's well-known song "Meu caro amigo," released the same year Geiger's work was made. In the song, the author sends news to his friend Augusto Boal, one of Brazil's most renowned theater directors and writers, who was living in exile in Europe at the time. Boal's social activism drew ire from the regime, and he was detained, tortured, and exiled to Argentina.[43] After multiple threats from the dictatorship, Buarque had also left Brazil in 1970, though he returned shortly after, in 1971, despite continued run-ins with the regime about the polemic nature of his songs, many of which were censored. The deceptively upbeat rhythm of "Meu caro amigo" belies its highly critical content. Mixed into the lyrics in which Buarque recounts the banalities of everyday life in Rio (soccer, samba, music, rain, and sun) are statements such as "What I really want to tell you is that things here are black," an allusion to the dark circumstances surrounding the heightened violence, censorship, and human rights violations marking the regime at that time. Buarque's refrain serves to prompt Geiger, who, as if on cue, begins to blacken the contoured outline of Brazil on her map. The musician's letter to his friend is thus performed in Geiger's depiction of the mappa mundi,

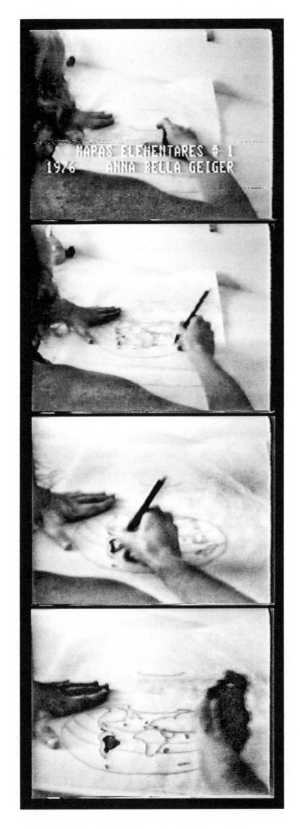

FIGURE 56. Anna Bella Geiger, *Mapas elementares 1* (*Elementary Maps 1*), 1976. Video stills. Camera work by Davi Geiger. Courtesy of the artist.

uniting the two disparate compositions into an alternative and certainly more critical mode of communication. Both the song and the map collaborate in getting across the message of a letter, acknowledging not only the exile of important cultural figures during this time but also other hardships of living in Brazil. Consider, for example, Buarque's refrain "Without *cachaça* no one can withstand this time bomb."[44] The musician also directly alludes to the prevalence of censorship with the words "I wanted to write you, but the mail is a risk." The selection of Buarque's song was no doubt strategic, allowing Geiger to embed his critique of the dictatorship into the operation of mapping. The musician and the artist together highlight the difficulties of conventional modes of communication: Buarque avoids the postal service and the telephone, while the artist proposes a symbolic visualization of the distances, both literal and conceptual, one has to go to overcome barriers to communication.

Recasting the mappa mundi in this way, Geiger positions Brazil as a site of trauma, indicating a void where Brazilian territory would normally be located. Unlike the tradition of mappae mundi, however, nothing else on the map is identified, either through text or otherwise. Instead, viewers are expected to rely on their existent knowledge of continental contours to get their geographical bearings. This is not difficult to do, given the prevalence of world maps for orienting one's spatial understanding. But Geiger's map refuses to fulfill the expected operation of a map, that is, identifying a place, and instead identifies a void. The negated space invokes a number of possible interpretations, none of which, however, support the optimism accompanying the new mapping practices and expansionist operations performed by the regime, both in the Amazon and elsewhere. If anything, the blackening of Brazil recalls satellite images of deforestations resulting from the occupation of the space for the construction of the Trans-Amazon Highway.

In *Elementary Maps 3*, Geiger once again uniquely tackles continental identity, but this time by summoning icons that draw on Brazil's racial and gendered history (figure 57). The video begins with the artist's disembodied hand drawing the shape of a clenched fist, which she then labels *Amuleto*, or amulet. Beside it, Geiger shifts the contour for a similar conical form, which she then fills in with facial features and labels *A mulata*. The form of a crutch follows, designated *A muleta*, and finally, the continental shape of South America, labeled *Am. Latina*. This time, the artist's activity is accompanied by an upbeat Argentinean bolero entitled "Virgen negra." The camera, as if reading the text, spans the four crudely drawn shapes from left to right, and it is clear that the cone-like forms are related through the phonetic resemblance of their labels. The fluid transitions between the four objects depicted suggest the connection and mutability between the four linguistic and geographic constructions. This taxonomic procedure, which is meant to impose spatial order, is organized in Geiger's work

FIGURE 57.
Anna Bella
Geiger, *Mapas
elementares 3
(Elementary
Maps 3)*, 1976.
Video stills.
Camera work
by Davi Geiger.
Courtesy of
the artist.

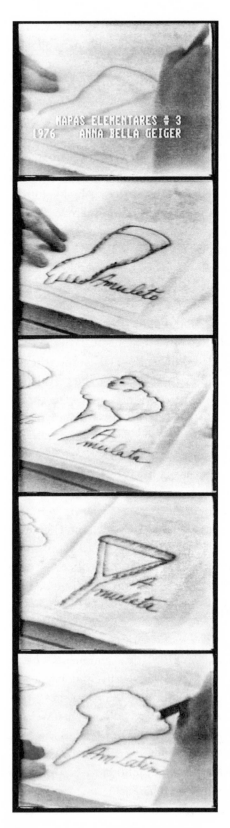

around what initially appears to be an arbitrary semiotic affinity, symbolically transforming space into a place with history.[45] Additionally, the playful textual and phonetic manipulation of *Amuleto, A mulata, A muleta,* and *Am. Latina* recalls strategies used by Brazilian concrete poets.[46]

Despite their widely different meanings, together the four cone-like contours she has drawn uniquely recast Latin America's identity through a gendered and racial lens. The first object we see, for example, is a popular amulet in the shape of a clenched fist (*"figa"* in Portuguese), an object with wide-ranging signification and strong ties to African religions. Brought over by African slaves to Brazil, amulets were often carved out of wood or stone and worn as jewelry, functioning as good luck shields and protecting their owners from the evil eye and illness.[47] Amulets figure prominently in folk art, and their prevalence in Brazilian culture at large speaks to the strength of African cultural traditions in the formation of Brazilian identity and Latin American identity more broadly. The clenched fist is also associated with sexuality and fertility.[48] These characteristics are also often invoked by the second figure Geiger composes, the figure of the mulatta, which is one of the more visible icons of Brazilian history. Symbolic of Brazil's complex ethnic composition, the mulatta attests to an irrefutably traumatic colonial past while sustaining the

notion of Brazil as a racial democracy. The image of the mulatta became particularly prominent during the twentieth century in the work of leading Brazilian modernist artists such as Emiliano di Cavalcanti, Tarsila do Amaral, Cândido Portinari, and Alfredo Volpi, all of whom are often evoked as having mastered a uniquely Brazilian sensibility and aesthetic. The mulatta is also steeped in sexuality and mythologized in a number of novels, including, for example, *Gabriela, cravo e canela* (*Gabriela, Clove and Cinnamon,* 1975) by Jorge Amado, one of Brazil's most prolific writers. She is also one of the most sought-out figures in Carnival, a wildly popular annual cultural parade, where her exaggerated, exoticized sexuality is on constant public display. The strategic placement of the crutch in between the figure of the mulatta and Latin America could hardly have been coincidental. It has long been known that while the mulatta is sexually desired in Brazilian culture, her identity serves as a crutch to aspirations outside of the erotic domain. Consider, for example, the well-known Brazilian saying "A white woman to marry, a mulatta to screw, and a black woman to work." Though this is clearly a racial taxonomy that few people take seriously, it has still survived in the popular imagination from the colonial era and time of slavery and is one that is promulgated in the popular culture circulating in (and about) Brazilian Carnival, as well as in popular soap operas, cinema, and novels.

The proximity of the crutch, a prop used to help and support the disabled, next to Latin America (in actuality the form she sketched is of South America) also suggests the continent's subaltern position and was likely a critical jab at the region's historical reliance on foreign economic and political aid and, more significantly, on external artistic models. Additionally, this juxtaposition implies that Latin American identity is closely imbricated with, and even dependent on, the history of (often violent) miscegenation, a crutch for the continent to bear.

Geiger's investigations into identity politics in her work were likely motivated by ongoing discussions, in Brazil as elsewhere, regarding Latin American identity within the arts at this time. A number of prominent critics and art historians from Latin America, among them Aracy Amaral, Frederico Morais, Marta Traba, Juan Acha, and Damián Bayón, were involved in symposia, exhibitions, and publications attending to the question of how to situate the Latin American artist.[49] The Brazilian art historian Aracy Amaral was a prominent voice in these discussions, both during the 1970s as well as today. Though she negated the idea that there were specific, identifiable traits in Latin American art, she did assert that there was a difference between those artists living in Europe and North America, who, she wrote, "have nothing to do with our mestizo culture," and further, "Latin America is a society of mestizos and in process of miscegenation."[50] In 1976, the São Paulo Biennial Foundation began to conceptualize its first-ever Bienal Latino-Americana de São Paulo, which eventually took place in November

of 1978. In addition to artworks, the organizers also proposed a documentation section in which the theme "Myth and Magic" would be explored in four proposed categories, one of which was miscegenation.[51]

Certainly in Geiger's *Elementary Maps 3*, the question of miscegenation is approached through a variety of angles, interrogating its semantic and symbolic contours while also including an aural lens, with the song playing in the background—a bolero popular throughout Latin America, entitled "Virgen negra" (Black Virgin). The black virgin, common in countries with large populations of African descent, refers to the dark-skinned Virgin Mary revered in many parts of Latin America. In the song, the Virgin is prayed to by devotees to help cure problems that have been troubling them. In Brazil, the dark-skinned Virgin is known as Our Lady of Aparecida (Nossa Senhora da Conceição Aparecida) and she was declared the patron saint of Brazil. The fact that the artist foregrounds the mulatta and the Black Virgin alongside the landmass that she labels Latin America inscribes the importance of the African female subject in the conception of this territory. Despite the critical tone connoted by the crutch among the other mutating silhouettes, the metamorphosis these forms undergo as their contours transform suggests their capacity to overcome bounded linguistic, if not territorial, categories.

Elementary Maps 3 was one of many works in Geiger's oeuvre in which she interrogated gender, racial, national, and continental identity, and it complements another compelling work by Geiger probing the contours of Brazil's "other." Her *Brasil nativo/Brasil alienígena* (*Native Brazil/Alien Brazil*), also from 1977, comprised a series of eighteen postcards, nine of which were of indigenous people in their environment within the Amazon basin, and the other nine, of the artist restaging the original scene in her own apartment in Rio de Janeiro (figure 58). Geiger bought the postcards she used in the work at one of the many news kiosks one finds throughout Brazil, where people can buy newspapers, magazines, and books as well as all kinds of trinkets and souvenirs. Geiger recounts that these kinds of postcards had begun to surface everywhere during the 1970s, depicting the people living in the Amazon in what she described as an exoticized way, and labeling them on the other side as "Native Brazil." This led the artist to probe the category of "native." The series of postcards attempts to undermine, or destabilize, the binary presented between "native" and "alien" by returning the ethnographic gaze directed at the indigenous people onto herself (figure 59). The nine postcards featuring the artist and others close to her approximate the scenarios of the originals and follow their color palette—varying between black and white and color.[52] In its entirety, the work presents Brazilian identity, both native and otherwise, as a flexible category that is not so much defined by place or ethnicity as by who claims the right to depict it. The range of situations presented in the original "native" scenes—

which include a group of people sitting down, someone sweeping, a person looking in a mirror, and, worse, the clichéd image of an indigenous man shooting a bow and arrow—become commonplace rather than markers of difference. Further, in Geiger's deliberate and sometimes comical restaging of the native scenes, it becomes apparent just how orchestrated the originals were. The proliferation of this kind of postcard was certainly related to the government's integrationist policies in the Amazon, allowing urbanites to easily and inexpensively collect tourist souvenirs of the "alien" territories without leaving the comfort of their city.[53] This quite literally brought a slice of the Amazonian territories and its people into thousands of homes, making the Amazon a material reality for Brazilians. Additionally, the indigenous people depicted on the postcards seem happy, smiling, and inviting, refuting the news about violent clashes resulting from the regime's encroachment on their territory. The fact that the artist puts herself in the place of the "native" Brazilians, highlighting, albeit ironically, her own identity as a European descendant, inevitably comments on the ways in which identity is not only choreographed but is also performed for specific audiences to meet political or national agendas.

Geiger's work with maps resemanticizes the physical landmass that is Latin America and

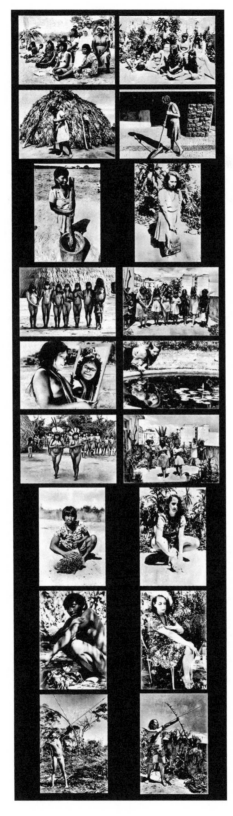

FIGURE 58. Anna Bella Geiger, *Brasil nativo/Brasil alienígena* (*Native Brazil/ Alien Brazil*), 1977. Series of nine pairs of postcards. Courtesy of the artist.

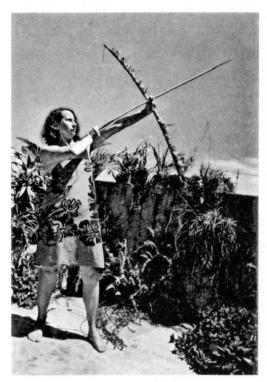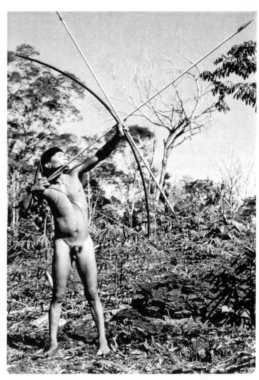

Brazil as well as the symbolically charged lexicon used to identify its people. With both *Elementary Maps*, Geiger, like Meireles, generates an alternative cartography in which space is mapped through a complex layering of historical, semantic, and social matrices and their intersection with place.

THE UNCONTAINED GRID IN SONIA ANDRADE'S *THE WORK/ THE SPECTACLE/THE PATHS/THE DWELLERS*

If Cildo Meireles's *Geographical Mutations* explored regional identity and Anna Bella Geiger's *Elementary Maps* series reflected on Brazil's national identity, then Sonia Andrade's *A obra/O espetáculo/Os caminhos/ Os habitantes* (*The Work/The Spectacle/The Paths/The Dwellers*) examined urban identity, particularly in São Paulo. To do so, Andrade conceived of a seemingly imaginary network that was capable of bridging geographic distances as well as diverse historical temporalities (figures 60 and 61). In 1977, concurrent to Geiger's work with postcards, Andrade (whose work with video was discussed at length in chapter 3) completed a work that also involved the use of postcards, among other media, *The Work/The Spectacle/The Paths/The Dwellers*. When it was first exhibited at the XIV International São Paulo Biennial in 1977, it was untitled, but it now goes by the title of the different operations involved therein. Exhibiting at the São Paulo Biennial at this time was a complicated undertaking, which involved breaking the boycott instituted in 1969 by politically committed Brazilian

FIGURE 60.
Sonia Andrade,
A obra/
O espetáculo/
Os caminhos/
Os habitantes
(*The Work/*
The Spectacle/
The Paths/The
Dwellers), 1977.
Installation
shot. Courtesy
of the artist.

artists and writers.[54] In her essay on the state of the São Paulo Biennial during the 1970s, the art historian Isobel Whitelegg has clarified that "refusal to participate in a vehicle for national pride and political expediency was seen by artists and other art professionals as an effective response to the intensification of state repression under the governments of Artur da Costa e Silva (1967–69) and Garrastazu Médici."[55] At the same time, frustration was growing about the lack of exhibition venues for artists seeking a broader international audience for their work outside of museums, galleries, and other market-oriented venues. The gallery system was largely resistant to exhibiting more experimental, conceptual works that were politically charged, and many of the artists working in this mode intentionally sought to eschew the more blatant commercial objectives associated with the art market. Aside from the São Paulo Biennial, few other options existed for the conceptually minded artist; among them were the Museum of Modern Art in Rio and São Paulo and the Museum of Contemporary Art at the University of São Paulo (MAC-USP), which hosted international exhibits such as *Prospectiva 74*, *Poéticas Visuais* (1977), and the annual *Jovem Arte Contemporânea* (Young Contemporary Art) exhibits, which began in 1963 but ended by 1974.[56]

While participating in the São Paulo Biennial was politically fraught, much of the energy around the boycott had dissipated by 1977. Whitelegg also pointed out that by then, the Biennial had adapted to include politi-

cal criticism, displaying such loaded works as *The Torturer* (Roberto Páez, 1973) and *Censorship—Violence* (Juan Bercetche, 1973).[57] Additionally, in 1975, Francisco Matarazzo retired as the director of the Biennial, which undoubtedly affected its organization, since he was often critiqued for his "dictatorial tendencies" with regard to the selection and display of the works.[58] The 1977 Biennial, for example, shifted away from organizing around national identity and instead introduced seven thematic categories that the committee identified as best representing contemporary art of the moment. The roster of exhibiting artists included a significant number of Brazilian as well as other prominent international artists. The categories chosen to organize the work in this Biennial were directly related to the mapping impulse that has been elaborated in this chapter, which suggests that it was a dominant tendency at this time. Among the categories were Archaeology of the Urban, Recuperation of Landscape, Catastrophic Art, and Spatial Poetry. All four addressed the ethos of construction, destruction, and reconstruction, both urban and rural, with the objective of reflecting on how space and its configuration reverberate in artistic propositions. In addition to the thematic selections, the committee also decided that video art, which included works of a documentary nature as well as aesthetic and conceptual experiments with the medium, be displayed under its own category.

Curiously, Andrade's *The Work/The Spectacle/The Paths/The Dwellers* was included in a category titled simply Arte Não Catalogada (Uncata-

logued Art), dedicated to works that are not easily classified, or those without identifiable aesthetic criteria such as a single medium, style, or theme. Andrade's installation straddled multiple media and comprised a complex array of objects such as correspondence, photographs, xeroxed copies, a road map of São Paulo from 1923, and postcards, as well as their documentation through video. The lengthy title of the work evidences an attempt to classify itself, joining signifiers from the world of art with those drawn from everyday life.

The first grouping, *The Work*, is based on the correspondence that details the inclusion of this piece in the Biennial alongside a collection of postcards (figure 62). The correspondence is hung on the wall and begins with a letter to Luiz Fernando Rodrigues Alves, the vice president of the Biennial's foundation, explaining what the work would entail, followed by his reply of acceptance. The letters are then interspersed with the display of a series of postcards, chosen from a collection of four hundred, which dominate the space of the wall.[59] By including her correspondence with the Biennial, Andrade acknowledged the institutional and bureaucratic foundation that is at the work's inception. The postcards, objects associated with correspondence, represent landscapes, buildings, and chosen monuments from different cities in Brazil between 1900 and 1960. A number of postcards, for example, are devoted to Brasília, the new capital city inaugurated in 1960, showing its different stages of development and focusing on the ethos of construction. These are interspersed with more stereotypical images of Rio de Janeiro's or Cabo Frio's famous beaches, constituting a visual map of Brazil's most prominent landscapes.

For the Biennial exhibit, Andrade had sent the postcards to the residents of the cities represented on the image with the request that a current image of the site depicted be reproduced in the present time and sent back to the Biennial. The artist sent the postcards from the post office, where she randomly chose residents from a city directory compiled by the post office (much like a phone book).[60] Before the cards were sent out, they were first documented with a video recorder, and the resulting video was continually looped on a television monitor in a space Andrade titled *The Spectacle*. All letters returned in response to the artist's request, including both the envelope and the returned image, were also exhibited, creating a unique visual topology, mapping both the historical evolution of national tourist sites deemed worthy of postcard illustration as well as the passage, or circulation, of these representations through the circuits of Brazil's postal service.[61] When possible, the original older postcard is juxtaposed with its contemporary double, but in other instances, the relationship of one postcard to the other is more ambiguous if not arbitrary, suggesting the impossibility of a one-to-one ratio between the past and present sites. According to the artist, about 30 percent of the people contacted replied to her written re-

quest, and people did so in a variety of ways, some with a brief handwritten note, others through more formal typed letters. In one letter, the recipient asked why he had been selected for such a task, while others responded lamenting that they were not able to locate the exact site first represented. The inclusion of the envelopes communicates the administrative activity of the post office as the letter made its way to the Biennial. There are, for example, the postage stamps used (though in several instances there was a note stating that the stamp had been stolen in transit) as well as a variety of rubber stamps that identify the letters as official documents.

The inclusion of these administrative, bureaucratic insignia links this project to works discussed in previous chapters, such as the rubber stamps Cildo Meireles used in his currency project (chapter 1), or his *Insertions into Newspapers* (chapter 2), where he adapted the regime's bureaucratic procedures as a means of imbuing his work with an official attribute, one that he then proceeds to transgress. In this way, Andrade's *The Work* approximates the procedures in Cildo Meireles's series *Insertions into Ideological Circuits* and, in particular, his project with currency, in which he adapts the traditional circulation of everyday objects as the prevailing operation of the work. Like currency, postcards are activated through circulation. These postcards accrue meaning as they make their way through different institutional circuits, including the post office and the administrative offices of the Biennial, but also through contact with an unsuspecting audience, one randomly selected by virtue of a specific locale. This is where Andrade's work departs from Meireles's *Insertions*, for rather than attempting to transgress institutional circuits, Andrade embeds them into her aesthetic operation. Her work overlaps with the administrative processes circumscribing the

institutional procedures of the Biennial as well as the bureaucratic appara-
tus of the post office. Unlike Meireles's *Insertions*, Andrade's work does not
openly subvert the system of maps. It is significant, though, that while the
category of national identity had been eliminated for this Biennial in favor
of a more thematic approach, Andrade's piece went against the grain by
including a panorama of national icons, and then relegating such iconog-
raphy to the Uncatalogued category.

The Paths was represented by the display of a road map of São Paulo from
1923 (figure 63). Andrade indicated that the map should be displayed in a
transparent case that would be hung in the middle of the exhibit space so
that viewers could see both sides of it. On one side was a map of the state
of São Paulo published by Guia Levi, a well-known publisher of city maps
and train schedules. The map depicted not only the state of São Paulo but
also neighboring states and countries (those to the south) and the Atlantic
Ocean, giving the viewer a sense of the geographic spatial coordinates of the
region from the early 1920s. On the other side was a more detailed close-up
of the city center, flanked by two buildings the mapmaker deemed impor-
tant, one an official government residence for the prefect (*prefeitura mu-
nicipal*) and the second, a luxurious residence, one of many that had occu-
pied Avenida Higienópolis at the time.[62] The close-up is also accompanied
by an index that lists twelve major points of interest. On both sides Andrade
had marked out a series of paths in red, routes that she claimed highlighted
the alterations of urban space throughout the decades. One of the itineraries
highlighted was the path from Rio to São Paulo and more precisely to the
location of the Biennial. The map itself, an official record of the city's bound-
aries in the 1920s, was quite fragile, deteriorated from decades of storage;

FIGURE 63. Sonia Andrade, map from *A obra/O espetáculo/Os caminhos/Os habitantes*
(*The Work/The Spectacle/The Paths/The Dwellers*), 1977. 1923 Map of São Paulo courtesy of the artist.

it was suspended from the ceiling in an acrylic support, and it hung higher than the rest of the objects in the installation, commanding the viewer's attention. Its fragile, brittle state depleted its once reigning authority, a testament to the waning power of official documents in representing place.

The fact that the map is dated one year after the landmark event that is now considered the hallmark of Brazilian modernism, Semana da Arte Moderna (Modern Art Week), is significant. The events of Modern Art Week, which took place at the Teatro Municipal (one of the twelve sites highlighted by the index) in 1922, established São Paulo as an important center for Brazilian art and its intersection with modernity.[63] Referencing the cultural milieu of São Paulo from 1923, when the nascent promises accompanying modernization were brimming with alluring possibility, drew comparison to the massive urban giant the city had become by the 1970s, one that hardly fulfilled the utopian ideals of modernity. São Paulo's urban landscape witnessed a number of grand transformations during the 1970s, particularly when the metro system began to operate in 1974, implementing a complex transportation network. All of these expanded the city into the megalopolis that it is today but did little to rid the city of underdevelopment.[64]

Finally, for the grouping *The Dwellers*, Andrade worked with another set of postcards, this time more intimate portraits of people taken from 1900 to 1920. The nine sepia postcards feature portraits of bourgeois women and children in studio settings (figure 64). Many of the postcards were in a deteriorated state, with conspicuous signs of discoloration as well as significant wear and tear, though in several the signature of the photographer is intact. The artist photocopied the postcards and then sent them, one by one, to the São Paulo Biennial Foundation in 1977. Once there, the postcards were affixed to the left-hand corner of the photocopy that corresponded to the original postcard, juxtaposing two different representational systems, the older medium of photography with that of the Xerox, a newer technology.[65] Exhibited on neighboring walls, *The Work* featured correspondence with the foundation and the monument postcards, while *The Dwellers* offered a more intimate glance at the people populating the landscapes in the first half of the twentieth century.

The topography presented in this work is constructed from diverse historical, geographic, and photographic layers. It is surprising that Andrade's reflection on São Paulo at this moment of heightened expansion reflected back on the city's past to a moment of prosperity now depicted in the deteriorating artifact of the old map or the discolored remains of aging postcards. Through this juxtaposition, she is certainly in dialogue with the Biennial's emphasis on notions of construction and reconstruction. However, the artist's reflection on modernity is presented through the vestiges of its signifying objects and their reinterpretation through new media (Xerox, video). This coming together of earlier apparatuses of representation, once

FIGURE 64.
Sonia Andrade,
portraits from
A obra/
O espetáculo/
Os caminhos/
Os habitantes
(*The Work/*
The Spectacle/
The Paths/The
Dwellers), 1977.
Courtesy of the
artist.

associated with the optimism of modernity, with newer ones suggests a fragmented and nonlinear notion of "progress," a term that had become a cornerstone of the regime's propaganda. The resulting combination of the different historical moments and their corresponding media maps the old onto the new, modeling the "multitemporal heterogeneity" that the Argentinean anthropologist and cultural theorist Néstor García Canclini popularized in his discussion of modernization and its nonlinear processes in the Latin American context.[66] With this work, the artist proposed modernization as not only a fragmented process but also one that is dialogical, pairing the past and the present as overlapping modalities, both dependent on and distinct from each other. *The Work/The Spectacle/The Paths/The Dwellers* suggests a constant vacillation between then and now. Rather than present technological advances as dividing the past from the present, the artist instead established a relationship between the two historical moments of modernity, cultivating an uneasy and fragmented continuity rather than a rupture.

Each of the modules of the work was exhibited as a separate unit, but a grid-like aesthetic structured the installation as a whole, imitating the logic of maps in presenting information as stable and easily legible. The tele-

vision monitor and the hanging map reinforced the grid-like appearance of the piece, and the postcards, letters, and xeroxed copies were also hung on the wall as if framed by a grid. Yet despite the appearance of spatial order, closer examination reveals the extent to which the sections bleed into each other. Escaping the circumscribed confines of the grid, the components of the work overlap in a complex layering of information, shifting not only from one medium to another but also to and from different geographic locales, historical periods, and subject matter. The television monitor, for example, still a relatively new system of display, exhibited the historic post-cards. The modern video technology was employed to keep the images moving in a constant loop, from one to another in an arbitrary sequence, preventing the formation of any kind of linear narrative. The constant motion and circularity of the images defied any point of origin or destination. Such disorientation is repeated in *The Paths*, where the map is presented as a visual artifact rather than a practical guide to a destination. While navigating *The Paths*, one wove in and out of different historical moments, with no end or beginning to orient the viewer. The work as a whole confounded claims that modernity and its apparatuses lead to progress. Instead, maps in this work are deployed as a means to look back in time and to chart the landscapes and people composing place rather than to identify a territory by the goods it provides.

CONCLUSION

This chapter has looked at a series of works that explored how artists' mapping strategies can contribute to more intimate and critical portraits of place. In Meireles's *Physical Art* series, this meant staging an encounter between regions through the exchange of their physical properties, requiring the bodily presence of the artist. In Geiger's *Elementary Maps*, the boundaries depicted by the artist overflow when she recast easily recognizable cartographic contours, modifying conceptions of Brazilian territory through an alternative gendered and racial lens. In Andrade's *The Work/The Spectacle/The Paths/The Dwellers*, the urban boundaries of São Paulo and the institutional ones of the Biennial spill over into her work, generating an alternative map that vacillates across different geographic and historical boundaries. All three artists contest the notion of a map as a neatly ordered document, in contrast to the one advertising the Amazon in the SUDAM pamphlet, discussed earlier in the chapter; all three also represent a systemic relationship not only with cartography and geography but with prevailing ideas about space and urban, national, and global identity.

During the 1990s, a number of exhibitions foregrounded the mapping impulse as a dominant trend within contemporary art practice. These exhibits coincided with the "spatial turn," a cross-disciplinary scholarly investigation of space concerned with situating the cultural and social relevance

of place, mapping, and geographies, which led to a renewed interest in the intersection between maps and the different ways in which artists deployed them. In his seminal work on mapping, the cultural geographer Denis Cosgrove challenged the notion that maps lay claim to "stable, uniform and smoothly mobile knowledge," asserting instead that they are "inherently unstable, uneven, fragmentary," a position that artists were particularly well suited to explore.[67] In his aptly titled article "Map Art," the cartography scholar Denis Wood clarified that "map artists do not reject maps. They reject the authority claimed by normative maps uniquely to portray reality as it is, that is, with dispassion and objectivity."[68] Situated within the scholarly inquiry addressed by Cosgrove and Wood and associated with the "spatial turn," this chapter turns to the mapping practices of three artists—hardly exhaustive but exemplary of the specific tendencies to be explored—who worked a few decades before the so-called "spatial turn" became a familiar phrase in the academic lexicon. Nevertheless, the artists exemplify many of the tenets that are at the core of this turn, challenging the physical representation of space in official maps as well as the authoritarian imposition of boundaries without regard to their social and cultural impact. As in other instances described throughout the book, artists adopted official mapping strategies only to modify them in unpredictable ways, presenting an expanded topology where the political, cultural, semantic, and psychological coordinates are brought to the fore.

Artistic production engaging mapping procedures did so to challenge circumscribed boundaries by exploring the ways in which maps, both historically and during the 1970s, were incapable of representing lived reality. In the hands of artists, maps did not present a new world order, as colonial maps had done, but rather repositioned how symbols and iconographies can be mobilized to signify and produce a different social, political, and aesthetic reality. Rather than represent borders, the artists discussed in this chapter represent overflow and the impossibility of containing space within the grid of a map. Brasília's emergence no doubt held sway over artists' conceptions of organizing space. The new capital city represented the culmination and failure of the urban grid to contain what was inside it, and the overflow that resulted generated unexpected and overlapping layers of economic, social, and cultural diversity. In addition, the failure, despite the use of the most advanced technologies, of the military's mapping efforts in the Amazon to account for the geographic challenges of building the Trans-Amazon Highway and consider the people living there focused attention on representing the lived experience of place rather than solely depicting space. While the artists discussed in this chapter were not necessarily directly responding to either Brasília or mapping technologies deployed in the Amazon, their mapping perspective complicated representations of space circulating in the social imaginary.

For its May 2014 issue, the art magazine *Artforum International* featured a work by artist Cildo Meireles on its cover, a five-real bill stamped with the rhetorical question "Cadê Amarildo?" (Where Is Amarildo?). The artist's references in this work are twofold: first, he is directly invoking the death of Amarildo de Souza, a bricklayer who disappeared in July 2013 from Rocinha (one of the oldest and largest favelas in Rio de Janeiro) after the police apprehended him for questioning; second, Meireles is reviving a series of works he began in the 1970s entitled *Inserções em circuitos ideológicos: Projeto Cédula* (*Insertions into Ideological Circuits: Project Banknote*), in which he stamped small-denomination banknotes with illicit and anti-regime messages such as "Eleições Diretas" that were circulated when the currency was exchanged for goods. Among the most provocative works from the *Insertions* series were the 1975 banknotes bearing the message, "Quem matou Herzog?" (Who Killed Herzog?), created shortly after the death of the Brazilian journalist Vladimir Herzog, who was also initially brought in for police questioning. It was clear from the circumstances of the disappearances in both cases that the police were responsible for the deaths of the missing men, though they denied any culpability. In both iterations of Meireles's work, the rhetorical question stamped onto the banknotes acts as a veiled accusation of blame, asking the viewer not only to state the obvious, that the victim died in the hands of the police, but also to circulate the instigation by engaging in daily monetary transactions.

Reflecting on the similarities and differences between the two versions of Meireles's *Insertions* currency works is one way to address the role of contemporary art in Brazilian society then and now. The first noteworthy modification is that while Meireles began this series during the 1970s with the cruzeiro banknote, the currency he used in 2013 is the real. Though the material and textual similarity is readily apparent between the two bills, the currency conversion foregrounds the many changes the Brazilian economy underwent—and continues to undergo—in its struggle with inflation. Equally significant is the transition from the political period known as the "*anos de chumbo*," the gruesome "leaden" period of the military dictatorship in which Meireles initiated his series, to the vibrant, albeit not conflict-free, period of democracy since the open elections of 1985. For the most part, artists have not been censored or persecuted since

then, nor has their work put their lives at risk, substantially shifting the stakes of artists' political gestures. And yet, in spite of this major change in Brazil's political situation, the tension between freedom and oppression continues to be at the center of discussion in Brazilian social life. A case in point is the disappearance and death of Amarildo de Souza, taken in by police officers in 2013 for questioning relating to drug trafficking inside the favela, just like the many who were taken in for police investigations of communist ties during the 1970s. De Souza's case makes it clear that the residue of the military regime persists in the infrastructure of the police force, prone to a legacy of excessive violence, while Meireles's currency *Insertions* reveal that artists then and now still see their role as denouncing such authoritarian excess.

Another facet to consider in the comparison of Meireles's former and current *Insertions* works is the divergent attitudes that artists held vis-à-vis art institutions and the art market more broadly. During the 1970s, Meireles emphasized that the *Insertions* series should exist and circulate outside of the confines of art institutions mainly through its integration with activities from daily life, such as monetary exchange. In this, he echoed the desire of many artists working at this time who sought to make work that was not only ideologically and socially committed but would also evade what they saw as the capitalist-driven commodification of the art object in the art market. Despite Meireles's desire to distance his work from the art world, an early form of institutional critique, the *Insertions* series was readily included in Kynaston McShine's seminal exhibit of conceptual art, *Information* (1970), displayed at one of the art world's most recognized institutions, the Museum of Modern Art in New York. Today among the most well-known figures of the art world, Meireles is unlikely to claim that he is eluding art institutions with *Where Is Amarildo?* The work was included in an exhibition at one of Brazil's most important art galleries, Galeria Luisa Strina, the same year it came out. Shortly thereafter, it was on the cover of *Artforum International*, arguably one of the most internationally circulated art publications today. Such institutional response to Meireles's work should come as no surprise, given the astronomical growth of the market for Brazilian art in the past few years, and even more so in 2014. Most recently, exhibitions such as *Lygia Clark: The Abandonment of Art (1948–1988)* at MoMA in New York and *Cruzamentos: Contemporary Art in Brazil* at the Wexner Center for the Arts in Ohio, as well as a constant stream of record-setting sales at art auctions make it difficult to claim that Brazilian artists today are resisting commodification. Though such avid acceptance in the marketplace has complicated the utopian desire to shun art institutions espoused by Brazilian avant-garde artists during the 1960s and later those of the 1970s, it is clear that a socialist agenda continues to drive the work of artists today. If, as the artist Hélio Oiticica claimed, the avant-garde artist

was tasked "not simply to create, but to communicate on a large scale, and not only to a limited group of elite experts,"[1] then Meireles's currency work from the 1970s and from 2013 corroborates such a claim.

The desire for communication clearly motivates younger Brazilian contemporary artists to create work that seeks a broader audience and is critical of and intervenes in social and political life. Brazilian artists have continuously been an important voice among the millions of other citizens who take to the streets to voice their opposition to errant government policies regarding such urgent issues as poverty, inequality, and police brutality. The 2014 FIFA World Cup gave rise to critical opinions from all sectors of Brazilian society, as many resented the government's prioritization of soccer over the multitude of unresolved social problems and basic infrastructure needs such as transportation, safety, sanitation, health, and education. As artists take center stage in street demonstrations, upholding an ideological commitment to social progress, it is apparent that artistic production is as embedded in social life today as it was during the 1970s. Not surprisingly, many of these artists claim their predecessors from the 1970s as important influences.

Taking the commitment to social progress and communication as a central tenet of artistic production during the 1970s, I trace the story of how artworks became integrated in broader social systems of representation and communication. It was apparent early in my research that traditional art historical categories such as style, form, medium, or the artist's biography were inadequate as models of interpretation for these works. In place of such recognizable frameworks, I propose in this book a unique interpretive model grounded in four dominant systems organizing society—currency, newspapers, television, and maps—systems that not only influenced but also forever transformed artistic modes of production and circulation. Prioritizing the matrix of relationships surrounding artistic production, this study has sought to foreground the artworks' aesthetic, political, and ethical commitments. Recognizing that artworks often fell short of their intended utopian aspirations, I claim that the artworks nevertheless stand as important testaments to the historical conditions surrounding their emergence.

Today, popular interest in the 1970s is growing, manifested in the quantity of recent movies, books, and media discussions that broach that period of the dictatorship. This is the result of not only the fiftieth anniversary of the year that the military first came into power in 1964 but also the gradual opening up of archives attesting to the military's abuse of power. Much is being said and written about moments of resistance and revolutionary acts of defiance to the dictatorship, which are heroicized in the mainstream media. It is clear that Brazilians today confront and continue to struggle with the legacy of the military dictatorship's most difficult years, investigating the historical past as a means to avoid its repetition in the future.[2]

Consider, for example, the establishment of the National Truth Commission in 2011, an opportunity to investigate the human rights abuses committed by the military regime during its twenty-one-year rule. Despite an amnesty law, signed in 1979, that impedes trying the people found guilty of such abuses, the research acts as important historical evidence, exposing and condemning criminal acts while rewriting history. Artistic production also stands as a significant testament of this historical moment, and it has been my contention throughout this book that a sustained and exhaustive analysis of artworks produced during this time reveals the legislative, economic, aesthetic, and technological relationships of this period, highlighting those legacies that endure into the future.

APPENDIX: ARTIST BIOGRAPHIES

Sonia Andrade

Sonia Andrade (b. 1935) is based in Rio de Janeiro and was a part of the first generation of video artists in Brazil. Andrade met regularly with a group of other artists, including Anna Bella Geiger, Letícia Parente, and others who were working in Rio in the early 1970s. Andrade's video works from this period investigate the relationship between the body, the medium of video, and the construction of identity in mass media. Additionally, many of her early videos feature her own body performing cumbersome, awkward, and painful actions, invoking the practices of torture employed by the Brazilian government during the dictatorship.

Artur Barrio

Born in Porto, Portugal, Artur Barrio (b. 1945) has been based in Rio de Janeiro, Brazil, since emigrating with his family in 1955. Barrio is best known for his series *Situações* (*Situations*) in which he placed sculptural bundles of waste—made up of meat, animal bones, and other materials, wrapped in white canvas and soiled in blood and other bodily fluids—in public locations around Rio and Belo Horizonte. In the late 1960s and early 1970s, Barrio positioned hundreds of these packages and recorded the responses of passersby with photographs and video. These "bloody bundles," as they are often called, signaled a turn toward the bodily in art, as well as alluding to the brutality of the regime, making visible the violence that the regime sought to conceal. See the artist's website for more information: http://arturbarrio -trabalhos.blogspot.com/.

Paulo Bruscky

Paulo Bruscky (b. 1949) continues to live and work in his hometown of Recife, Brazil. Bruscky's work takes many forms, including mail art, performance, and photography. Credited with pioneering mail art practices in Brazil, Bruscky is well known for his projects in association with international Fluxus networks. Bruscky began his career during the military regime of the late 1960s, and his work often critically explored life under the dictatorship and the methods of oppression employed by the regime.

Leonhard Frank Duch

Born in Berlin in 1940, Leonhard Frank Duch emigrated to São Paulo in 1951, where he attended art school and studied journalism. Duch was active in the mail art scene from 1975 to 1994. His work was often directly critical of the military dictatorship. For *Protestbook*, a work made in 1979, Duch fabricated rubber stamp images of anti-government graffiti he encountered on the streets.

Anna Bella Geiger

Anna Bella Geiger (b. 1933) is based in Rio de Janeiro. Although Geiger has worked with a wide range of techniques and materials, including engraving, photomontage, mixed-media constructions, printmaking, and more, she is recognized as a foundational member of the first generation of video artists in Brazil. In the 1970s, her studio became a meeting place for artists experimenting with video. Geiger, along with several others from this group of artists, exhibited in the groundbreaking exhibition *Video Art* at the Institute of Contemporary Art at the University of Pennsylvania in 1975, the first instance of Brazilian video art shown outside of Brazil.

Paulo Herkenhoff

Paulo Herkenhoff (b. 1949) is based in Rio de Janeiro and is the cultural director at the MAR-Museu de Arte do Rio (Museum of Art of Rio). In the early 1970s, he participated in creating video artwork alongside Anna Bella Geiger, Sonia Andrade, and Letícia Parente, but he is primarily recognized for his career as an art critic, curator, and museum director. Among the notable exhibitions he organized are the Brazilian Pavilion at the 47th Venice Biennale (1997); the 24th São Paulo Biennial, *Cultural Anthropophagy* (1998); and *Tempo* at the Museum of Modern Art in New York in 2002. Herkenhoff has published texts on many contemporary artists, both Brazilian and otherwise, including Cildo Meireles, Raul Mourão, Guillermo Kuitca, Rebecca Horn, Julião Sarmento, and Louise Bourgeois, among others.

Roberto Jacoby

Roberto Jacoby (b. 1944), born in Buenos Aires, was the central figure of "media art," a movement that, in response to the rise of happenings in the 1960s, sought to create artworks that exist solely in the media. His best-known work, *Happening para un jabalí difunto* (*Happening for a Dead Boar*), from 1966, was created in collaboration with Eduardo Costa and Raúl Escari and publicized an art event in the media that never actually occurred. Jacoby also participated in the famous exhibition *Tucumán Arde* (*Tucumán Is Burning*) in 1968, a show staged in protest of the military dictatorship that was shut down by the police in Buenos Aires. For more information, see the artist's website: http://www.jacoby.org.ar/.

Unhandeijara Lisboa

Unhandeijara Lisboa (b. 1944), born in João Pessoa, Brazil, is an artist and poet associated with the mail art movement. In the 1970s, Lisboa edited the mail art journals *Karimbada: Arte em Karimbo* (*Art of the Rubber Stamp*), which featured works by international mail artists who experimented with rubber stamping.

Antonio Manuel

Antonio Manuel (b. 1947) was born in Avelãs de Caminha, Portugal, and settled in Rio de Janeiro with his family in 1953. As an artist interested in experimenting with media beyond conventional genres, much of Manuel's early work employed

the newspaper as its vehicle. In the 1960s and 1970s, Manuel was keenly focused on criticizing the abuses of the Brazilian dictatorship, highlighting censorship and military violence against the public, themes that are evident in his work.

Glauco Mattoso

Glauco Mattoso (b. 1951), a pseudonym for Pedro José Ferreira da Silva, is a writer and poet born in São Paulo, Brazil. In the late 1970s, Mattoso edited *Jornal Dobrabil*, a satirical publication made in parody of the major Brazilian newspaper *Jornal do Brasil*. *Jornal Dobrabil* replaced the official news stories of the real paper (which was subject to careful government censorship) with politically derisive, and often offensive, material.

Cildo Meireles

Cildo Meireles (b. 1948) was born in Rio de Janeiro, Brazil, and is recognized as a key figure in the development of conceptualism in Brazil. Much of his work from the 1970s, like his well-known project *Insertions into Ideological Circuits: Project Coca-Cola* from 1970, in which he recirculated Coca-Cola bottles stamped with critical political statements, explored alternative networks of artistic exchange outside of artistic institutions as well as the systems of control exercised by the military regime. Meireles's work has been included in numerous international exhibitions.

Geraldo Anhaia Mello

Geraldo Anhaia Mello (1955–2010) was a journalist, cultural activist, and videographer born in São Paulo, Brazil. In 1978, his artist video *The Situation* critiqued the discrepancies between the severity of life under the oppression and violence of the military regime and the false optimistic tenor of news broadcasting.

Paulo Miranda

Paulo Miranda (b. 1950) is a Brazilian visual poet. In his work *Poem of Value* (1978), he stamped a poem onto a one-cruzeiro banknote, raising questions about the value of not only the banknote but also the artwork, in this case the poem it supported.

Hélio Oiticica

One of the best-known Brazilian artists of the twentieth century, Hélio Oiticica (1937–1980) was born in Rio de Janeiro, Brazil. Associated with the neoconcrete group in the 1960s, Oiticica's work sought to encourage active viewership and participation in the work of art. His series of works entitled *Penetráveis* (*Penetrables*) from 1960 to 1979, for example, were environments that encouraged the viewer to move through the prescribed space. In his well-known work *Tropicália* (1967), which gave name to the broader Tropicália movement in Brazil, Oiticica fabricated a multimedia installation replete with references to and stereotypes of Brazil, including parrots, tropical fauna, and allusions to favela architecture. *Tropicália* both critiqued superficial tropes of Brazil as a tropical paradise and, like his *Penetrables*,

required the active participation of the viewer to move through the space of the artwork. For more on the artist, see http://www.heliooiticica.org.br/home/home.php.

Letícia Parente

Originally trained as a chemist, Letícia Parente (1930–1991) was born in Salvador, Bahia, and began making video art in the mid-1970s in Rio de Janeiro. She was a central figure in the informal group of early video artists working in Rio at the time. Parente's videos during this period invoke the brutality of the military regime by performing acts of violence on her own body. Her work investigates the construction of identity and reflects on issues of national, gender, and racial identity. For more on the artist, see http://www.leticiaparente.net/.

Daniel Santiago

Daniel Santiago (b. 1949), born in Recife, often collaborated with Paulo Bruscky in artworks that involved advertisements in newspapers. Along with Bruscky, he organized Brazil's Second International Mail Art Exhibit in 1976, at which three thousand works from twenty-one countries were exhibited. Closed by the police immediately after opening, and seen by only a dozen viewers, the exhibit landed Bruscky and Santiago in prison, where they were in isolation without any communication for ten days. The police held the works from the exhibit for a month, and many were confiscated, though others, albeit damaged, were later returned to the artists.

Thereza Simões

Born in 1941 in Rio de Janeiro, Simões actively participated in a number of important art exhibitions during the 1960s, including Opinião 66 in 1966, New Brazilian Objectivity at the Museum of Modern Art in Rio in 1967, and Compass Salon in 1969. Her work with rubber stamps was included in the exhibit, *Object and Participation*, organized by Frederico Morais in Belo Horizonte in 1970 at the Palace of Arts at the same time as his three-day event, *From Body to Earth*, took place.

Joaquín Torres García

Joaquín Torres García (1874–1949) was a painter born in Montevideo, Uruguay, who, influenced by his studies of European constructivism, conceived a theory of abstraction he called Universal Constructivism. With this practice, Torres García imbued geometric abstraction with symbolism drawn from pre-Columbian imagery. Torres García is also known for his influential drawing *América Invertido* (*Inverted Map of South America*) from 1943, in which he drew a map of South America reoriented so that the southernmost tip extends northward. This work illustrates the appeal he made in his manifesto "School of the South" for Latin American artists to find inspiration for their work in the south, rather than seeking it abroad. For more on the artist, see http://www.torresgarcia.org.uy/index_1.html.

NOTES

INTRODUCTION

1. Frederico Morais, "Contra a arte afluente: O corpo é o motor da 'obra,'" *Vozes* 64, no. 1 (January–February 1970): 45: "A obra não existe mais. A arte é um sinal, uma situação, um conceito."

2. The six Sundays were: "Um Domingo de Papel," "O Tecido do Domingo," "O Domingo por um Fio," "Domingo Terra a Terra," "O Som do Domingo," "O Corpo a Corpo do Domingo." The materials used were donated scraps. This moment in the museum's history was recently captured in *Um domingo com Frederico Morais*, a documentary directed by Guilherme Coelho (Rio de Janeiro, Brazil: Matizar and Retratos Contemporâneos da Arte, 2011), DVD.

3. See *Jornal do Brasil* (Rio de Janeiro), March 30, 1971, Caderno B, 4.

4. "O museu deve preocuparse em trazer ao grande público o próprio ato criador, semando condições para que todos possam exercitar livremente sua criatividade." Frederico Morais, *Artes plásticas: A crise da hora atual* (Rio de Janeiro: Paz e Terra, 1975), 106.

5. For a seminal theoretical study on the intersection of systems theory and art, see the work of the German sociologist Niklas Luhmann, particularly *Art as a Social System*, trans. Eva M. Knodt (Stanford, CA: Stanford University Press, 2000), originally published in German as *Die Kunst der Gesellschaft* (Frankfurt am Main: Suhrkamp, 1995). For a more recent study from within art history, see Francis Halsall, *Systems of Art: Art, History and Systems Theory* (Oxford: Peter Lang, 2008).

6. Ludwig von Bertalanffy, "An Outline of General System Theory," *British Journal for the Philosophy of Science* 1, no. 2 (1950): 134–165.

7. Ludwig von Bertalanffy, *General System Theory: Foundations, Development, Applications* (New York: George Braziller, 1968). Since 1949, von Bertalanffy had been living in Canada and the United States, thus his books were published in English.

8. Jack Burnham, "Systems Esthetics," *Artforum* 7, no. 1 (September 1968): 30–35. *Artforum* is one of the most well-known and -read magazines devoted to contemporary art.

9. Jack Burnham, *Great Western Salt Works: Essays on the Meaning of Post-Formalist Art* (New York: George Braziller, 1974), 16.

10. Burnham, ibid., 15.

11. See the exhibition announcement from the Centro de Arte y Comunicación (CAyC): *"CAyC: Arte de Sistemas en el Museo de Arte Moderno (GT54),"* June 28, 1971; available from Biblioteca del Museo Nacional de Bellas Artes, Buenos Aires.

12. According to Juan Carlos Romero, one of the members of the Grupo de los Trece (Group of Thirteen) that Glusberg founded, Glusberg did not refer to Burnham in their meetings, and he believes that the coincidence is due to the synchronicity of ideas. Juan Carlos Romero, e-mail message to author, July 6, 2010.

13. See, for example, Jorge Glusberg, "Arte y cibernética," in *Primera muestra del Centro de Estudios de Arte y Comunicación de la Fundación de Investigación Interdisciplinaria presentada en la Galería Bonino de Buenos Aires* (Buenos Aires: Centro de Estudios de Arte y Comunicación [CEAC], 1969); exhibition catalogue.

14. Digital recordings and selected transcripts of interviews with artists Sonia Andrade, Artur Barrio, Augusto de Campos, Antonio Dias, Wlademir Dias-Pino, Anna Bella Geiger, Nelson Leirner, Antonio Manuel, Cildo Meireles, José Resende, and Regina Silveira are in the author's possession.

15. Aracy Amaral, "Aspectos do não-objetualismo no Brasil," in *Arte novos meios/multimeios: Brasil 70/80*, ed. Daisy Peccinini (São Paulo: Fundação Armando Álvares Penteado, 1985), 101–106.

16. See, for example, Annateresa Fabris, ed., with Cacilda Teixeira da Costa et al., *Arte e política: Algumas possibilidades de leitura* (Belo Horizonte: Editora C/Arte, 1998), and in particular the essay by Marília Andrés Ribeiro; or Sheila Kaplan, "Visualidade, Anos 70," in *Vinte anos de resistência: Alternativas da cultura no regime militar*, ed. Maria Amélia Mello (Rio de Janeiro: Espaço e Tempo, 1986).

17. The Spanish art historian Simón Marchán Fiz, in his early 1972 study, was one of the first to cite an ideological variant of conceptual art in Latin America, basing his writing largely on art from Argentina in the 1960s. See Simón Marchán Fiz, *Del arte objetual al arte de concepto (1960–1974)* (Madrid: Ediciones Akal, 1986; orig. pub. 1972). Mari Carmen Ramírez, in her insightful essay "Tactics for Thriving on Adversity: Conceptualism in Latin America, 1960–1980," expanded the study of conceptualism to the politically motivated art of the 1960s and 1970s in Latin America; see *Global Conceptualism: Points of Origin, 1950s–1980s*, ed. Luis Camnitzer et al. (New York: Queens Museum of Art, 1999), 53-71. And for a more recent and widely used publication dedicated to political conceptualism, see Luis Camnitzer, *Conceptualism in Latin American Art: Didactics of Liberation* (Austin: University of Texas Press, 2007). The category of conceptual art in Latin America is also supported by several institutional and archival initiatives, including the ambitious primary documents digital archive at the International Center for the Arts of the Americas, or ICAA, at the Museum of Fine Arts in Houston, and MOMA's Primary Documents Series. Additionally, several manuscripts on conceptualism are in the process of being written in different countries in Latin America, including Mexico, Argentina, and Chile.

18. See cover page, *Jornal do Brasil*, October 31, 1969.

19. "Entre os autores censurados no Brasil, nos últimos anos, figuram desde

Sófocles e Miguel Ângelo (um poster com o seu *David* foi considerado imoral)." Zuenir Ventura, Heloisa Buarque de Hollanda, and Elio Gaspari, *Cultura em trânsito: Da repressão à abertura* (Rio de Janeiro: Aeroplano, 2000), 44.

20. In fact, just before every film screening, government propaganda films would air, advertising such messages as "Meu Brasil, eu amo você" (My Brazil, I love you) and others focusing on hygiene, health, and a strong work ethic.

21. Morais, "Contra a arte afluente," 45.

22. See Yvana Fechine, "O vídeo como projeto utópico de televisão," in *Made in Brasil: Três décadas do vídeo brasileiro*, ed. Arlindo Machado (São Paulo: Itaú Cultural, 2003), 88.

CHAPTER 1

1. Mathieu Deflem, "The Sociology of the Sociology of Money: Simmel and the Contemporary Battle of the Classics," *Journal of Classical Sociology* 3, no. 1 (2003): 71.

2. Ibid.

3. See table 3.1 in Albert Fishlow, "Some Reflections on Post-1964 Brazilian Economic Policy," in *Authoritarian Brazil: Origins, Policies, and Future*, ed. Alfred Stepan (New Haven: Yale University, 1973), 72.

4. For a concise discussion of the downside of the "Brazilian Miracle," see Manuel Miranda, *The Other Side of the Brazilian Way of Living with Inflation* (Toronto: Brazilian Studies, 1975), 4.

5. See Fred and Maxine Molyneux Halliday, "Brazil: The Underside of the Miracle," *Ramparts* 12, no. 9 (1974): 14–20.

6. The name of the currency, cruzeiro, is short for *cruzeiro do sul*, or the Southern Cross, the most well-known constellation of stars found in the Southern Hemisphere (like the Big Dipper in the Northern Hemisphere), which appear to be in the shape of a cross. It is the smallest of the existing constellations and has five stars. It is also a common appellation for everything from sports clubs and soccer teams to the popular magazine *O Cruzeiro*, which circulated from 1928 to 1975. It is also the title of a well-known work by Cildo Meireles, *Cruzeiro do Sul* (1969–1970), a small wooden sculpture (9 × 9 × 9 mm).

7. The currency underwent five more changes before it became the Brazilian real, Brazil's currency since 1994. The real is related to Brazil's original currency, réis, used for centuries, beginning under Portuguese rule in the sixteenth century and lasting until 1942, when it became the cruzeiro.

8. Ronald A. Krieger, "Inflation and the 'Brazilian Solution,'" *Challenge* 17, no. 4 (September/October 1974), 44.

9. Fernando J. Cardim Carvalho, "Strato-inflation and High Inflation: The Brazilian Experience," *Cambridge Journal of Economics* 17, no. 1 (1993), 63–78; see figs. 3–5, pp. 72–74.

10. William G. Tyler, "Exchange Rate Flexibility under Conditions of Endemic Inflation: A Case Study of the Recent Brazilian Experience," in *Leading Issues*

in International Economic Policy, ed. C. Fred Bergsten and William G. Tyler (Lexington, MA: Lexington Books, 1973), 22. See table 2-2, p. 23, for a list of the adjustments. Also see Congressional Urban Growth Study Group, *Urban Growth in Brazil and Colombia: [prepared at the request of the] Subcommittee on Housing and Community Development of the Committee on Banking, Currency and Housing, House of Representatives, 94th Congress, 2d sess.* (Washington, DC, 1976), 69.

11. Marvine Howe, "Test for Brazil's Inflation System," *New York Times*, Business and Finance (April 14, 974), 1.

12. Miranda, *The Other Side of the Brazilian Way*, 10.

13. Vera Rita de Mello Ferreira, "Living with Inflation and without Inflation—a Psychoanalytical View at the Brazilian Experience," http://www.verarita.psc .br/pdf/en_iarepcongress.pdf (accessed August 2, 2011). For an extended study of buying practices under inflation, see Maureen O'Dougherty, *Consumption Intensified: The Politics of Middle-Class Daily Life in Brazil* (Durham, NC: Duke University Press, 2002), chapter 2 in particular.

14. O'Dougherty, *Consumption Intensified*, 55.

15. See Krieger, "Inflation and the 'Brazilian Solution,'" 45.

16. The working class, especially those earning minimum wage, were the hardest hit by the military government's economic policy. Immediately after the military took over and during the 1970s, Brazilian minimum-wage workers, who made up the majority of the population, experienced up to a 60 percent decrease in purchasing power. The lower classes were also the hardest hit by the military regime's new tax policies. See Miranda, *The Other Side of the Brazilian Way*, 10 and the statistical graph on p. 12.

17. Raymond F. Devoe Jr., "Under the Southern Cross: The Role of 'Monetary Adjustment' in Brazil's Economic Miracle," *Financial Analysts Journal* 30, no. 5 (1974): 38.

18. José Carlos Durand, *Arte, privilégio e distinção* (São Paulo: Perspectiva, 1989), 197.

19. The two biggest auction houses were the Associação Nacional dos Comerciantes em Arte do Brasil in São Paulo and Bolsa da Arte in Rio de Janeiro. For more detailed information, see "O mercado dos best sellers: As polêmicas, as surpresas e as contradições do mercado de arte no Brasil," *Veja*, January 17, 1973, 44–53.

20. The works of Cândido Portinari (1903–1962), Tarsila do Amaral (1886–1973), Ismael Nery (1900–1934), Alfredo Volpi (1896–1988), and Emiliano di Cavalcanti (1897–1976) were particularly popular.

21. It is unclear where the work was first exhibited. The artist largely exhibited in museums until 1969; however, there is no record of this having been displayed in a museum.

22. Thaís de Souza Rivitti, "A idéia de circulação na obra de Cildo Meireles" (master's thesis, University of São Paulo, 2007), 47.

23. Of course, Meireles was not the first to use money as a work of art. The capriciousness of the art market and the rapid commercialization of art objects are some of the themes that drove the work of prominent pop artists such as Andy Warhol. One well-known example is Warhol's first silk-screen painting, *200 One Dollar Bills* (1962), which ironically sold for over $43 million dollars in 2009. Meireles was acquainted with Warhol's work, not only through art magazines but from his inclusion in the Ninth São Paulo Biennial in 1967, dedicated to US pop art.

24. See, for example, the interview by Hugo Auler, "A arte nos caminhos da morte?," *Correio Braziliense*, January 28, 1976; reprinted in *Cildo Meireles*, ed. Felipe Scovino (Rio de Janeiro: Beco do Azougue Editorial, 2009), 42.

25. Guy Brett, ed., *Cildo Meireles* (London: Tate Publishing, 2008), 76; exhibition catalogue.

26. The *Zero* series comprises both banknotes and coins; however, in this chapter I focus on the banknotes.

27. The artist and graphic designer, Aloisio Magalhães, was selected following a 1966 bid to change the image on the cruzeiro to look more modern, incorporating geometric lines. See João de Souza, ed., *A herança do olhar: O design de Aloisio Magalhães* (Rio de Janeiro: Artviva, 2003).

28. Ibid. From what I could ascertain, money issued before 1965 was printed by a series of foreign printing presses, the largest being Thomas de La Rue & Co., based in London; see http://www.girafamania.com.br/americano/brasil-moedas.htm (accessed August 2, 2011). For more details on the process used by the Casa da Moeda to print banknotes, see http://www.casadamoeda.gov.br/portalCMB/menu/negocios/solucoesSeguranca/cedulas.jsp or http://www.casadamoeda.gov.br/portalCMB/layout/images/docs/comercial/catalogo-ingles.pdf (accessed March 2015).

29. Scovino, *Cildo Meireles*, 252–253.

30. Meireles wrote, "As with the *Money Tree*, *Zero Cruzeiro* always ran the risk of being mistaken for a commentary or criticism of inflation." Brett, *Cildo Meireles*, 78.

31. Alex Shoumatoff, "The Museum of Money," Talk of the Town, *New Yorker*, February 10, 1986, 30.

32. Marcos Faber, "História do dinheiro no Brasil," http://www.historialivre.com/brasil/dinheiro_brasil.pdf (accessed August 30, 2011).

33. See the Central Bank of Brazil's website for more detailed information on the different designs of Brazilian currency throughout the twentieth century: http://www.bcb.gov.br/Pre/PEF/PORT/publicacoes_DinheironoBrasil.pdf.

34. There is a fairly extensive bibliography, particularly from the field of economics, on the Brazilian experiment with monetary correction. Marvine Howe, "Test for Brazil's Inflation System," Business and Finance, *New York Times*, April 14, 1974, 1; and Congressional Urban Growth Study Group, *Urban Growth in Brazil and Colombia*, 64.

35. See Central Bank of Brazil's website for more details: http://www.bcb.gov.br/?BCHISTORY (accessed August 1, 2011).

36. Brett, *Cildo Meireles*, 14.

37. See Scovino, *Cildo Meireles*, 253. The Krahô people live in Bico do Papagaio, between the states of Goiás, Pará, and Maranhão. For more on the group, see http://pib.socioambiental.org/en/povo/kraho (accessed August 4, 2011).

38. Central Bank of Brazil website, http://www.bcb.gov.br/htms/museu-espacos/cedulas/TN_CM.asp?idpai=CASAMOEDA%20#CR500 (accessed August 4, 2011).

39. PIN was created by a government decree in 1970. For more detailed information on the president's justification of the program, see Flavio Alcaraz Gomes, *Transamazônica: A redescoberta do Brasil* (São Paulo: Livraria Cultura, 1972).

40. Congressional Urban Growth Study Group, *Urban Growth in Brazil and Colombia*, 35.

41. Shelton H. Davis, *Victims of the Miracle: Development and the Indians of Brazil* (Cambridge: Cambridge University Press, 1977), 39.

42. Ibid., 40.

43. See Antonio Carlos Guedes, "Conservation and Cultural Values: Brazil," http://ssc.undp.org/uploads/media/Conservation_and_Cultural_Values_Brazil.pdf (accessed August 4, 2011). Guedes claims that the government encouraged the Krahô tribe to switch to harvesting one single cash crop, in this case, rice, thereby promoting a monoculture. Such policies, foreign to the tribe's long-established methods of cultivation, led to malnutrition and full dependence on government aid.

44. Interview with Frederico Morais originally published in *O Globo*, March 16, 1977, reprinted in Scovino, *Cildo Meireles*, 46–51. For an excellent overview of the foundation of SPI and its impact within indigenous communities, see chapter 1 in Davis, *Victims of the Miracle*.

45. Author's translation of "Os 4 mil índios se transformaram em 400, dos quais, 200 ficaram enlouquecidos, porque haviam perdido tudo: família, vínculo e vida identitária." Scovino, *Cildo Meireles*, 253. For more on the plight of the Krahô as well as more details about the massacre Meirelles (the father) was referring to, see Julio Cezar Melatti, *Índios e criadores: A situação dos Krahô na área pastoril do Tocantins* (Rio de Janeiro: Instituto de Ciências Sociais, 1967).

46. The report was published by Patrick Braun in an article titled "Germ Warfare against Indians Is Charged in Brazil," cited in Davis, *Victims of the Miracle*, 11.

47. Octavio Ianni, *Ditadura e agricultura: O desenvolvimento do capitalismo na Amazônia, 1964–1978* (Rio de Janeiro: Editora Civilização Brasileira, 1979).

48. Ibid., 183.

49. "O índio ou comunidade indígena como objeto de propaganda turística ou de exibição para fins lucrativos." See the FUNAI website, http://www.funai.gov.br/quem/legislacao/estatuto_indio.html (accessed August 25, 2011). It is unclear if Meireles was familiar with this law.

50. Meireles had lived in Brasília from 1958 to 1967.

51. Meireles interview, in Scovino, *Cildo Meireles*, 255.

52. For more information, see http://casadaspalmeiras.blogspot.com/ (accessed September 13, 2011).

53. Meireles continued his investigation into this topic with his work entitled *Sal sem carne* (1975), which features photographs of the Krahô and the inmate from *Zero Cruzeiro*. This work is accompanied by an LP of the sounds he recorded during his travels to Goiás in 1974.

54. Meireles believes they sold for about one cruzeiro. E-mail message to author, May 29, 2014.

55. Scovino, *Cildo Meireles*, 256; and Thaís de Souza Rivitti, "A idéia de circulação na obra de Cildo Meireles," 79.

56. Brett, *Cildo Meireles*, 80.

57. The declassified files were sent to the Lyndon Baines Johnson Library and Museum in Austin, Texas. The *Jornal do Brasil* article from December 19, 1976, is reprinted in full in Marcos Sá Corrêa, "Operação Brother Sam," in *10 reportagens que abalaram a ditadura*, ed. Fernando Molica (Rio de Janeiro: Record, 2005), 175–196.

58. NSA archives on Brazil made available through http://www.gwu.edu/~nsarchiv/NSAEBB/NSAEBB118/ (accessed August 4, 2011).

59. Ibid.

60. Congressional Urban Growth Study Group, *Urban Growth in Brazil and Colombia*, 68.

61. Advertisement found in *O Estado de São Paulo*, December 30, 1973.

62. Kynaston McShine, ed., *Information* (New York: Museum of Modern Art, 1970), 139; exhibition catalogue.

63. Ibid., 138.

64. Though I discuss two variants of this series in this chapter, the Coca-Cola bottles and the banknotes, the *Insertions into Ideological Circuits* series also includes *Inserçoes em jornais* (*Insertions into Newspapers*) from 1969 to 1970 and *Inserçoes em circuitos antropológicos* (*Insertions into Anthropological Circuits*) from 1971.

65. See, for example, Brett, *Cildo Meireles*, 64–65.

66. The Tate Modern in London alone has nine variations. See http://www.tate.org.uk/servlet/ArtistWorks?cgroupid=999999961&artistid=6633&page=1 (accessed August 5, 2011).

67. The use of currency as a support reappears in Paulo Miranda's *Poema de valor* (*Poem of Value*, 1978; see figure 9), which poses the question of how value is determined in the art object. Like Meireles, Miranda uses the cruzeiro bill, which he slightly manipulated, as the poem. The title most certainly is an ironic quip on the commodification of poetry. For further discussion of this work, see Omar Khouri, "Poesia visual brasileira: Uma poesia na era pós-verso" (PhD diss., Pontifica Universidade Católica de São Paulo, 1996), 196.

68. The phrase "mais amplo e abrangente" appears in Meireles's statement accompanying his works for *Information*, in Paulo Herkenhoff, Gerardo Mosquera, and Dan Cameron, *Cildo Meireles*, Contemporary Artists (London: Phaidon, 1999), 110.

69. My rewording of Cildo Meireles's statement about his participation in *Information* in Herkenhoff, Mosquera, and Cameron, *Cildo Meireles*, 109.

70. See interview with Gerardo Mosquera in *Pressplay: Contemporary Artists in Conversation* (London: Phaidon, 2005), 466.

71. "A arte teria uma função social e teria de ser mais ou menos densamente consciente. Maior densidade de consciência em relação à sociedade da qual emerge." Herkenhoff, Mosquera, and Cameron, *Cildo Meireles*, 112.

72. Paulo Herkenhoff explained that "in the most exacerbated period of anti-Americanism, Latin America experienced the deepest impact of United States' Pop Art." Paulo Herkenhoff, "Deconstructing the Opacities of History," in *Encounters/Displacements: Luis Camnitzer, Alfredo Jaar, Cildo Meireles*, ed. Mari Carmen Ramírez and Beverly Adams (Austin: Archer M. Huntington Art Gallery, University of Texas, 1992), 50.

73. Ibid., 49.

74. Robert Moss, "The Moving Frontier: A Survey of Brazil," *The Economist* (September 1972), 11.

75. Davis, *Victims of the Miracle*, 42. In 1967, the twelve major advertisers in Brazil were the following corporations: Willys Overland, Sidney Ross, Volkswagen, Gillette, Gessy Lever, Nestlé, Ford, Rhodia, Fleishman and Royal, Coca-Cola, Shell, and Colgate Palmolive. See Fernando Henrique Cardoso, "Associated— Dependent Development: Theoretical and Practical Implications," in *Authoritarian Brazil: Origins, Policies, and Future*, ed. Alfred Stepan (New Haven: Yale University Press, 1973), 144.

76. Cited in Davis, *Victims of the Miracle*, 42.

77. Herkenhoff, Mosquera, and Cameron, *Cildo Meireles*, 109.

78. Deflem, "*Sociology of Money*," 70.

79. Ibid., 71.

80. MR8 made headlines when they (along with ALN) kidnapped the American ambassador Charles Burke Elbrick in 1969 and exchanged him for the release of imprisoned members of their group. This event was popularized in the movie *Four Days in September* (1997), directed by Bruno Barreto, based on the politician Fernando Gabeira's memoir, *O que é isso, companheiro?* (1979).

81. Marighella had lived under the military dictatorship of Getúlio Vargas (1930–1945) and was active in the resistance to the later regime, installed by the coup of 1964. He was shot to death during a 1969 ambush by military police. For more biographical details, see http://pt.wn.com/carlos_marighella/biography (accessed August 5, 2011).

82. Elio Gaspari, *A ditadura escancarada* (São Paulo: Companhia das Letras, 2002), 142.

83. Carlos Marighella, *Minimanual of the Urban Guerrilla*, English translation (Los Angeles: Committee on Latin American Solidarity [COLAS], 1969), 2.

84. "O caráter da 'inserção' nesse circuito seria sempre o de contra-infromação." Ronaldo Brito and Eudoro Augusto Macieira de Souza, *Cildo Meireles*, Arte Brasileira Contemporânea series (Rio de Janeiro: FUNARTE, 1981), 24.

85. The title could be a reference to Pedro Malasartes, a well-known trickster figure from Portuguese and Brazilian folklore, popularized in the film *As aventuras de Pedro Malasartes* (1960). Though only three issues of the journal were published, it is an important publication for understanding the leading theoretical issues and cultural stakes of cultural production during the 1970s.

86. Ronaldo Brito, "Análise do circuito," *Malasartes* 1 (1975): 5–7.

87. "comprometido com os sistemas e processos de significação em curso na sociedade." Ibid., 6.

88. "As *Inserções em circuitos ideológicos* nasceram da necessidade de criar um sistema de circulação, de intercâmbio de informações que não dependesse de nenhum tipo de controle centralizado. Como é o caso da televisão, do rádio, da imprensa, mídias que atingem de fato um público imenso, mas onde sempre se exerce determinado controle." Herkenhoff, Mosquera, and Cameron, *Cildo Meireles*, 110.

89. Scovino, *Cildo Meireles*, 247.

90. Morais's installation was the fourth in a series of exhibits at Agnus Dei Gallery in 1970. Morais's exhibition was entitled *A nova crítica*. See Gloria Ferreira, *Arte como questão: Anos 70/Art as Question: The 1970s* (São Paulo: Instituto Tomie Ohtake, 2009), 125.

91. Meireles equivocates with regard to this question. Artist interview with the author, March 25, 2006.

92. Anne-Marie Smith, *A Forced Agreement: Press Acquiescence to Censorship in Brazil* (Pittsburgh: University of Pittsburgh Press, 1997), 29.

93. Oscar Fernández, "Censorship and the Brazilian Theatre," *Educational Theatre Journal* 25, no. 3 (October 1973): 290.

94. Smith, *A Forced Agreement*, 141.

95. This decree was delivered via the *Jornal do Brasil* newspaper, July 13, 1973. Cited in ibid., 141.

96. For more details on Herzog's life and plight, see the documentary *Vlado: 30 anos depois* (2005), directed by João Batista de Andrade. In 2009, the Instituto Vladimir Herzog was established to promote human rights and justice with regard to freedom of information. Their website has more in-depth biographical information on Herzog: http://www.vladimirherzog.org/biografia/.

97. Photos were released in 2004 and published by international news media that point to the staged suicide hanging of Herzog. See Larry Rohter, "Exhuming a Political Killing Reopens Old Wounds in Brazil," *New York Times*, sec. 1, October 24, 2004, 8.

98. "Death of Newsman Held by Army Stirs Brazilians," *New York Times*, October 31, 1975, 10.

99. Johanna Drucker, "The Crux of Conceptualism: Conceptual Art, the Idea of Idea, and the Information Paradigm," in *Conceptual Art*, ed. Michael Corris (New York: Cambridge University, 2004), 251.

100. Liz Kotz, *Words to Be Looked At: Language in 1960s Art* (Cambridge: MIT Press, 2007), 8.

101. For the broad cultural ramifications of this turn, see James Gleick, *The Information: A History, a Theory, a Flood* (New York: Pantheon Books, 2011), and Frederick Adams, "The Informational Turn in Philosophy," *Minds and Machines* 13, no. 4 (2003): 471–501.

102. Shannon establishes three main questions circumscribing the mathematics of communication: 1. How accurately can the symbols of communication be transmitted? (the technical problem); 2. How precisely do the transmitted symbols convey the desired meaning? (the semantic problem); 3. How effectively does the received meaning affect conduct in the desired way? (the effectiveness problem), in Claude E. Shannon and Warren Weaver, *The Mathematical Theory of Communication* (Urbana: University of Illinois Press, 1963), 7.

103. Marshall McLuhan, *Understanding Media: The Extensions of Man*, 2nd ed. (New York: Signet, 1964); introduction to the 2nd edition, ix.

104. Quoting George Bailey Sansom, McLuhan wrote that the money economy in Japan "caused a slow but irresistible revolution, culminating in the breakdown of feudal government." McLuhan, *Understanding Media*, 33.

105. For a copy of the translated manifesto as well as additional information on the media-related works by the same artists, see Inés Katzenstein, *Listen, Here, Now! Argentine Art of the 1960s: Writings of the Avant-Garde* (New York: Museum of Modern Art, 2004), 223–224.

106. Katzenstein, *Listen, Here, Now!*, 223.

107. "Cinco Séculos de Gutenberg," *Jornal do Brasil*, December 14, 1968, Caderno B, 4. Additionally, in 1970 *Jornal de Brasil* published a list of the year's one hundred most influential thinkers, and McLuhan made the list.

108. See André Stolarski, ed., *Alexandre Wollner e a formação do design moderno no Brasil: Depoimentos sobre o design visual brasileiro*, trans. Anthony Doyle (São Paulo: Cosac Naify, 2005); and Pedro Luiz Pereira de Souza, *ESDI: Biografia de uma ideia* (Rio de Janeiro: EDUERJ, 1996). According to Pignatari, he was the first to teach a formal course on information theory in Brazil. From conversation with the author, December 2005.

109. For further discussion and illustration of Paulo Miranda's work, see Omar Khouri, "Poesia visual brasileira: Uma poesia na era pós-verso" (PhD diss., Pontifícia Universidade Católica de São Paulo, 1996), 196.

110. This verse is taken from the third and final section of Dante's *Divine Comedy* (1308–1321), Paradiso. The whole line in the Divine Comedy is "By the love that

moves the sun and the other stars." Miranda replaced the "love" with the Brazilian Republic.

111. Philadelpho Menezes described intersemiotics as "the indistinct use of the signs of a diverse nature and not in the disfiguration of nature specific to each field of art." Philadelpho Menezes, *Poetics and Visuality: A Trajectory of Contemporary Brazilian Poetry* (San Diego, CA: San Diego State University Press, 1994), 75. Charles Perrone, a scholar of Brazilian poetry, explained that intersemiotic creation "covers publications . . . built on interplay among sign systems, varied spatio-typographic representations, illustrated verse, photographs, and other combinations." Charles A. Perrone, "The Imperative of Invention: Brazilian Concrete Poetry and Intersemiotic Creation," *Ubuweb*, http://www.ubu.com /papers/perrone.html.

112. *Viva Há Poesia* (1979): 10. The publication was printed on newsprint in the format of a newspaper, edited by Villari Herrmann and designed by the visual artist Julio Plaza. See Khouri, "Poesia visual brasileira," 38.

113. Thereza Simões had a history of subversive works, several of which had been seized by the military at the Second Bienal Nacional de Artes Plásticas, which took place in Bahia during December 1968. Given this history, it is possible that she wrote the messages, all of which allude to the precarious political situation, in English and German as a means to evade military censors.

114. There is a growing body of scholarship on the phenomenon of mail art in Latin America. See Chuck Welch, *Eternal Network: A Mail Art Anthology* (Calgary: University of Calgary Press, 1995); Annmarie Chandler and Norie Neumark, *At a Distance: Precursors to Art and Activism on the Internet* (Cambridge: MIT Press, 2005); Graciela Gutiérrez Marx, *Arte correo: Artistas invisibles en la red postal* (Buenos Aires: Ediciones Luna Verde, 2010); Vanessa Davidson, "Paulo Bruscky and Edgardo Antonio Vigo: Pioneers in Alternative Communication Networks, Conceptualism, and Performance (1960s–1980s)" (PhD diss., New York University, 2011).

115. Géza Perneczky, *The Magazine Network: The Trends of Alternative Art in the Light of Their Periodicals, 1968–1988* (Cologne: Soft Geometry, 1993), 81.

116. Ibid., 89. Leonhard Frank Duch moved to São Paulo in 1951 from Berlin, where he was born in 1940. Though he studied journalism, he was a painter and worked with film and performance. For more information, see http://mailartists.word press.com/2009/02/06/leonhard-frank-duch/ (accessed August 29, 2011).

117. More information about this publication is available in Perneczky, *The Magazine Network*, 81, 239. The only images I have found of *Karimbada* are available in a later publication by the same author, Géza Perneczky, *Assembling Magazines, 1969–2000* (Budapest: Árnyékkotok Foundation, 2007), 43. Perneczky describes the publication as an envelope that contains twenty separate leaves. See Géza Perneczky, *Network Atlas: Works and Publications by the People of the First Network*, Vol. 1: A–N (Cologne: Soft Geometry, 2002), 233.

118. The term *nanica* is a diminutive for banana and refers to the small bananas that are commonly available in Brazil.

CHAPTER 2

1. "Tempo negro. Temperatura sufocante. O ar está irrespirável. O país está sendo varrido por fortes ventos." Cover page, *Jornal do Brasil*, December 14, 1968. The paper was founded in 1891.
2. "Tempo bom. Temperatura: em elevação. Ventos: norte, fracos. Visib: boa." Cover page, *Jornal do Brasil*, December 13, 1968.
3. Ibid. See the description of the act on the cover page.
4. "Ontem foi o Dia dos Cegos." This appeared on the right side of the header on the cover page of *Jornal do Brasil*, December 14, 1968.
5. "Eu posso. Eu tenho o AI-5 nas mãos e, com ele, posso tudo." From Antonio Carlos Scartezini, *Segredos de Médici*, 61, quoted in Gaspari, *A ditadura escancarada*, 129–130.
6. Luciano Martins, *A Geração AI-5 e Maio de 68: Duas manifestações intransitivas* (Rio de Janeiro: Argumento, 2004). For an excellent study on this generation in English, see Christopher Dunn, "*Desbunde* and Its Discontents: Counterculture and Authoritarian Modernization in Brazil, 1968–1974," *The Americas* 70, no. 3 (2014): 429–458.
7. See Thomas Skidmore, *The Politics of Military Rule in Brazil, 1964–1985* (New York: Oxford University Press, 1988), 82; and Gaspari, *A ditadura escancarada*, 213. The journalist Castello Branco was arrested shortly after the publication of his column on the same day as the forecast. See Carlos Castello Branco, "Coluna do Castello: Primeiras Impressões sôbre o ato de ontem," *Jornal do Brasil*, December 14, 1968, 4. He was let go in January of 1969.
8. For a complete list of the prohibitions, see Paolo Marconi, *A censura política na imprensa brasileira, 1968–1978* (São Paulo: Global, 1980), 225–303.
9. Gaspari, *A ditadura escancarada*, 218.
10. During the 1950s in Rio de Janeiro, there were twenty-two daily newspapers with different political editorial agendas, and by 1970 there were only seven papers left. Not all of the closures were due to censorship; many also could not withstand the increases in the cost of paper following the petroleum crisis of 1973. See Alzira Alves de Abreu, *A modernização da imprensa (1970–2000)* (Rio de Janeiro: Jorge Zahar, 2002), 18.
11. This decree is available for viewing from this government website: http://www.planalto.gov.br/ccivil_03/decreto-lei/Del0972.htm (accessed September 20, 2011).
12. See http://www2.camara.gov.br/legin/fed/declei/1970-1979/decreto-lei-1077-26-janeiro-1970-355732-publicacaooriginal-1-pe.html (accessed September 15, 2011).
13. "Não serão toleradas as publicações e exteriorizações contrárias à moral e aos bons costumes quaisquer que sejam os meios de comunicação." Ibid.

14. See "Brazil: No Nudes Is . . . ," *Time Magazine*, April 30, 1973, http://www.time .com/time/magazine/article/0,9171,907116,00.html (accessed October 2, 2011).

15. "De ordem superior, fica terminantemente proibida a publicação de críticas ao sistema de censura, seu fundamento e sua legitimidade, bem como de qualquer notícia, crítica, referência escrita, falada e televisada, direta ou indiretamente formulada contra órgão de censura, censores e legislação censória" (Proibição da Polícia Federal, de 4.6.73). Quoted in Marconi, *A censura política*, 37.

16. "De ordem superior, fica terminantemente proibida, por qualquer meio de comunicação, rádio, televisão e jornais, até o dia 5 de maio do corrente ano, de notíticias relacionadas com o aniversário de Lenin ou qualquer divulgação relativa à Cortina de Ferro." Ibid., 13.

17. Ibid., 273. Lúcio Flávio was a famous bandit and bank robber in Rio de Janeiro who was imprisoned in 1974. The events were later dramatized in a 1977 film entitled *Lúcio Flávio, o Passageiro da Agonia*, by the director Hector Babenco.

18. See James Green, *We Cannot Remain Silent: Opposition to the Brazilian Military Dictatorship in the United States* (Durham, NC: Duke University Press, 2010), 125. Among the roster of renowned scholars forced to resign were Florestan Fernandes, Fernando Henrique Cardoso, and Octavio Ianni (mentioned in chapter 1). Skidmore, *Politics of Military Rule*, 84. For a complete list of all the professors, see José Eduardo Ferraz Clemente, "Ciência e política durante a ditadura militar: O caso da comunidade brasileira de físicos (1964–1979)" (master's thesis, Universidade Federal da Bahia, 2005).

19. Laurence Hallewel, *Books in Brazil: A History of the Publishing Trade* (Metuchen, NJ: Scarecrow Press, 1982), 351.

20. Patrícia Marcondes de Barros, "A imprensa alternativa brasileira nos 'anos de chumbo,'" *Akrópolis: Revista de Ciências Humanas da UNIPAR* 11, no. 2 (April/June 2003): 63–66.

21. This is further discussed in chapter 1.

22. Charles A. Perrone, "Margins and Marginals: New Brazilian Poetry of the 1970s," *Luso Brazilian Review* 31, no. 1 (1994): 18–19.

23. For more on this topic, see Mark Antliff and Patricia Leighten, *Cubism and Culture* (New York: Thames and Hudson, 2001).

24. Examples include Luciano Figueiredo, Ana Vitória Mussi, Paulo Herkenhoff, Nelson Leirner, and the Rex group.

25. "Cinco séculos de Gutenberg," *Jornal do Brasil*, December 14, 1968, Caderno B, 4.

26. "uma verdadeira obra de arte coletiva: a imagem do mundo sob a forma de um conjunto de notícias e anúncios publicitários em uma forma que não é mais linear e sim mosaica." Ibid.

27. For more on McLuhan in Brazil, see chapter 1 of this book.

28. *The Lusiads*, first printed in 1572, narrated the adventures of the Portuguese during their voyages of discovery. See "Acervo mostra as marcas de censura—Economia—Estadão.com.br," *Estadão*, http://economia.estadao.com.br

/noticias/economia,acervo-mostra-as-marcas-de-censura,113609,0.htm (accessed August 16, 2013). Last year the newspaper began a digitizing project to document all instances of censorship from 1972 to 1975, which are now available online at: http://acervo.estadao.com.br/paginas-censuradas/.

29. Marconi, *A censura política*, 82–83. For more on censorship and newspapers, see Jane Leftwich Curry and Joan R. Dassin, eds., *Press Control around the World* (New York: Praeger, 1982).

30. Paulo Herkenhoff, *Cildo Meireles: Geografia do Brasil* (Rio de Janeiro: Artviva Produção Cultural, 2001), 60.

31. Brett, *Cildo Meireles*, 60.

32. Meireles clarified that no letters were received.

33. Herkenhoff, *Cildo Meireles*, 60.

34. Smith, *A Forced Agreement*, 6.

35. Ibid.

36. Ibid., 123.

37. Ibid., 141.

38. The point of origin could have been any one of the following: the president; one of his ministers; the civil, military, or federal police; the army; the marines; or the air force. See Juarez Bahia, *Jornal, história e técnica* (São Paulo: Ática, 1990), 320. Later the notes were replaced by telephone calls, often anonymous.

39. Ibid., 338.

40. Jaguar and Sérgio Augusto, "Toda a verdade (vá lá, meia) sobre o começo do Pasquim," in *O melhor do Pasquim: Antologia (1969–1971)*, ed. Sérgio Augusto and Jaguar (Rio de Janeiro: Desiderata, 2006), 8.

41. For a detailed history of this publication's different phases, see José Luiz Braga, *O Pasquim e os anos 70: Mais pra epa que pra oba* (Brasília, DF: Editora UnB, 1991).

42. Curry and Dassin, *Press Control around the World*, 162.

43. I have encountered different versions for the number of issues initially printed. In the Leila Miccolis Collection index it states 30,000, whereas in Braga, *O Pasquim e os anos 70*, 28, the first print run is given as 20,000, rising to 200,000 at issue number 27.

44. Smith, *A Forced Agreement*, 48. For one of the most complete indexes of the alternative press, along with brief descriptions, see the the Leila Miccolis Collection acquired by the University of Miami in 2005 and housed in their Special Collections.

45. The editorial team comprised Tarso de Castro (editor), Sérgio Jaguaribe (Jaguar), Sérgio Cabral, Carlos Propseri (graphic editor), and Claudius Ceccon. This group shifted throughout the years. Among its collaborators were Millôr Fernandes, Ziraldo, Luiz Carlos Maciel, Paulo Francis, Martha Alencar, Olga Savary, Sérgio Augusto, Ivan Lessa, Fortuna, and Henfil Sylvio Abreu. Its founders figured that people would inevitably mock it by calling it "jornal de O Pasquim," or a pasquinade, so they decided to be the first to do so. Frederico

Morais, *Cronologia das artes plásticas no Rio de Janeiro, 1816–1994* (Rio de Janeiro: Topbooks, 1995), 308.

46. *"Mocotó"* was a slang word with a sexual connotation. Erlon Chaves performed the song at the televised 1970 Festival Internacional da Canção in what he conceived of as a happening, during which he arranged for two women to scream "Queremos mocotó!" as they kissed him on stage. Though the "happening" was wildly applauded, Chaves was immediately taken away and accused of obscenity and bad taste. Apparently there were a few wives of army generals who were offended by the performance. For a full account of the incident, see Zuza Homem de Mello, *A era dos festivais: Uma parábola* (São Paulo: Editora 34, 2003), 381–390.

47. Ibid., 15.

48. Marconi, *A censura política*, 243.

49. They were eventually released without charge and the inquiry was dropped.

50. Heloísa Buarque de Hollanda, *Impressões de viagem: CPC, vanguarda e desbunde, 1960–1970*, 4th ed. (Rio de Janeiro: Aeroplano, 2004), 72.

51. Marconi, *A censura política*, 307.

52. Part of the more recent scholarship on *O Pasquim* is a more critical assessment of its gender and class biases and in particular its targeting of a countercultural elite; Anne-Marie Smith also claimed that it was "so egregiously sexist and persistently racist that one has to ask, alternative to what?" Smith, *A Forced Agreement*, 39.

53. Darlene J. Sadlier, *Brazil Imagined: 1500 to the Present* (Austin: University of Texas Press, 2008), 328.

54. Paulo Bruscky and Daniel Santiago often collaborated, and they were known as the team Bruscky and Santiago.

55. "Arteaeronimbo. Composição aleatória de nuvens coloridas no céu de Recife. A Equipe Paulo Bruscky—Daniel Santiago, responsável pela idéia, deseja entrar em contato com Químico, Meteorologista ou qualquer pessoa capaz de colorir uma nuvem. Correspondência para Arteaeronimbo, Posta restante," in *Diário de Pernambuco*, September 22, 1974.

56. Ad, *Jornal do Brasil*, December 24, 1976, Caderno B, 6.

57. See the description of his work in "Desclasificados," *Veja*, July 27, 1977, 122.

58. *Diário de Pernambuco*, Sunday, July 3, 1977, page c-21. Cited in Cristina Freire, *Paulo Bruscky: Arte, arquivo e utopia* (São Paulo: Companhia Editora de Pernambuco, 2006), 46.

59. This concept is later dramatized in a Hollywood thriller entitled *Brainstorm* from 1983.

60. "Desclassificados," *Veja*, July 27, 1977, 122.

61. Ibid.

62. Freire, *Paulo Bruscky: Arte, arquivo e utopia*, 46.

63. Glauco Mattoso is the pseudonym for Pedro José Ferreira da Silva and is a linguistic pun on the condition of glaucoma, which eventually caused the poet's

blindness. See Steven F. Butterman, *Perversions on Parade: Brazilian Literature of Transgression and Postmodern Anti-Aesthetics in Glauco Mattoso*, 1st ed. (San Diego: Hyperbole Books, San Diego State University Press, 2005).

64. Sheila Kaplan, "Visualidade, anos 70," in *Vinte anos de resistência: Alternativas aa cultura no regime militar*, ed. Maria Amélia Mello (Rio de Janeiro: Espaço e Tempo, 1986), 129.

65. Perrone, "Margins and Marginals," 23.

66. Ibid., 49.

67. Morais, *Cronologia das artes plásticas*, 307.

68. The jury was made up of a panel of renowned artists and critics: José Roberto Teixeira Leite, Walter Zanini, Frederico Morais, Ivan Serpa, Renina Katz, Roberto Magalhães, Anna Letycia, Pedro Escosteguy, Jackson Ribeiro, Humberto Franceschi, Armando Rosário, Niomar Moniz Sodré, Mário Pedrosa, and Marcos Konder Netto. Morais, *Cronologia das artes plásticas*, 307.

69. For a more thorough account of the events surrounding this biennial and its boycott, see chapter 1 in Claudia Calirman, *Brazilian Art under Dictatorship: Antonio Manuel, Artur Barrio, and Cildo Meireles* (Durham, NC: Duke University Press, 2012); James Green, *We Cannot Remain Silent: Opposition to the Brazilian Military Dictatorship in the United States* (Durham, NC: Duke University Press, 2010), 117–124; and Leonor Amarante, *As Bienais de São Paulo, 1951 a 1987* (São Paulo: Projeto Editores Associados, 1989), 180–198.

70. Virgínia Gil Araujo, "Uma parada—Antonio Manuel e a imagem fotográfica do corpo: Brasil anos 67/77" (PhD diss., University of São Paulo, 2007), 65.

71. Moniz Sodré recounts that she hid the work underneath the pillows of her sofa, fearing that the military officials would search the newspaper's headquarters as well. Morais, *Cronologia das artes plásticas*, 308. She ended up buying the work; however, it was destroyed in a fire at her apartment in 1978.

72. The newspaper had printed the headline "Press Censorship Is Abolished." Gaspari, *A ditadura escancarada*, 214. Moniz Sodré, quoted in Marconi, *A censura política*, 40.

73. The editorial is quite blunt in blaming the government for its use of violence against the freedom of expression. She stated, "The authorities today . . . did not hold back in the use of force and terror." Marconi, *A censura política*, 41.

74. For a discussion of the events surrounding the boycott, see Amarante, *As Bienais de São Paulo*, 180–198.

75. Grace Glueck, "São Paulo Show Loses U.S. Entry; Artists Boycott Bienal Over Military Repressions," *New York Times*, July 17, 1969. Kepes had organized a two-part installation. The first, *Information*, reflected the informational aesthetic that was featured in the eponymous exhibit at MoMA in 1970, and *Community*, which featured the idea of collaborative practice through interactive sculpture.

76. Many of the artists I spoke with discussed the pervasive peer pressure not to participate in this important international platform, and those who chose to

do so had to withstand the resentment of those within the art community, so many desisted from participating. One of the detrimental results of the boycott was that it deprived Brazilian artists of a much-needed forum for international exposure.

77. The Bienal de Artes Plásticas da Bahia reopened a month later and stayed open until February 15, 1969. See http://enciclopedia.itaucultural.org.br /evento81697/bienal-nacional-de-artes-plasticas-1-1966-salvador-ba (accessed September 22, 2011).

78. Antonio Manuel, *Antonio Manuel/Entrevista a Lúcia Carneiro e Ileana Pradilla* (Rio de Janeiro: Lacerda Editores, 1999), 16.

79. The film was shot at the location of military violence during student protests against Edson Luís's death. It was shown in the Cinemateca at the Museum of Modern Art, Rio de Janeiro, in August 1969, just a few months after the closure of the Paris biennial's preview, and it managed to secure screenings at movie theaters around the country through clandestine channels. Araujo, "Uma parada—Antonio Manuel," 73–75. The director, Olney, fared worse; he was taken in for questioning for having infringed on the National Security Law, and was tortured; one author surmised that it was due to the trauma he suffered that he died in 1978. The censors lost the film negatives, and no documentation of the film remains. See Marcelo Lins de Magalhães, "Antonio Manuel: Arte em jornal" (master's thesis, Pontifícia Universidade Cátolica do Rio de Janeiro, 2004), 48–49.

80. Law No. 5.439 was passed on May 22, 1968. Carlos Fico, *Como eles agiam: Os subterrâneos da ditadura militar, espionagem e polícia política* (Rio de Janeiro: Editora Record, 2001), 246.

81. Décio Pignatari later wrote about one of Manuel's *Clandestines* in *Semiótica e literatura* (São Paulo: Editora Perspectiva, 1974), 165.

82. Manuel, *Antonio Manuel/Entrevista a Lúcia Carneiro e Ileana Pradilla*, 15.

83. The supplement, though relatively short-lived, featured a broad array of artistic, literary, and poetic proposals; manifestos; and criticism, including regular contributions by the poet and critic Ferreira Gullar; the art critic Mário Pedrosa; the poet and theorist Décio Pignatari; the poets Mario Faustino, Haroldo de Campos, and Augusto de Campos, as well as literary personalities such as Clarice Lispector.

84. "Estes trabalhos nasceram de minha paixão pelo jornal enquanto meio de captar a realidade imediata, tornar possível a criação poética e sobretudo a idéia de síntese entre o verbal e o visual contida no veículo." Antonio Manuel, *Antonio Manuel*, Arte Brasileira Contemporânea series (Rio de Janeiro: FUNARTE/ Instituto Nacional de Artes Plásticas, 1984), 45.

85. "A maneira como os jornais são expostos nas bancas, o tipo de diagramação e paginação, com aquele apelo poético, dramático, serviu de material para elaboração dos trabalhos—poemas visuas—, que a princípio eram desenvolvidos

no ateliê e depois realizados nas próprias oficinas de jornais, junto ao barulho constante da redação e da rotativa." Ibid., 46.

86. Roberto Pontual, *Antonio Manuel* (Rio de Janeiro: Galeria Goeldi, October 30, 1967); two-page pamphlet.

87. An earlier version of this work, from 1967, is also referred to as *Jornal*. See Ronaldo Brito, *Antonio Manuel* (Rio de Janeiro: Centro Cultural Hélio Oiticica, 1997), 52; exhibition catalogue. It is possible that the title of this work was referencing an earlier work by Waldemar Cordeiro, *Jornal* from 1964. *Jornal* featured strips of newspaper collaged together to form the front cover of a newspaper. The viewer can make out what resembles the front page of the *Última Hora* (Last Hour). The spliced-together clippings manage to barely maintain the coherence of the text printed on them. Though full legibility is impossible, loaded words like "Revolução," "Guerra" (War), *"Comunistas,"* and "Kruschev" make their way through the visual noise even though their context is never disclosed. Embedded in the work was the history of *Última Hora*, a left-leaning paper founded in Rio in 1951 and run by Samuel Wainer, who claimed its objective was to challenge the mainstream press with a more independent approach. As one struggles to make meaning of the barely perceptible text, one is left to question the newspaper's objective as a tool for informing the public. Cordeiro's work thus hints at the complications of communication mechanisms, particularly in a mass media vehicle such as the newspaper.

88. According to Manuel, it was the French word *"flan"* that was used to refer to the stereotype matrix in Brazil.

89. Newspapers eventually replaced this somewhat laborious process with offset printing, which in Brazil took place during the late 1970s for most of the major newspapers.

90. It is difficult to locate all the *flans*, as they are scattered across different collections both in Brazil and internationally, including several at MoMA in New York and the Tate in London. For one of the most comprehensive pictorial indices of the *flans*, see Paulo Venâncio Filho, *Fato Antonio Manuel* (São Paulo: Centro Cultural do Banco do Brasil, 2007); exhibition catalogue.

91. Antonio Manuel, interview with author, digital recording, Rio de Janeiro, Brazil, November 18, 2005.

92. For an ambitious and thorough analysis of all ten *Clandestines*, comparing the original newspaper with Manuel's intervention, see Lins de Magalhães, "Antonio Manuel: Arte em jornal," 67–78.

93. Marialva Barbosa, *História cultural da imprensa: Brasil, 1900–2000* (Rio de Janeiro: Mauad X, 2007), 213.

94. Ibid., 214.

95. Manuel, *Antonio Manuel/Entrevista a Lúcia Carneiro e Ileana Pradilla*, 37. In another interview with Felipe Scovino, he cites having circulated 100–200 copies. See http://www.anpap.org.br/anais/2009/pdf/chtca/felipe_scovino _gomes_lima.pdf, 1850–1851.

96. "Era assim um lado marginal, clandestino dentro da própria estrutura de um veículo industrial de massa." Manuel, *Antonio Manuel*, 45.

97. Marconi, *A censura política*, 84.

98. Barbosa, *História cultural da imprensa*, 213.

99. Ibid., 218–219.

100. It also helped that *O Dia*, unlike *Tribuna da Imprensa*, *Jornal do Brasil*, *Correio*, and others, was not a target of newspaper censors, so that he was more likely to get away with more subversive material.

101. Manuel proclaimed that he was an avid reader of *O Pasquim* and had even planned to publish the photographic novella (*fotonovela*) *A arma fálica*, conceived with Lygia Pape, in its pages in 1969. Interview with author, November 18, 2005.

102. In 1970, Manuel had proposed to exhibit his own body as a work of art at the Museum of Modern Art in Rio, but the jury denied his proposal. The artist then spontaneously undressed in a public performance on the opening night, striking poses in the nude throughout the museum.

103. Manuel, *Antonio Manuel/Entrevista a Lúcia Carneiro e Ileana Pradilla*, 45.

104. Assis Chateaubriand also helped found the Museum of Art in São Paulo, MASP. Assis's son, Gilberto Chateaubriand, whose collection of artworks is the permanent collection of the Museum of Modern Art in Rio de Janeiro, bought many of Antonio Manuel's works on and with newspaper.

105. Ramos originally wanted to give Manuel three out of six pages of the supplement, but Manuel, who wanted to publish all of his proposals, asked for and was given all six pages.

106. To my knowledge, no newsstand is open all twenty-four hours, but given the wide reach of the supplement (60,000 copies), it is possible that several venues were.

107. Manuel makes reference to the pasture on the cover of this supplement, where he makes the claim that art should be experienced sensually so as "to perceive and feel the thing . . . covering the body." The intellectual, he claimed, "should graze" rather than overrationalize works of art. See page one of the supplement of *O Jornal*, July 15, 1973.

108. For a detailed description of Manuel's six proposals, see Artur Freitas, "Contra-Arte: Vanguarda, Conceitualismo e Arte de Guerrilha—1969–1973" (PhD diss., Federal University of Parana, 2007), 183–217.

109. There are a number of possible references within this work, including to Robert Rauschenberg's *Monogram* (1959), a stuffed goat that was displayed on top of a platform, or to Jannis Kounellis's *Untitled (12 Horses)* from 1969, which involved staging twelve live horses inside a gallery. Live goats are also often used as live sacrifices in Afro-Brazilian religious ceremonies associated with Candomblé and Umbanda.

110. Manuel, *Antonio Manuel*, 48.

111. For full text, see Claudia Calirman and Gabriela Rangel, *Antonio Manuel: I*

Want to Act, Not Represent! (New York: Americas Society, 2011), 17; exhibition catalogue.

112. Manuel, *Antonio Manuel*, 47.

CHAPTER 3

1. McLuhan, *Understanding Media*, 271.

2. The appropriation of *Tropicália* for broader cultural purposes was lamented by Oiticica as commodification of his vanguard idea, causing him to disassociate himself from the movement. In his writing from the time, he bemoaned the fact that *Tropicália* became another ism as the use of "Tropicalism" and the consumption of things tropical became fashionable without people understanding exactly what it meant. See his text entitled "Tropicália" (March 4, 1968), reproduced in Guy Brett et al., eds., *Hélio Oiticica* (Rotterdam: Witte de With; Minneapolis: Walker Art Center, 1991). For scholarship on the cultural and countercultural impact of *Tropicália*, see Celso Favaretto, *Tropicália: Alegoria, Alegria* (São Paulo: Kairós, 1979); Carlos Calado, *Tropicália: A história de uma revolução musical* (São Paulo: Editora 34, 1997); Christopher Dunn, *Brutality Garden: Tropicália and the Emergence of a Brazilian Counterculture* (Chapel Hill: University of North Carolina Press, 2001); and the recent exhibition catalogue edited by Carlos Basualdo, *Tropicália: A Revolution in Brazilian Culture (1967–1972)* (São Paulo: Cosac Naify, 2005).

3. Oiticica's first penetrable was conceived of in 1960 and is commonly referred to as *PN1*. For a description of the significicance of Brazilian imagery, see Hélio Oiticica, "Tropcália: The Image Problem Surpassed by That of a Synthesis," in *Tropicália: A Revolution in Brazilian Culture*, ed. Carlos Basualdo (São Paulo: Cosac Naify, 2005), 309.

4. By the late 1960s, Rio de Janeiro had the highest concentration of favelas in Brazil and possibly in Latin America, with favelas housing a third of Rio's population. For more information on the role of favela architecture in Oiticica's work, consult Paola Berenstein Jacques, *Estética da ginga: A arquitetura das favelas através da obra de Hélio Oiticica* (Rio de Janeiro: Casa da Palavra/RIOARTE, 2001); Janice E. Perlman, *The Myth of Marginality: Urban Poverty and Politics in Rio de Janeiro* (Berkeley: University of California, 1976), 1.

5. Oiticica designated the penetrable spaces as *PN2, A pureza é um mito* (*Purity Is a Myth*), and *PN3, Imagético* (*Imagetic*).

6. "Os poemas-objetos de Roberta são como que inscrições no material que lhes dá a completa significação—a frase, o poema, estão inscritos numa estrutura-objeto: o tijolo, o isopor, o concreto, a madeira: não se sabe onde começa o material a ser poema ou passa este a ser material . . . O subjetivo, a mensagem, a revolta encontram-se presentes, aqui, num novo contexto experimental." Hélio Oiticica, *Aspiro ao grande labirinto* (Rio de Janeiro: Rocco, 1986), 100–101.

7. See Néstor García Canclini and his notion of "multitemporal hetereogeneity" in

his seminal book *Hybrid Cultures: Strategies for Entering and Leaving Modernity* (Minneapolis: University of Minnesota Press, 2005), 47. First published in Spanish as *Culturas híbridas: Estrategias para entrar y salir de la modernidad* (Mexico City: Grijalbo, 1990).

8. Oiticica's text "Esquema geral da Nova Objetividade" accompanied the exhibit (see exhibition catalogue for *Nova objetividade brasileira*), and is reprinted in Oiticica, *Aspiro ao grande labirinto*, 84–98, as well as in Brett et al., *Hélio Oiticica*, 110–120. The translated version can be found in Brett et al., *Hélio Oiticica*, 119, and in Basualdo, *Tropicália: A Revolution in Brazilian Culture*, 221. Additionally, the document *A declaração de princípios básicos da Nova Vanguarda* (The Declaration of Basic Principles of the New Avant-Garde), signed by a number of the exhibit's artists, was included in the exhibition.

9. "não só de criar simplesmente, mas de comunicar algo que para ele é fundamental, mas essa comunicação teria que se dar em grande escala, não numa elite reduzida a 'experts.'" See Oiticica, *Aspiro ao grande labirinto*, 84–98.

10. The media theorist Raymond Williams wrote more on this in his seminal study of television in 1975: "The principal incentives to first-stage improvements in communications technology came from problems of communication and control in expanded military and commercial operations." Williams, *Television: Technology and Cultural Form*, 2nd ed. (London: Routledge, 1975), 20.

11. See José Eduardo Pereira Filho, "A Embratel: Da era da intervenção ao tempo da competição," *Revista de Sociologia e Política* 18 (2002): 33–47.

12. John Sinclair, *Latin American Television: A Global View* (New York: Oxford University Press, 1999), 69.

13. Mexico had inaugurated its station just days earlier, making it the first country to do so in Latin America. See Alcir Henrique da Costa, Inimá Ferreira Simões, and Maria Rita Kehl, eds., *Um país no ar: História da TV brasileira em três canais* (São Paulo: Brasiliense, 1986). TV Tupi was one of the many media outlets composing Assis Chateaubriand's extensive media network Diários Associados (Associated Dailies), which included numerous radio stations, newspapers, and magazines such as the wildly popular weekly *O Cruzeiro*. It came to Rio de Janeiro in 1951 and to Belo Horizonte in 1955.

14. As discussed in chapter 2, "Newspapers," Chateaubriand was also the patron and cofounder of the São Paulo Museum of Art (MASP) in 1947. Sinclair, *Latin American Television*, 64.

15. Invictus went out of business in 1972, after the introduction of color television in Brazil. It could not compete with the manufacturing capacity of European and Japanese electronic companies.

16. "Vinte anos de televisão," *Veja*, September 23, 1970, 63.

17. The 1970 census stated that there were 4,250,404 televisions and 4,594,920 refrigerators. Statistic from Braune Bia and Ricardo Xavier, *Almanaque da TV* (Rio de Janeiro: Ediouro, 2007), 18. For other useful statistics, see Sérgio

Augusto Mattos, *A televisão no Brasil: 50 anos de história (1950–2000)* (Salvador: PAS-Ianamá, 2000), 274 and ch. 1, available online at http://www.sergio mattos.com.br/liv_impacto4.html.

18. "Vinte anos de televisão," *Veja*, September 23, 1970, 60–71.

19. McLuhan, *Understanding Media*, 269–270.

20. Ibid., 37.

21. Ibid., 272.

22. Ibid., 271.

23. Ibid., 279.

24. Oiticica reassessed his relationship to television after he left Brazil for New York in 1970, and he made ample references to McLuhan's *Understanding Media* in his texts from 1971, after which he also began to use the terms "cold" and "hot" media.

25. Williams, *Television: Technology and Cultural Form*, 128.

26. Muniz Sodré, *O monopólio da fala: Função e linguagem da televisão no Brasil* (Petrópolis: Editora Vozes, 1977), 18.

27. McLuhan, *Understanding Media*, 321.

28. Sodré, *O monopólio da fala*, 28–29.

29. "Vinte anos de televisão," *Veja*, September 23, 1970, 60–63.

30. Oiticica, *Aspiro ao grande labirinto*, 107.

31. Quoted in Venicio A. de Lima, "The State, Television, and Political Power," *Critical Studies in Media Communication* 5, no. 2 (1988): 120.

32. *Pra frente, Brasil* was also the title of a 1982 film, by the director Roberto Farias, whose plot fictionalizes the arrest of a man who is mistakenly identified as a political activist by the regime during the 1970 FIFA World Cup. The film belies the exaggerated optimism promoted in television programming, showing instead the more brutal, repressive reality of living under the military regime. Not surprisingly, it was prohibited in Brazil, but it was eventually released in 1984. See Lima, "The State, Television, and Political Power," 125n8.

33. "Sinto-me feliz, todas as noites, quando ligo a televisão para assistir ao jornal. Enquanto as notícias dão conta de greves, agitações, atentados e conflitos em várias partes do mundo, o Brasil marcha em paz, rumo ao desenvolvimento. É como se tomasse um tranqüilizante após um dia de trabalho." Mattos, *A televisão no Brasil*, 119.

34. Williams, *Television: Technology and Cultural Form*, 23.

35. The artist's full name is Artur Alípio Barrio de Sousa Lopes, though he often goes by just Barrio.

36. The Globo empire's holdings during the 1970s included *O Globo*, a prominent newspaper based in Rio; seven radio stations; five television stations with hundreds of affiliate stations transmitting their programming throughout Brazil; Rio Gráfica, a publishing company; SIGLA, a recording studio; VASGLO, a show business company; Globo-Video, a video company; TELCOM, an electronic industry; and Global, an art gallery. See *Anos 70: Televisão* (Rio de

Janeiro: Europa, 1980) and Lima, "The State, Television, and Political Power," 119.

37. TV Tupi closed definitively in 1981. Its decline hastened after the death of Assis Chateaubriand and its inability to withstand the competition from TV Globo.

38. Lima, "The State, Television, and Political Power," 119.

39. Time-Life agreed to supply financial, technical, and management assistance, in the broadest sense, covering the cost of equipment, financial controls, training, programming, and marketing for a return of 30 percent of the profits. Because the constitution prevented foreign participation in a television license, Globo was ordered to rectify the situation, but the order was not enforced until 1968, when the arrangement was officially canceled. Globo paid off its financial obligations to Time-Life in 1971, but Joe Wallach, a top executive from the United States, stayed on in management at Globo. The financial and technical expertise gave Globo an enormous advantage, allowing it to surpass the other competing stations in audience ratings. See Joseph D. Straubhaar, "Television and Video in the Transition from Military to Civilian Rule in Brazil," *Latin American Research Review* 24, no. 1 (1989): 141, and Sinclair, *Latin American Television*, 66–67.

40. Lima, "The State, Television, and Political Power," 119.

41. Maria Rita Kehl, "Um só povo, uma só cabeça, uma só nação," in *Anos 70: Televisão* (Rio de Janeiro: Europa, 1980), 13.

42. The executive is unnamed and is cited in Lima, "The State, Television, and Political Power," 120.

43. Ibid., 120.

44. Decreto No. 70.185. See http://legis.senado.gov.br/legislacao/ListaPublicacoes .action?id=200032 (accessed March 7, 2012).

45. See Kehl, "Um só povo, uma só cabeça, uma só nação," 15. The televised format lasted until 2008.

46. Ibid., 15.

47. Embratel was an affiliate of Intelsat (International Telecommunications Satellite Consortium), initially comprising eleven countries. By 1969, Intelsat had established the world's first global communications system, just in time to air the live broadcast of Neil Armstrong's landing on the moon. See Intelsat's website for a detailed history: http://www.intelsat.com/about-us/history/intelsat -1960s.asp (accessed March 8, 2012).

48. "O *Jornal Nacional*, da Rede Globo, um serviço de notícias integrando o Brasil novo, inaugura-se neste momento: imagem e som de todo o país."

49. Elisabeth Carvalho, "Telejornalismo: A década do jornal da tranquilidade," in *Anos 70: Televisão* (Rio de Janeiro: Europa, 1979), 33.

50. Ibid.

51. *Veja* magazine conducted a study on censorship restrictions and found, for example, that in the city of Rio de Janeiro during 1973, one hundred prohibitions had been administered. See Carvalho, "Telejornalismo," 35.

52. "Fica proibida a divulgação em material de qualquer natureza, inlusive tradução e transcrição, referência ou comentários sobre publicação em jornais e revistas estrangeiras de materias abordando temas ofensivos ao Brasil, suas autoridades e entidades—Agente Beningo." See Carvalho, "Telejornalismo," 34.

53. Ibid.

54. The Korean artist Nam June Paik (1932–2006) is often cited as the first artist to have bought the Sony Portapak in 1965. He showed his first artist tape, accompanied by the text "Electronic Video Recorder," at the Café Au Go Go in New York, where performances were often shown. For the text, see http://www.medienkunstnetz.de/source-text/35/ (accessed April 12, 2012).

55. "A videoarte nunca chegou a existir de fato no Brasil. Os poucos trabalhos feitos para esse meio são profundamente tediosos, mal feitos e quase nunca levaram em conta nossa realidade cultural e econômica." Frederico Morais, "A força específica do audiovisual," *O Globo*, August 29, 1978, Sec. F, 47.

56. The artists, in the order they were presented in the catalogue, were Angelo de Aquino, Anna Bella Geiger, Fernando Cocchiarale, Ivens Olinto Araujo (who now goes by Ivens Machado), and Sonia Andrade. According to the *JAC 8* exhibition catalogue, the video pieces included here (with the exception of Aquino's work) were the ones sent to the Institute of Contemporary Art in Philadelphia.

57. The exhibitions took place between 1974 and 1978, in places like Paris, London, Buenos Aires, Caracas, Lima, Mexico, and Tokyo, bringing the work of video artists from Latin America in contact with a broader audience.

58. By the 1980s, video art's initial experimental energy shifted as artists became more technically adept and equipment became more readily available. Additionally, as government restrictions on television censorship were eased, video artists engaged other social questions, including what such democracy would mean.

59. Fernando Barbosa Lima, Gabriel Priolli, and Arlindo Machado, *Televisão e vídeo* (Rio de Janeiro: Jorge Zahar, 1985), 25.

60. See Arlindo Machado, "Video Art: The Brazilian Adventure," *Leonardo* 29, no. 3 (1996): 225–231; and "As linhas de força do vídeo brasileiro," in *Made in Brasil: Três décadas do vídeo brasileiro*, ed. Arlindo Machado (São Paulo: Itaú Cultural, 2003), 13.

61. Richard Paterson, ed., *TV Globo: Brazilian Television in Context* (London: British Film Institute, 1982), 14.

62. For an English-language study on Brazilian *telenovelas*, see Michèle Mattelart and Armand Mattelart, *The Carnival of Images: Brazilian Television Fiction*, trans. from the French by David Buxton (New York: Bergin and Garvey, 1990), 14.

63. In 1972, Flusser moved from Brazil to Europe, where he moved around taking on different lecture and teaching opportunities. It is rumored that his move was a result of difficulties he ran into with the authorities over censorship, although I have not seen this substantiated.

64. Walter Zanini, "Videoarte: Uma poética aberta," in *Made in Brasil: Três déca-das do vídeo brasileiro*, ed. Arlindo Machado (São Paulo: Itaú Cultural, 2003), 56.

65. See Vilém Flusser, "Proposal for the Organization of Future São Paulo Bi-ennials on a Communicological Basis" (year of creation unknown), script, Vilém Flusser Archive, Berlin (reference number: 3-BIENAL-18_2184).

66. "Cheguei aqui não tinha nada . . . Ninguém queria saber de vídeo, era um desânimo total. A gente não sabia o que ia acontecer." *Videoarte Brasil: Os pio-neiros*, Centro Cultural Banco do Brasil, February 25–March 6, 1994, exhibi-tion catalogue, unpaginated.

67. Cacilda de Teixera, "Videoarte no MAC" in Machado, *Made in Brasil*, 70.

68. The exhibit catalogue for *Arte novos meios/multimeios* held at FAAP in 1985 documents a series of experiments conducted in 1971 with 1-inch videotape by Gabriel Borba Filho and ten students using the professional television equip-ment at the School of Communications and Art at the University of São Paulo (ECA-USP). See Daisy V. M. Peccinini, ed., *Arte novos meios/multimeios: Bra-sil 70/80* (São Paulo: Fundação Armando Álvares Penteado, Instituto de Pes-quisa Setor Arte, 1985), 43.

69. It should be noted that the Brazilian artist Antonio Dias, who was living in Milan at the time, had used video as part of his series *The Illustration of Art*, in two works: *Music Piece* (1971) and *Two Musical Models on the Use of Multi-media* (1974). It is rumored that the videos still exist in an archive in Florence; however, attempts by the author to locate them proved unsuccessful.

70. "Eu tinha visto uma mostra de video, na Bienal de São Paulo, e achava com-pletamente natural que aqueles trabalhos fossem feitos em video, mas nós estávamos totalmente fora do circuito, uma vez que não tinhamos equipa-mento." Anna Bella Geiger, quoted in *Videoarte Brasil: Os pioneiros*, Centro Cultural Banco do Brasil, February 25–March 6, 1994, exhibition catalogue, unpaginated.

71. Jom Azulay, a former Brazilian consul based in Los Angeles, brought the Porta-pak back to Rio de Janeiro in 1974. According to first-hand accounts, Azulay, a filmmaker himself, shared his equipment with the Rio de Janeiro group of artists. In many of the works, he appears in the credits as the cameraman. The camera was passed around to the different artists, who often conceived and executed their projects within a week so that the camera could be returned to its owner. The group later acquired their own Portapak in 1975. In 1977, Walter Zanini was able to purchase video equipment for MAC-USP, after which São Paulo artists began to produce video art as well.

72. Walter Zanini, then director of the Museum of Contemporary Art in São Paulo, extended the invitation to Anna Bella Geiger. The exhibition, curated by Suzanne Delehanty, traveled to the Contemporary Arts Center in Cincinnati, the Museum of Contemporary Art in Chicago, and the Wadsworth Atheneum in Hartford. See Fernando Cocchiarale, "Primórdios a videoarte no Brasil," in

Made in Brasil: Três Décadas Do Vídeo Brasileiro, ed. Arlindo Machado (São Paulo: Itaú Cultural, 2003), 63.

73. For more details, see Arlindo Machado, "Notas sobre uma televisão secreta," in Barbosa Lima, Priolli, and Machado, *Televisão e Vídeo*, 53–75.

74. David Joselit, *Feedback: Television against Democracy* (Cambridge: MIT Press, 2007).

75. Ibid., 30 and 41.

76. The journal was organized by Beryl Korot and Phyllis Gershuny, along with a number of prominent US video artists. The periodical lasted until 1974, and eleven issues were published, now available online. For a detailed history, see http://www.radicalsoftware.org/e/history.html (accessed April 11, 2012).

77. Michael Shamberg, *Guerrilla Television* (New York: Holt, Rinehart and Winston, 1971), 9.

78. Ibid., 48.

79. Ibid., 45.

80. *Radical Software* demonstrated an awareness of what was going on in Latin America, and more specifically in Brazil, with regard to human rights violations. It also reported on news events related to Latin America. For example, the first issue includes a reprinted newspaper article about a plane falling in São Paulo; *Radical Software*, 1, no. 1 (Spring 1970): 6.

81. The first issue of *Radical Software* can be retrieved online; see http://www.radicalsoftware.org/e/volume1nr1.html (accessed September 2011). See page 1 for "self-cybernation" reference.

82. Ibid., 1.

83. Jorge Glusberg, "Video in Latin America," in *New Television: A Public/Private Art: Essays, Statements, and Videotapes*, based on *"Open Circuits: An International Conference on the Future of Television,"* ed. Allison Simmons and Douglas Davis (Cambridge: MIT Press, 1977), 204.

84. Ibid.

85. The US video artist Vito Aconcci created a work by the same name in 1970, but it is very unlikely that Parente would have known anything about it, so it is probably a case of synchronous ideas circulating, supporting a systems approach.

86. *Trademark* was one of seven videos she made during the 1970s. For detailed biographical information, see *Letícia Parente* (Rio de Janeiro: Oi Futuro, 2011); exhibition catalogue. Also consult the bilingual website: http://www.leticia parente.net.

87. Christopher Dunn, "Tom Zé and the Performance of Citizenship in Brazil," *Popular Music* 28, no. 2 (2009): 220. Oiticica's *Tropicália* similarly satirizes a prepackaged Brazilian aesthetic and links to consumption via the television.

88. Ibid.

89. Ibid., 218.

90. This study was led by the Justice and Peace Commission of the Roman Catholic

Church in São Paulo, quoted in Fátima Jordão, "TV Globo Rules the Brazilian Skies," in *TV Globo: Brazilian Television in Context*, ed. Richard Paterson, 5.

91. See chapter 1 for a discussion of Cildo Meireles's *Insertions into Ideological Circuits: Coca-Cola Project* (1969).

92. For more information about the CNRC, its founding, and its director, see Zoy Anastassakis, "Dentro e fora da política oficial de preservação do patrimônio cultural no Brasil: Aloísio Magalhães e o Centro Nacional de Referência Cultural," PhD diss., Universidade Federal do Rio de Janeiro, 2007; and the government website http://www.monumenta.gov.br/site/?page_id=165 (accessed March 19, 2012).

93. Magalhães stated that his objective was "to study preindustrial lifestyles and activities which are disappearing, to document them, and in another phase to try and influence them, helping to animate them." See Anastassakis, "Dentro e fora da política oficial," 70.

94. Ibid., 71.

95. For a comprehensive discussion of the activities of the CNRC, see Anastassakis, "Dentro e fora da política oficial."

96. I adapted the phrase used in Fátima Jordão's "TV Globo Rules the Brazilian Skies," in *TV Globo: Brazilian Television in Context*, ed. Richard Paterson, 4.

97. Nelly Richard, "Margins and Institutions: Performances of the Chilean *Avanzada*," in *Corpus Delecti: Performance Art of the Americas*, ed. Coco Fusco (London: Routledge, 2000), 214.

98. Ibid., 215.

99. Though there has been confusion surrounding the titles for the eight videos she produced from 1974 to 1977, Andrade clarifies that the series should be considered one untitled work. The following descriptive titles will be used for clarification purposes only: *Feijão (Beans*, 1975), *Fio (Wire*, 1977), *Pelos (Hair*, 1977), *Gaiolas (Cages*, 1977), *Pregos (Nails*, 1977), and *T.V.* (1977). Sonia Andrade, interview by author, digital recording, Rio de Janeiro, Brazil, October 26, 2005.

100. Ibid.

101. See chapter 2, note 13, above for the text in the decree. Also see http://www2 .camara.gov.br/legin/fed/declei/1970-1979/decreto-lei-1077-26-janeiro-1970 -355732-publicacaooriginal-1-pe.html (accessed September 15, 2011).

102. Braune Bia and Ricardo Xavier, *Almanaque da TV* (Rio de Janeiro: Ediouro, 2007), 171.

103. "O futuro de um império," *Veja*, October 6, 1976, 87.

104. Sodré, *O monopólio da fala*, 111.

105. Barbosa Lima, Priolli, and Machado, *Televisão e vídeo*, 11.

106. Richard Paterson, ed., *TV Globo: Brazilian Television in Context*, 11.

107. Esther Hamburger, "Teleficção nos anos 70: Interpretação da nação," in *Anos 70: Trajetórias* (São Paulo: Iluminuras, 2005), 48.

108. For a more comprehensive study, consult Ana Maria Colling, *A resistência da mulher à ditadura militar no Brasil* (Rio de Janeiro: Rosa dos Tempos, 1997).

109. Shortly after 1975, there was an increase in Brazil in the number of publications exploring the topic of gender in society. One such example is Heleieth Iara Bongiovani Saffioti's *A mulher na sociedade de classes: Mito e realidade*, 2nd ed. (Petrópolis: Vozes, 1976).

110. Paterson, *TV Globo: Brazilian Television in Context*, 28.

111. Marta Lamas, "Identity as Women?: The Dilemma of Latin American Feminism," in *Being América: Essays on Art, Literature and Identity from Latin America*, ed. Rachel Weiss and Alan West, 129–141 (New York: White Pine Press, 1991), 132.

112. The newspaper *Brasil Mulher*, related to the Amnesty movement, was also founded in 1975. Instituto de Estudos sobre a Violência do Estado, *Dossiê ditadura: Mortos e desaparecidos políticos no Brasil (1964–1985)* (São Paulo: Imprensa Oficial, 2009), 678.

113. Sonia Andrade, interview with author, Rio de Janeiro, October 26, 2005.

114. Ibid.

115. One prominent example is Cornelia Butler, ed., *Wack!: Art and the Feminist Revolution* (Los Angeles: Museum of Contemporary Art, 2007); exhibition catalogue.

116. Dunn, "Tom Zé," 221.

117. Paterson, *TV Globo: Brazilian Television in Context*, 15.

118. Ibid., 16.

119. One notorious example is Nelson Leirner's *O porco* (1967).

120. Elaine Scarry, *The Body in Pain: The Making and Unmaking of the World* (New York: Oxford University Press, 1985), 4.

121. Some of the headlines we see are: "Censura troca de casa" (Censorship changes homes), "Senador applaude censura" (Senator applauds censorship), "Cartas ao Leitor: Artes e Censura" (Letters to the Reader: Art and Censorship), and "*Cadernos de Opinião* é aprendido" (*Cadernos de Opinião* is seized).

122. "Anthropophagy" refers to the symbolic consumption of prevailing aesthetic models stemming from Europe and using them to nourish and transform elements of Brazilian "native" cultures into something visually "Brazilian." The Brazilian scholar Roberto Schwarz aptly described Oswald de Andrade's approach as advocating "cultural irreverence in place of subaltern obfuscation, using the metaphor of 'swallowing up' the alien: a copy, to be sure, but with regenerative effect." See Roberto Schwarz, "Brazilian Culture: Nationalism by Elimination," *New Left Review* 1, no. 167 (January–February 1988): 83.

123. The phrase quoted is from Oswald de Andrade's "Anthropophagite Manifesto," originally published in *Revista de Antropofagia* 1 (May 1928) in São Paulo. For an annotated translation, see Leslie Bary, "Oswald de Andrade's Cannibalist Manifesto," *Latin American Literary Review* 19, no. 38 (July–December 1991): 35–47; quote on page 43.

124. "É a imagem que devora então o participador" (It is the image that devours then the participant). Hélio Oiticica, *Aspiro ao grande labirinto*, 107.

125. Mello is one of few artists from São Paulo who joined the group of video artists in 1976, when Zanini purchased a Portapak and made it available for the artists. Other artists from that group include Regina Silveira, Julio Plaza, Carmela Gross, Donato Ferrari, Gabriel Borba Filho, Marcello Nitsche, and Gastão de Maglhães.

CHAPTER 4

1. See chapter 3 for more details.

2. CRADAM was part of the ambitious National Integration Plan (Plano de Integração Nacional; PIN) that was responsible for the construction of the Trans-Amazon Highway. See http://www.cprm.gov.br/publique/cgi/cgilua.exe/sys/start.htm?infoid=796&sid=9 and ftp://ftp.daac.ornl.gov/data/lba/carbon_dynamics/RADAMBrasil/comp/Pre_LBA_RADAMBrasil.pdf (both accessed July 16, 2012). For more context, see João Carlos Meireles Filho, *O livro de ouro da Amazônia: Mitos e variedades sobre a região mais cobiçada do planeta* (Rio de Janeiro: Ediouro, 2004).

3. RADAM was facilitated by such US companies as Goodyear Corporation and Litton Industries. See Davis, *Victims of the Miracle*, 64.

4. It is known as the RADAMBRASIL Project.

5. For more on the development of geography as an academic discipline, see Márcio Willyans Ribeiro, "Origens da disciplina de Geografia na Europa e seu desenvolvimento no Brasil," *Revista Diálogo Educacional* 11, no. 34 (September–October 2011): 817–834. Available online at http://www.redalyc.org/articulo.oa?id=189121361010 (accessed February 2013).

6. Ibid., 831.

7. Livestock subsidies were among the most common, and ranches were responsible for 30 percent of forest clearing between 1973 and 1983. For more information, see Christian Brannstrom, "Renewed El Dorado," in *Mapping Latin America: A Cartographic Reader*, ed. Jordana Dym and Karl Offen (Chicago: University of Chicago Press, 2011), 270.

8. For more detailed information on the topic, see John O. Browder, "Public Policy and Deforestation in the Brazilian Amazon," in *Public Policies and the Misuse of Forest Resources*, ed. Robert Repetto and Malcolm Gillis (Cambridge: Cambridge University Press, 1988), 247–297; and Marianne Schmink and Charles H. Wood, *Contested Frontiers in Amazonia* (New York: Columbia University Press, 1992), in particular chapter 3.

9. The area featured was called Amazonia Legal, an administrative term, which was conceived in 1953 under President Gétulio Vargas with the constitutional decree Lei No. 1.806, which expanded the Amazonian region to include territories in today's states of Mato Grosso, Tocantins, and Maranhão. João Augusto Meirelles, *O livro de ouro da Amazônia*, 4th ed. (Rio de Janeiro: Ediouro, 2004).

10. For a more in-depth discussion, see Davis, *Victims of the Miracle*, 36.

11. This anonymous map is identified with Cantino, an Italian tasked with smuggling it out of Portugal in 1502.

12. Álvares Cabral first referred to the Portuguese territory as the Ilha de Vera Cruz, or Island of the True Cross, and it underwent several name changes before it became known as the Terra do Brasil. During the early modern period, it was common practice for explorers to name territories for the goods produced there. See Yuri T. Rocha, Andrea Presotto, and Felisberto Cavalheiro, "The Representation of *Caesalpinia echinata* (Brazilwood) in Sixteenth- and Seventeenth-Century Maps," *Anais da Academia Brasileira de Ciências* 79, no. 4 (December 2007): 751–765. For a detailed history of Brazilwood, see Eduardo Bueno and Ana Roquero, *Pau-Brasil* (São Paulo: Axis Mundi Editora, 2002).

13. Davis, *Victims of the Miracle*, 38.

14. An image of the five-hundred cruzeiro bill from 1972 can be found at http://www.bcb.gov.br/Pre/Museu/cedulas/CR70/500a.asp?idpai=CRUZ70.

15. The reverse side of the bill shows five different faces, each representing a different ethnicity, the melding of which is thought to be responsible for the modern-day Brazilian citizen.

16. In 1970, the Brazilian government began construction on three highways, the most ambitious and well-known of which was the 5,000 km Trans-Amazon Highway, running east to west, from northeastern Brazil's Atlantic coast to the frontier with Peru. The other highways were BR-165, or Santarém-Cuiabá Highway (north to south through west-central Brazil), and BR-174, connecting Manaus with Boa Vista along the northern frontier. The coordinating agency was the Departamento Nacional de Infraestrutura de Transportes DNER (Brazilian National Highway Department), which was reorganized in 1969. See Davis, *Victims of the Miracle*, 62–63.

17. The SPI was consequently replaced by the Fundação Nacional do Índio, or FUNAI, in 1967, though the crimes committed were rarely acknowledged, and no justice was ever dispensed.

18. "Tomaremos todos os cuidados com os índios, mas não permitiremos que entravem o avanço do progresso." Octavio Ianni, *Ditadura e agricultura: O desenvolvimento do capitalismo na Amazônia, 1964–1978* (Rio de Janeiro: Editora Civilização Brasileira, 1979), 183.

19. Schmink and Wood, *Contested Frontiers in Amazonia*, 59.

20. See Davis, *Victims of the Miracle*, 47.

21. A few notable sources for such scholarship are Barbara E. Mundy, *The Mapping of New Spain: Indigenous Cartography and the Maps of the Relaciones Geográficas* (Chicago: University of Chicago Press, 2000); Nicolás Wey Gómez, *The Tropics of Empire: Why Columbus Sailed South to the Indies* (Cambridge: MIT Press, 2008); Raymond B. Craib, *Cartographic Mexico: A History of State Fixations and Fugitive Landscapes* (Durham, NC: Duke University Press, 2004); and Jordana Dym and Karl Offen, eds., *Mapping Latin America: A Cartographic Reader* (Chicago: University of Chicago Press, 2011).

22. For a concise but more expanded discussion of this work, see Jennifer Jolly, "Reordering Our World," in *Mapping Latin America: A Cartographic Reader*, ed. Jordana Dym and Karl Offen (Chicago: University of Chicago Press, 2011), 198–211.

23. The Brazilian artist Rubens Gerchman later revived this concept in a drawing completed while he was living in New York entitled *A nova geografia/Homenagem a J. Torres García* (*New Geography/Homage to Torres García*), dated 1971–1979. In the drawing, a map depicting the Americas shows North America as America do Sul, and South America as America do Norte in an obvious tribute to Torres García's work.

24. The work of the artist Horacio Zabala during the 1970s at the time of the Argentinian dictatorship is a case in point. See his *Revisar/censurar* from 1974 at http://www.horaciozabala.com.ar/english/obras.html (accessed August 13, 2013).

25. Raymond B. Craib, "Cartography and Power in the Conquest and Creation of New Spain," *Latin American Research Review* 35, no. 1 (2000): 7–36. Available at http://lasa-2.univ.pitt.edu/LARR/prot/search/retrieve/?Vol=35&Num=1&Start=7 (accessed March 2012).

26. Meireles's *Arte física: Caixas de Brasília/Clareira* from 1969 orchestrates such an opposition between conceived and lived space. See Elena Shtromberg, "Spatial Effects: Navigating the City in Cildo Meireles's *Arte Física: Caixas de Brasília/Clareira*," in *The Utopian Impulse in Latin America*, ed. Kim Beauchesne and Alessandra Santos (New York: Palgrave Macmillan, 2011), 187–202.

27. The treaty of San Il Defonso (1774) gave the Portuguese a much more significant chunk of the Amazonian forest, reflecting more accurately how the territory is divided today. See S. Whittemore Boggs, "The Map of Latin America by Treaty," *Proceedings of the American Philosophical Society* 79, no. 3 (1938): 399–410.

28. The fact that at the time of writing this book, the areas doled out by Tordesilhas are still under debate stands as a testament to how indefinable certain geographic territories continue to be despite sophisticated cartographic technologies.

29. See Scovino, *Cildo Meireles*, 239.

30. Paraty was founded by the Portuguese in the seventeenth century and was used as a port of exit for the large gold deposits, as well as other precious stones, found in the mines of the state neighboring Rio de Janeiro, Minas Gerais, during the eighteenth century. Once the gold was depleted, it served as a port to route other commodities to Portugal, including cane sugar and *cachaça* (an alcoholic beverage made from cane sugar), and eventually coffee in the nineteenth century. Though it was relatively dormant in 1969, Paraty became a popular tourist destination shortly after the construction of highway BR-101 from Rio de Janeiro to another port city, Santos.

31. Cotrim cites, for example, the Carajá group in Araguaia, whose whole genesis is

intricately imbricated with the land where they are located. "To take them out of there is to destroy their whole reason for being." See Antônio Cotrim Soares, "Índios: Sinais de crise," *Veja*, May 31, 1972, 20.

32. Rosalind Krauss, "Notes on the Index: Seventies Art in America," *October* 3 (Spring 1977): 70. To briefly summarize, in the semiotic theory of Charles Sanders Peirce (1839–1914), he conceived of the sign with regard to how it related to the object it was representing and came up with the following tripartite classification: icon, symbol, and index. In this typology, the index had a physical connection to the object.

33. Brett, *Cildo Meireles*, 46.

34. Scovino, *Cildo Meireles*, 240.

35. Ronaldo Brito, *Neoconcretismo: Vêrtice e ruptura do projeto construtivo brasileiro* (São Paulo: Cosac Naify, 1999), 55. Merleau Ponty advocated the importance of lived experience in grasping the nature of language, perception, and the body.

36. There persists to this day a latent resentment between artists from the two cities, voiced in the artist interviews conducted for this book.

37. The latest example is the inclusion of *Rio-São Paulo Border* in *Ends of the Earth: Land Art to 1974*, a global survey of land art works, also frequently referred to as earthworks, at the Museum of Contemporary Art in Los Angeles (2012). See Philipp Kaiser and Miwon Kwon, *Ends of the Earth: Art of the Land to 1974* (Munich, Germany: Prestel Publishing, 2012).

38. For an example of the rhetorical affinity, consider the work *Ground Mutations* by the US artist Dennis Oppenheim, coincidentally also from November 1969. The informational caption that is included alongside photographic documentation of this work states: "Shoes with ¼ [-inch] diagonal grooves down the soles and heels were worn for three months. I was connecting the patterns of thousands of individuals . . . my thoughts were filled with marching." Beyond the similarity of the titles, the works by Oppenheim and Meireles also share the idea that a territory is portrayed through the body's physical relationship to it.

39. Meireles participated in this event with the work *Totem—Monumento aos presos políticos* (*Totem—Monument to the Political Prisoners*).

40. See the interview with Gerardo Mosquera in Herkenhoff, Mosquera, and Cameron, *Cildo Meireles*, Contemporary Artists series (London: Phaidon, 1999), 29.

41. It is worth noting that Anna Bella Geiger had a long-standing interest in maps, partially owing to her husband, Pedro Geiger, who was mentioned earlier in the chapter as one of the leading geographers to introduce a critical study of urban geography in Brazil during the 1960s. The artist was thus exposed to many of the scholarly debates within the discipline, all of which informed (and continue to do so today) her own practice with mapping.

42. Though there was originally an *Elementary Maps 2*, it was lost early on and now exists in a contemporary restaged version.

43. Argentina was where Boal published his best-known book, *Theater of the Oppressed* (1973), after which he left for France.

44. Author's translation of "sem a cachaça ninguém segura esse rojão."

45. For more on this within a colonial context, see Craib's exceptional analysis in Raymond B. Craib, "Cartography and Power in the Conquest and Creation of New Spain," *Latin American Research Review* 35, no. 1 (2000): 7–36, http://lasa-2.univ.pitt.edu/LARR/prot/search/retrieve/?Vol=35&Num=1&Start=7 (accessed March 2012).

46. I want to thank Christopher Dunn for bringing this relationship to my attention.

47. See Amanda Gatinho Ferreira, "Poder, simbolismo, religiosidade e misticismo," *Tucunduba*, no. 2 (2011), available at http://www.revistaeletronica.ufpa.br/index.php/tucunduba/article/viewArticle/41 (accessed August 7, 2012).

48. Ibid., 22.

49. Many of the prominent voices were compiled in Damián Bayón, ed., *El artista latinoamericao y su identidad* (Caracas: Monte Avila Editores, 1977).

50. Aracy Amaral, "O regional e o universal na arte: Por que o temor pelo latinoamericanismo?," *O Estado de São Paulo*, Suplemento Cultural, October 8, 1978, 3.

51. See *1 Bienal Latino-Americana de São Paulo*, exhibition catalogue, http://issuu.com/bienal/docs/nameb1fc34 (accessed August 10, 2012).

52. The artist and others in her staged scenes were photographed by Luiz Carlos Velho.

53. The publisher of the postcards, Bloch Editores, was a large media conglomerate, which comprised magazines, newspapers, and later the television station TV Manchete. Among the magazines that Bloch Editores inaugurated during the 1970s was the *Revista Geográfica Universal*, which followed the design and format of *National Geographic* and often depicted indigenous people from the Amazon.

54. For more on the boycott of the Bienal, see chapter 2. For a discussion of the São Paulo Biennial and its activity during the 1970s, see Isobel Whitelegg, "The Bienal de São Paulo: Unseen/Undone (1969–1981)," *Afterall: A Journal of Art, Context, and Enquiry* 22 (Autumn/Winter 2009): 106–113.

55. Ibid., 108.

56. MAC-USP not only organized a number of international manifestations of conceptual art throughout the 1970s, but its director at the time, Walter Zanini, also bought and collected many of the works, accumulating throughout the years what is no doubt one of the biggest repositories of conceptual art (including documentation of performance art, mail and xerox art, etc.) in Brazil.

57. Whitelegg, "The Bienal de São Paulo," 113.

58. Margaret Garlake, *Britain and the São Paulo Bienal, 1951–1991* (London: The British Council, 1991), 24.

59. Andrade encountered the collection of postcards among an uncle's possessions after he passed away. She points out that it is important for the work that none

of the postcards were ever purchased. Sonia Andrade, correspondence with the author, July 12, 2012.

60. Ibid.

61. The post office in Brazil also functioned as a system during the 1970s, and though it is beyond the confines of this book, it would make for a fascinating study related to the important phenomenon of mail art.

62. Majestic residences began to populate Avenida Higienópolis in what was the city's oldest neighborhood as a result of booming coffee sales and wealthy coffee barons.

63. The events of Modern Art Week took place at the Teatro Municipal de São Paulo and lasted from February 13 to 17, 1922, and included exhibits of painting, drawing, and sculpture, as well as literary readings, musical events, and scandalous performances. Participating visual artists included Anita Malfatti, Emiliano di Cavalcanti, Victor Brecheret, Ferrignac, John Graz, Martins Ribeiro, Antônio Paim Vieira, Vicente do Rego Monteiro, Yan de Almeida Prado, Zina Aita, Hildegardo Leão Velloso, and Wilhelm Haarberg. For a replica of materials and postcards of images included in the event, see the portable exhibit, organized as a box by Jorge Schwartz, *Caixa modernista* (São Paulo: EDUSP, 2003). For a sense of the cultural context for this event, see Jorge Schwartz, "Literature and the Visual Arts: The Brazilian Roaring Twenties," Institute of Latin American Studies, University of Texas at Austin, 2002, available at http://lanic.utexas.edu/project/etext/llilas/vrp/jschwartz.htm.

64. Though the Companhia do Metropolitano de São Paulo was founded in 1968, and the metro began operation in 1972, it is not until 1974 that it officially opens to the public.

65. Xerox, a US company, was established in Brazil in 1965. Artists rapidly adopted the inexpensive technology, experimenting with its features to establish a new medium of representation. The Xerox was particularly important for the experimental publications artists and poets were collaborating on, explained in further detail in chapter 2, "Newspapers."

66. "This multitemporal heterogeneity of modern culture is a consequence of a history in which modernization rarely operated through the substitution of the traditional and the ancient. There were ruptures provoked by industrial development and urbanization that, although they occurred after those of Europe, were more accelerated." Néstor García Canclini, *Hybrid Cultures: Strategies for Entering and Leaving Modernity* (Minneapolis: University of Minnesota Press, 2005), 47. First published in Spanish as *Culturas híbridas: Estrategias para entrar y salir de la modernidad* (Mexico City: Grijalbo, 1990).

67. Denis Cosgrove, "Introduction," in *Mappings*, ed. Denis Cosgrove (London: Reaktion, 1999; distributed by the University of Chicago Press), 11–12.

68. Denis Wood, "Map Art," *Cartographic Perspectives* 53 (Winter 2006): 13.

EPILOGUE

1. "não só de criar simplesmente, mas de comunicar algo que para ele é fundamental, mas essa comunicação teria que se dar em grande escala, não numa elite reduzida a 'experts.'" From Oiticica's text "Esquema geral da Nova Objetividade," which accompanied the *Nova objetividade brasileira* exhibit. The text is reprinted in Oiticica, *Aspiro ao grande labirinto*, 84–98, as well as in Brett et al., *Hélio Oiticica*, 110–120. The translated version can be found in Brett et al., *Hélio Oiticica*, 119, and in Basualdo, *Tropicália: A Revolution in Brazilian Culture*, 221.

2. One excellent case in point is the publication by Rebecca J. Atencio, *Memory's Turn: Reckoning with Dictatorship in Brazil* (Madison: University of Wisconsin Press, 2014).

INDEX

Page numbers in italics indicate illustrations.